DRAWINGS FROM THE COLLECTION OF LORE AND RUDOLF HEINEMANN

DRAWINGS FROM THE COLLECTION OF LORE AND RUDOLF HEINEMANN

CATALOGUE BY

FELICE STAMPFLE

AND CARA D. DENISON

WITH AN

INTRODUCTION BY

JAMES BYAM SHAW

The Pierpont Morgan Library

NEW YORK 1973

TABLE OF CONTENTS

PREFACE

WE are very happy to show at The Pierpont Morgan Library a selection of the finest drawings in the collection of Dr. and Mrs. Rudolf Heinemann. It is without question one of the most distinguished private collections of drawings in the United States and, as yet, except for a few drawings, unknown to the American public. Preeminent in the Heinemann collection is the group of drawings by Giambattista and Domenico Tiepolo, a collection which was in large part formed by Tomas Harris. When that collection was shown in London in 1955, it was a revelation of the extraordinary draughtsmanship of the two Tiepolos, father and son. It was there that I, for one, first appreciated how vital and immediate their draughtsmanship is. Now, after eighteen years, we can see in New York what gave so much pleasure to the English public. New York today holds the most important collections of the drawings of the Tiepolo family, but we can learn a great deal from the drawings in the Heinemann collection which are not usually housed in this city.

Like all exhibitions at the Library, this one is meant to delight and to inform. We are simply following J. P. Morgan's wishes when he gave the books and the art collections to the public that they should be "permanently available for the instruction and pleasure of the American people." We believe that it will be valuable to give the admirer of eighteenth-century draughtsmanship and all scholars another opportunity to see the range and variety of the drawings of Giambattista and Domenico Tiepolo. Even after the recent exhibitions at the Fogg Museum, at Stuttgart and Udine, and that sponsored by the Metropolitan Museum and the Morgan Library during the centennial year of the Metropolitan, there are many questions unanswered, and this exhibition may help to solve a few of them.

Rudolf Heinemann was first inspired to enjoy the drawings of the Tiepolos by his long friendship with Tomas Harris, who unfortunately died early in a tragic accident in Palma, Majorca. This exhibition, however, is in particular a tribute to Rudolf Heinemann and to James Byam Shaw, two men who have been dominant forces in the collection of art, and the development of the most important collections of art during the past forty or fifty years. Mr. Byam Shaw (the great student of the Tiepolos and Guardi) has always been especially associated with drawings, Dr. Heinemann, with paintings; but both are linked in this exhibition which gives us an opportunity to honor these two men. Both

7

men have combined uniquely the attributes of connoisseur and scholar. Without them our knowledge would have been far less rich.

Dr. Heinemann was born in that celebrated center of art historical studies, Munich, and was educated there and in two other places of comparable importance—Berlin and Florence. He was a favorite student of some of the most famous scholars of the past generations: Wölfflin, Wagenbauer, and Bode. From the mid-nineteen-twenties, he has been chiefly responsible for the development of the Thyssen Museum in Lugano, and most of the notable paintings there came through his direction. At the same time, since for many years he has spent half his time in Europe and half in the United States, he has brought a number of the greatest paintings to American museums: to the Metropolitan Museum, the Frick Collection, the National Gallery, and the museums in Boston, Cleveland, Detroit, Toledo, and Chicago. He worked first with Arnold Seligmann Rey and Co., Inc., and then with M. Knoedler and Co., Inc., where he enjoyed a close friendship with Charles Henschel until his death; afterwards he has often been associated with Thos. Agnew & Sons, Ltd. Dr. Heinemann was instrumental in obtaining from the Italian government the pictures for the San Francisco Golden Gate exhibition in 1938.

Mrs. Heinemann has shared with her husband his keen appreciation of drawings and has encouraged him to collect these beautiful works of art by the two Tiepolos, by Piazzetta, Ingres, and many others. I have mentioned the Tiepolos first of all because two-thirds of the exhibition is devoted to their works. Yet the series of Ingres drawings would make any museum proud. It is a rare opportunity as well to show in America a charming watercolor by Avercamp, a small but sweeping landscape by Koninck, a classical landscape by Van Huysum, or the landscape by David; the *veduta esatta* of Pannini and the superlative Moroccan watercolor by Delacroix are among other notable drawings.

This sample of the Heinemann collection will show many of their remarkable acquisitions. The catalogue is the work of Miss Stampfle and Mrs. Denison who, as always, have worked far beyond the call of any duty to make possible this exhibition. We owe them, the Heinemanns, and Mr. Byam Shaw our deepest gratitude. For advice and help of various kinds, thanks are also due to our friends and colleagues here and abroad, Mr. Jacob Bean, Dr. K. G. Boon, Mr. Anthony M. Clark, Miss L. C. J. Frerichs, Mr. Carlos van Hasselt, Professor Egbert Haverkamp-Begemann, Mr. Michael Levey, Miss Agnes Mongan, Dr. Hans Naef, Professor W. R. Rearick, Miss Elizabeth Roth, Mr. Germain Seligman, Mr. F. J. B. Watson, and Mr. Christopher White; and to our associates at the Library, Mrs. Ruth S. Kraemer, Mr. A. J. Yow, Mrs. Patricia Reyes, and Mrs. Judith Grant. To the Heinemanns, we are above all thankful, for we have reason to hope that the greater part of their collection will someday be permanently at The Pierpont Morgan Library.

<div align="right">

CHARLES RYSKAMP, *Director*

</div>

INTRODUCTION

IN WRITING an introduction, at the invitation of Mr. Ryskamp and Miss Stampfle, to the catalogue of this exhibition, I must ask the indulgence of the reader if I devote my remarks almost entirely to the drawings of the Tiepolos. I do so for two reasons. In the first place, these are the drawings in this collection that are best known to me: many of them I have seen often; whereas the drawings by other masters that Dr. and Mrs. Heinemann have acquired—other Italians, Netherlandish, French, Spanish, and German—I know less well. And secondly, though the exhibition includes a variety of things of other periods and schools, pride of place here must unquestionably be accorded to the Tiepolos; for this is certainly as choice a collection of their drawings as any still remaining in private hands. It is indeed one that will stand comparison, in quality if not in numbers, with the famous collections of the Morgan Library and the Metropolitan Museum; and although the Heinemann treasures are usually housed only partly in New York, it is pleasant to reflect that at this moment, for the duration of this exhibition, such rich material is added to the extraordinary range of Tiepolo drawings that is otherwise available for the public to see in the museums of this city. Two years ago, a similar opportunity presented itself, when that great selection from the Morgan and Metropolitan Tiepolos was reinforced from all the New York private collections, in the eighteenth century Italian exhibition of 1971; but in that *embarras de richesse* there were only twelve drawings by Giambattista and six by Domenico of those belonging to Dr. and Mrs. Heinemann. Now there are more than forty of each; the standard of quality is not diminished, and much of the material will be new to many of the visitors.

The collection has been assembled, I believe, chiefly in the last twelve or fifteen years; and in the process, Dr. Heinemann's greatest single *coup* was his acquisition in 1963 of the entire Tiepolo material gathered by that discriminating connoisseur, the late Tomas Harris, most of which was exhibited by the Arts Council in London in 1955. Harris, who began his career as a dealer, was by instinct rather an artist and also a compulsive collector; and when Richard Owen died in Paris in 1952, and his private collection of drawings was sold in London, Tomas Harris had the good fortune to be offered his choice, and the taste and judgment to take the best. Thus he acquired those wonderfully beautiful drawings of Giambattista, the *Virgin and Child Seated on a Globe* (No. 40) and the *Annunciation* (No. 37) —to name only two of several which Owen had bought at the famous Orloff sale in

9

Paris in 1920 and retained for his own enjoyment until his death. There must still be elder statesmen of the art world in America, former museum directors and amateurs, who remember the Orloff sale, and remember also Richard Owen's shop on the Quai Voltaire. He was, like Harris, a man of real taste, and the shop was full of fine things of the eighteenth century; but these drawings of Tiepolo, I think, were never there for sale.

From Harris, too, the Heinemanns have had many more of the best drawings in the present exhibition. Two masterpieces that are exceptional in subject are the *Design for an Overdoor with Cherubs* (No. 78) and the *Study for a Family Group* (No. 77); but of a more familiar sort, those variations on the theme of the *Holy Family* are no less outstanding in quality. It was a theme that seems particularly to have inspired Giambattista in the late 1750's, before his departure for Spain; and it is a series that must be reckoned among his greatest achievements in drawing, so infinitely varied in composition, so passionately devotional, and yet so tenderly, touchingly conceived. Nothing could be more beautiful, or illustrate better what I mean, than that one which is composed—unusually and with marvelous skill—in oblong format (No. 62), in which St. Joseph kneels to adore the Child, and the Child gently strokes the old man's head. But who can describe the beauty and the skill of the execution of such a drawing? The writer seeks words to convey, in the language of poetry or music, the impact of the pen or the brush on the paper; and in the end must content himself with silent admiration of so magical a performance.

This series of compositions of the *Holy Family* came from one of the albums of Tiepolo drawings which belonged to an Englishman, Colonel Edward Cheney, in the middle of the last century—long before any of his countrymen, or indeed anyone at all, had discovered much interest in Tiepolo's art. Nine of these albums, as Professor George Knox has shown, were sold in one lot for a trifling sum at the Cheney sale at Sotheby's in London in 1885; and their subsequent history has been plausibly traced by Knox, first in his catalogue (1960) of the two albums now in the Victoria and Albert Museum, and more recently (with some modifications) in the catalogue of the Stuttgart exhibition of 1971. I need not repeat it all here; but from the same precious lot (lot 1024) in that Cheney sale, bought by the London dealer Parsons and now scattered, came the group of masterly foreshortened figures (Nos. 55–61) and the single draped figures (Nos. 44–50) in the present exhibition—the latter a series generally known as *Sole figure vestite*, from the title inscribed in the cover of one of the two whole albums which were acquired for the Victoria and Albert Museum a year after the sale.

The splendid study in red chalk (No. 71), from that bust of the painter Palma Giovane by Alessandro Vittoria which provided the model for other surviving drawings by Giambattista and both his sons, came from another well-known source of Tiepolo drawings, on the history of which Professor Knox, again, has published valuable information (in his catalogue of the Stuttgart exhibition of 1971). Sold at Stuttgart in 1882, this vast material

passed partly to the Graphische Sammlung of that city; but a large part was acquired by Dr. Hans Wendland of Lugano, whence, indirectly, the Palma Giovane has come in the course of time to Dr. Heinemann. It is a drawing that provides a touchstone of style and quality for the distinction of Giambattista's hand from that of his sons, in a medium that was, I believe, less commonly used by him than by Domenico and Lorenzo.

One other group of drawings here exhibited deserves particular notice, and I must discuss it briefly, though such argument is perhaps not properly the business of an introductory preamble: I must make a plea for the recognition of Giambattista as a caricaturist, here once more using his favorite medium of pen and wash. All the caricatures in this exhibition (Nos. 73–76) were attributed to Domenico Tiepolo, and were I believe accepted as such by the present owner; a single example from a private collection, also attributed to Domenico, was in the Stuttgart exhibition. I believe that all these, including the drawing at Stuttgart in 1971, which I imagine all came from one source, are by Giambattista, who in this *genre*, as in so much else, inspired his son. We know, of course, that Domenico was a brilliant caricaturist—almost, but not quite, as good as his father. A well-known example in the Metropolitan Museum (which I reproduced, again as a touchstone, in my book on Domenico's drawings in 1961) is signed by him, having on the same sheet some very characteristic head-studies by him; and there are others which I believe are rightly attributed to him in the Museum of Trieste and elsewhere. But the connoisseur should compare carefully the linework in those drawings, and perhaps more particularly the brushwork, with those of the Heinemann drawings. Giambattista's line is more spontaneous, more broken and economical; and he uses his wash, very slight and pale, and instantaneously applied, to give the merest hint of tone—not, as Domenico does with his ragged brushstrokes, to help in the suggestion of form. This is the same medium and method that Giambattista used for his most grandiose effects; the unerring touch, here applied to an ephemeral *jeu d'esprit*, is the same. The distinction between this and the method of Domenico is at first sight very narrow; but I am convinced that it can be made.

As to Domenico, this exhibition includes examples of nearly every category of drawing produced by that devoted son, who seems in some respects to have been determined to sink his own talents and personality in those of his father, and yet emerges to his familiars as an original and greatly gifted artist in his own right, who had, perhaps, more influence in the family studio than is generally recognized. Here are twelve of those very large drawings of biblical subjects—subjects often obscure, derived from the apocryphal Gospels—of which a whole album-full, known as the *Recueil Fayet*, is in the Louvre, and a very fine group in the Morgan Library; certainly not studies for painting, but album-drawings done for their own sake. Here are two of the series of *St. Anthony and the Child Christ*; three of the *Trinity* or *God the Father Supported by Angels*; four of *Child Angels* or *Cupids*, tumbling in the clouds (the sacred theme merging into the profane); one of the *Pagan*

Gods and Goddesses that recall so charmingly the sculpture in the villa gardens of the Veneto; and two of *Hercules and Antaeus*—all categories that are familiar, since such innumerable variations on a single theme are characteristic of Domenico's habit in drawing. There is also at least one chalk drawing (No. 79) which is a typical record of detail from one of the works that remained behind in Germany when the Tiepolos left Würzburg in 1753. But besides all these, and perhaps more important—because they were Domenico's own invention, modes in which he, rather than his father, became the family expert—there are the fascinating Satyr subjects, and the animals, the subjects from daily life which have a dash of satire (No. 112), and the Punchinellos, with all of which he decorated the family villa at Zianigo near Padua. He made in his old age, as is well known, a long series of more than a hundred delightful drawings, to illustrate the story of Punchinello, that feckless, engaging character of the Italian Comedy, whom he had already introduced in the frescoes of the villa. The series was exhibited *in toto* (except for one single example which had already found its way into the Morgan Library) at the Musée des Arts Decoratifs in Paris more than fifty years ago, and was then distributed piece-meal to museums and private collections all over the world. These drawings have become increasingly sought after, as they change hands from time to time, and are justly prized. Many are now in America, and two particularly charming examples (Nos. 113–114) have come to the Heinemann collection. I think it is fair to say that, excepting the Morgan Library and the Metropolitan, this is on the whole the finest and most representative group of Domenico's drawings that could be mustered anywhere from one source.

The rest of the exhibition I must not presume to write about, since, as I have said, I have seen only a few of the originals. It would be invidious and misleading, perhaps, to single out those that I recognize from long ago—the Canaletto, the Ostade, the delightful gondolas by Francesco Guardi—without referring to others that I have seen only in reproduction; such as the Claude, the varied group of Ingres, and the studies by that fine draughtsman Menzel. Too many people, I am afraid, speak too familiarly on such slight acquaintance. One day perhaps I may be privileged to see them all and know them better.

JAMES BYAM SHAW

12

LIST OF ABBREVIATIONS

Works Cited in an Abbreviated Form

Byam Shaw, *Domenico Tiepolo*
J. Byam Shaw, *The Drawings of Domenico Tiepolo*, London, 1962.

De Vesme
Alexandre de Vesme, *Le Peintre-graveur italien*, Milan, 1906.

Lugt
Frits Lugt, *Les Marques de collections de dessins et d'estampes . . .* , Amsterdam, 1921.

Lugt S.
Frits Lugt, *Les Marques de collections de dessins et d'estampes . . . Supplément*, The Hague, 1956.

Hadeln I and II
Detlev Baron von Hadeln, *The Drawings of G. B. Tiepolo*, 2 vols., Paris and New York, 1928.

Knox, *The Orloff Album*
George Knox, "The Orloff Album of Tiepolo Drawings," *Burlington Magazine*, CIII, 1961, pp. 269–75.

Morassi, 1955
Antonio Morassi, *G. B. Tiepolo, His Life and Work*, London, 1955.

Morassi, 1962
Antonio Morassi, *A Complete Catalogue of the Paintings of G. B. Tiepolo*, London, 1962.

Sack, *Tiepolo*
Eduard Sack, *Giambattista und Domenico Tiepolo*, Hamburg, 1910.

Exhibitions Cited in an Abbreviated Form

Fogg Art Museum, Tiepolo Exhibition, 1970.
Cambridge, Mass., Fogg Art Museum, Harvard University, "Tiepolo, A Bicentenary Exhibition, 1770–1970" (catalogue by George Knox), 1970.

London, Arts Council, Tiepolo Exhibition, 1955.
London, Arts Council, "Drawings and Etchings by Giovanni Battista Tiepolo and Giovanni Domenico Tiepolo" (catalogue by J. Byam Shaw), 1955.

London, Royal Academy, 1953.
London, Royal Academy, "Drawings by the Old Masters" (catalogue by Dr. K. T. Parker and James Byam Shaw), 1953.

London, Royal Academy, 1954–55.
London, Royal Academy, "European Masters of the Eighteenth Century," 1954–55.

London, Savile Gallery, Tiepolo Exhibition, 1928.
London, Savile Gallery, "Drawings by Giovanni Battista Tiepolo," 1928.

New York, Metropolitan Museum, Drawings from New York Collections III, 1971.
New York, The Metropolitan Museum of Art and The Pierpont Morgan Library, "Drawings from New York Collections III: The Eighteenth Century in Italy" (catalogue by Jacob Bean and Felice Stampfle), 1971.

Stuttgart, Tiepolo Exhibition, 1971.
Stuttgart, Staatsgalerie, and elswhere, "Drawings by Giambattista, Domenico and Lorenzo Tiepolo from the Graphische Sammlung Staatsgalerie Stuttgart, from Private Collections in Wuerttemberg and from the Martin von Wagner Museum of the University of Wuerzburg" (catalogue by George Knox in collaboration with Christel Thiem), exhibition circulated by the International Exhibitions Foundation, 1971.

CATALOGUE

Dutch School

HENDRICK AVERCAMP
AMSTERDAM 1585 – 1634 KAMPEN

1 *Winter Landscape: Farm Buildings on a Canal*

Pen and brown and gray-black ink over preliminary indications in black chalk, watercolor in gray-green, blue, and red. Sight measurements: 5 ⅞ × 11 ⅝ inches (14.9 × 29.5 cm.). Inscribed (signed?) with the artist's monogram in black ink at lower center.

Avercamp, the deaf-mute painter and draughtsman, was the first of the Dutch artists to specialize in winter scenes of outdoor life. A finished, tinted drawing such as this was no doubt destined to be sold as an individual work. It is difficult to date Avercamp's work because there is relatively little change in his style and so few of his drawings bear a date alongside his monogram. Professor Egbert Haverkamp-Begemann has suggested that such a drawing as this may be early, not, however, as early as the drawing of 1613 in the Frits Lugt Collection, Fondation Custodia, Institut Néerlandais (Inv. no. 4953), the artist's earliest dated work. A certain tentativeness in the rendering of the figures is understandable in the light of an early date.

PROVENANCE: Dr. H. C. Valkema Blouw (Lugt 2505; sale, Amsterdam, Frederik Muller and Co., March 2–4, 1954, no. 9).

DUTCH SCHOOL
SEVENTEENTH CENTURY

2 *Couple Crossing a High Trestle Bridge above a Rocky Stream*

Black chalk, brown wash. 5 ⅝ × 8 ½ inches (14.3 × 21.6 cm.).

In view of the somewhat northern character of the rushing, rocky stream and the dead pines it depicts, this drawing in the past has been attributed to Allaert van Everdingen who is known to have traveled in Sweden and Norway in the early 1640's. In handling, however, it is unlike this artist's rather deliberate way of working. In its quick spontaneity of execution it is perhaps more in the spirit—if not the customary medium—of the pen-and-wash landscapes of Roelant Roghman, and the subject matter is not alien to his paintings of mountainous landscapes where pines or firs and waterfalls are often found. His name occurred independently to both Mr. J. Byam Shaw and Miss L. C. J. Frerichs as a possible author of the Heinemann sheet. Another name that perhaps should be considered is that of Herman Saftleven who had a preference for black chalk in combination with brown wash but usually not with the sense of liveliness of immediate notation that this drawing conveys.

GERBRAND VAN DEN EECKHOUT
AMSTERDAM 1621 – 1674 AMSTERDAM

3 *The Satyr and the Peasant*

Pen and brown ink, light brown wash. 4⅜×5⅜ inches (11.0×13.7 cm.). Inscribed on verso: at top in red chalk, *WJ*; at lower left in pen and brown ink, *660*.

This drawing, attributed to Eeckhout by Dr. J. C. Ebbinge-Wubben, illustrates the Aesopian story of the satyr who is astounded to find the peasant first blowing hot to warm his hands and then cold to cool his porridge. The subject appears to have been a popular one in the seventeenth century, which witnessed the publication of La Fontaine's *Fables* in 1668; earlier such works as Gabriello Faerno's *Fables* (Rome, 1563) would have been available. The theme was particularly favored in the Low Countries, Jordaens representing it more than once in Flanders, and artists in the orbit of Rembrandt turning to it in Holland though no painting or drawing by the great Dutch master himself is known. (Otto Benesch in his corpus listed a drawing in the Art Institute at Chicago under the category "attributions" [Vol. IV, A. 31, fig. 1031].) Eeckhout depicted the subject on several occasions. His chalk drawing in the Institut Néerlandais (Inv. no. 9206) is a study for the signed painting in the Nationalmuseum, Stockholm (as noted by Trautscholdt in his contribution to the *Festschrift* [1969] for Professor Krönig); his drawing of the subject at the Kunsthalle, Hamburg, is preparatory for a painting dated 1653 (Berlin art market, about 1960).

JAN VAN GOYEN
LEIDEN 1596 – 1656 THE HAGUE

4 *Houses along a Canal with Boats and a Bridge*

Black chalk and some gray wash. 6½×10¾ inches (16.5×27.3 cm.). Signed with monogram and dated at lower right: *VG 1653*.

During the years 1651–54 Van Goyen seems to have devoted much of his time to drawing. Like the present sheet dated 1653, a year when he apparently drew more than he painted, the drawings from these years are complete compositions, rendered with a lively touch in black chalk and lightly brushed washes in gray or brown. Signed with his monogram and dated, they were very possibly made for sale as independent works to supplement Van Goyen's always precarious finances. The artist, despite his commissions and a variety of financial activities—these included art dealing and speculation in real estate and tulips—died insolvent. Whether or not this drawing was actually made on the scene, certain elements, such as the diagonal rank of steep-gabled houses on the left, must have been derived from earlier sketchbook jottings after nature.

PROVENANCE: William Mayor (Lugt 2799); Prince Liechtenstein; Professor Leopold Ruzicka, Zurich.

JAN VAN HUYSUM
AMSTERDAM 1682 – 1749 AMSTERDAM

5 *Classical Landscape*

Pen and brown ink and some gray ink over faint traces of black chalk, brown and gray washes. $9\frac{1}{8} \times 10\frac{7}{8}$ inches (23.2×27.6 cm.).

Although his name is most commonly associated with his brilliant flower pieces in chalk and watercolor, Van Huysum, acclaimed in his day as the "phoenix of flower painters," also produced a number of finely worked classical landscapes in pen and wash. The Heinemann example with its ruins and arcadian figures moving in a woodland setting is typical. There is a similar but slightly simpler version in the Albertina, Vienna (Inv. no. 10542). A painting of the same composition was etched by Victor Pillement (1767–1814) as no. 346 in Joseph Lavallée's *Galerie du Musée Napoléon* (pub. by A. M. Filhol, engraver), Paris, 1804–28; the picture is still in the Louvre (Inv. no. 1381).

PROVENANCE: Prince Liechtenstein; Professor Leopold Ruzicka, Zurich.

PHILIPS KONINCK
AMSTERDAM 1619 – 1688 AMSTERDAM

6 *Flat Landscape with Scattered Houses and a Windmill*

Pen and brown ink over faint indications in black chalk, with brown wash and watercolor in green, gray-blue, rose, and yellow. $4\frac{5}{8} \times 9\frac{7}{16}$ inches (11.7×24 cm.). Signed with initials and dated on verso in red chalk (according to Muller sale catalogue, 1912): *p.ko.1671.*

Indebted to Rembrandt if not actually his pupil, Philips was the most important of a family of artists, which included his older brother and teacher Jacob and his cousin Salomon. Today he is best known for his landscape paintings and drawings, but in his day his portraits and genre paintings found favor. This flat landscape with its great distances is characteristic of his late period when he frequently used watercolor. As was sometimes his practice, Koninck signed the sheet on the verso, in this instance, with his initials. He also similarly marked the drawings of other artists, which he as one of the more prosperous Dutch artists of the seventeenth century was apparently able to collect. (See the exhibition catalogue by Carlos van Hasselt, "Dessins de paysagistes hollandais du XVIIᵉ siècle," Brussels, 1968–69, no. 26.)

PROVENANCE: Thomas Dimsdale (Lugt 2426); J. E. Fordham sale, London, April 9, 1910, no. 89; sale, Amsterdam, Muller, June 11–14, 1912, no. 136; Prince Liechtenstein; Professor Leopold Ruzicka, Zurich.

BIBLIOGRAPHY: Horst Gerson, *Philips Koninck*, Berlin, 1936, pp. 66, 139, no. z.7.

ADRIAEN VAN OSTADE

HAARLEM 1610 – 1685 HAARLEM

7 *Reading the News at the Weaver's Cottage*

Pen and brown ink over black chalk, watercolor, and some gouache. $9\frac{5}{16} \times 7\frac{7}{8}$ inches (23.6×20 cm.). Signed and dated at lower right in pen and brown ink: *Av. Ostade 1673*. Watermark: Monogram *IHS* surmounted by small cross, letters *PB* below (according to Schneider sale catalogue). Engraved by Cornelis Ploos van Amstel (1765); Captain William Baillie (1768); François Janinet; and Christian Josi (1821).

Finished watercolors of scenes of rustic domesticity were produced in quantity by Ostade in his later years, especially in the 1670's. Sometimes the same subjects were also developed as paintings and etchings, but this does not seem to have been the case with the present drawing as far as could be ascertained. *Le Lecteur de Gazette* or *Le Nouvelliste* is, however, one of Ostade's best-known watercolors and was engraved repeatedly. Its provenance can be traced back to the late eighteenth-century Amsterdam burgomaster, Jonas Witsen, who owned some of the finest of Ostade's watercolors. Josi states that he engraved it again when he brought out the augmented series of plates by Ploos von Amstel because he felt that "Dans la première épreuve de cette estampe, donnée par M. Ploos lui-même, il règne généralement une désagréable couleur rougeâtre: précisément l'opposé du dessin original d'après lequel la dite épreuve a été exécutée." Ostade, himself the son of a weaver, here depicts the interior of the weaver's cottage in the delicate color harmonies characteristic of his art.

PROVENANCE: Jonas Witsen (sale, Amsterdam, August 16, 1790); Pierre-François Basan, Paris (according to Rudolph Weigel, *Die Werke der Maler in ihren Handzeichnungen* . . . , Leipzig, 1865, p. 445, no. 5287); Bernardus de Bosch (sale, Amsterdam, Roos, March 10, 1817, p. 43, no. 1, 1500 florins); H. van Cranenburg (sale, Amsterdam, Roos, October 26, 1858, no. 3, 980 florins); Eugène Schneider (sale, Paris, Hôtel Drouot, April 7, 1876, no. 79, 2400 francs).

French School

JACQUES-LOUIS DAVID

PARIS 1748 – 1825 BRUSSELS

8 *View of a Town in the Roman Campagna*

Brush and gray wash over pencil. Sight measurements: $5\frac{1}{4} \times 9$ inches (13.3×23.1 cm.). Inscribed by the artist in pencil along lower edge, *du Sens opposé, le jour venant de derrière*; initialed by the artist's sons Eugène and Jules in pen and brown ink at lower left, *E D / J. D.*

This charming view came from Album 10, one of two albums of David's drawings, numbered 3 and 10, which were on the New York art market some years ago. There were originally twelve of these *Albums Factices* which the artist began in 1774 on his first trip to Italy. (For a discussion

of these, see D. L. Dowd, *Jacques-Louis David: Pageant Master of the Republic*, 1948, pp. 9ff., 195.) While he filled them for the most part with rough studies of ancient art and copies of Italian paintings, his inclusion of some landscape drawings reflects his response to Rome and the Italian countryside as well. (Album 10 contained eleven of these.) Album 3 was recently sold more or less intact to the Nationalmuseum, Stockholm (see Per Bjurström, "Ein skissbok av David," *Kontact Nationalmuseum*, 1969, pp. 7–18), but Album 10 was dismembered and the drawings sold separately. An inscription, which was probably made around the time of the David sales on the endpapers of the original binding which is still here in New York, notes that Album 10 contained eighty-four drawings and seventeen tracings on twenty-three leaves, but another inscription dated 1886 reveals that there were only seventy-one drawings and fifteen tracings at that time, which would suggest that some drawings were removed from the album before 1886. The artist's own inscription on the bottom of the Heinemann drawing indicates that he drew this picturesque view more than once, but the town has yet to be identified. Mr. Byam Shaw suggests that it may represent one of the Tiber islands.

PROVENANCE: Jules and Eugène David (Lugt 1437 and 839); David sale, Paris, salle Lebrun, April 17, 1828, part of lot 66; 2nd David sale, Paris, March 11, 1835, lot 10; M. Chassegnolles (David's grandson?); Marquise de Ludre (David's great-granddaughter); sale, London, Christie's, July 7, 1959, no. 42, repr.

BIBLIOGRAPHY: Jules David, *Le Peintre Louis David*, Paris, 1880, pp. 651, 653; Klaes Holma, *David, son évolution et son style*, Paris, 1940, p. 113; Louis Hautecoeur, *Louis David*, Paris, 1954, p. 38.

9 *Preparations for the Battle of the Milvian Bridge: The Gallic Cavalry and the Infantry*

Pen and brown ink, brown and gray wash, over black chalk. Sight measurements: 8 1/8 × 11 15/16 inches (20.6 × 30.2 cm.). Inscribed by the artist in pen and brown ink at lower left, *dapres jules romain*; initialed by the artist's sons at lower right, *E.D.* and *J.D.*

This drawing and No. 10 were probably done during David's first trip to Rome when he made numerous copies of Italian art and antiquities, and it is very likely that they came from one of the *Albums Factices* (see No. 8). Both drawings copy different sections of the same fresco which the artist thought was by Giulio Romano following the tradition that this series of seven chiaroscuro *basamenti* in the Sala di Costantino, Vatican, were painted by Giulio and his assistants. Now, however, many scholars believe that, while Giulio painted the large frescoes, these small panels are the work of Polidoro da Caravaggio (see A. Marabottini, *Polidoro da Caravaggio*, Rome, 1969, pp. 46ff.). While this drawing copies approximately half of the first of three of these small panels or *finti bronzi* (simulating the bronzes of the ornament above) which are situated directly beneath Giulio's *Battle of the Milvian Bridge* and depict incidents relating to the battle, No. 10 shows half of the middle panel.

PROVENANCE: Jules and Eugène David (Lugt 1437 and 839).

10 *Bound Captives Brought before Constantine after the Battle at the Milvian Bridge*

Pen and brown ink, brown and gray wash, over black chalk. Sight measurements: 8 × 12 inches (20.3 × 30.5 cm.). Inscribed by the artist in pen and brown ink at lower left, *dapres jules / romain*; initialed by the artist's sons at lower right, *E.D.* and *J.D.*

See No. 9.

HILAIRE-GERMAIN-EDGAR DEGAS
PARIS 1834 – 1917 PARIS

11 *Portrait of Adelchi Morbilli*

Pencil. Sight measurements: 3 × 2½ inches (7.6 × 6.4 cm.).

The subject of this tiny portrait is traditionally identified as Degas' cousin Adelchi Morbilli (1837–1913), who was to become the director of the Banca Nazionale, but there is strong evidence rather to identify the sitter as Adelchi's eldest brother Gustavo (1828–1848), who died heroically in the revolution of 1848 (see Boggs, 1962, p. 87, note 49). The known portraits of Adelchi do not resemble the Heinemann drawing (according to Boggs, 1962, *loc. cit.*); it, however, closely resembles both a drawing and a plaster mask of Gustavo which—at least in 1958—were still in the possession of the Morbilli family (see Riccardo Raimondi, *Degas e la sua famiglia in Napoli, 1793–1917*, Naples, 1958, pls. 9 and 11). It may even be that the artist drew Gustavo's likeness here from the drawing and the plaster mask. The composed features and nearly closed eyes of the subject of both the mask and the Heinemann drawing particularly support the suggestion that this portrait is posthumous. The careful line of Degas' drawing of Gustavo also contrasts with the rather freer line of the artist's portraits of the other members of the Morbilli family drawn from life. His ties to this branch of the family were further strengthened by the marriage of his sister Thérèse to yet another Morbilli cousin, Edmondo (their portraits are now in the National Gallery of Art, Washington, and the Museum of Fine Arts, Boston).

PROVENANCE: Morbilli family; Marcel Guérin, Paris; Mr. and Mrs. John Rewald, New York (sale, London, Sotheby's, June 7, 1960, no. 24).

BIBLIOGRAPHY: Jean Sutherland Boggs, *Portraits by Degas*, Berkeley, 1962, p. 87, note 49; Jean Sutherland Boggs, "Edgar Degas and Naples," *Burlington Magazine*, CV, 1963, p. 274, note 25.

EXHIBITIONS: New York, Charles E. Slatkin Galleries, "Renoir, Degas: a loan exhibition of drawings, pastels, sculpture," 1958, no. 43; Los Angeles, Municipal Art Gallery, "The Collection of Mr. and Mrs. John Rewald," 1959, no. 23.

EUGÈNE DELACROIX

CHARENTON–ST. MAURICE 1798 – 1863 PARIS

12 *Three Studies of a Young Arab Woman*

Watercolor over pencil. Sight measurements: 9⅛ × 14⅞ inches (23.2 × 37.8 cm.).

That Delacroix accompanied Louis-Philippe's emissary, Count Charles de Mornay, on his good-will visit to the Sultan of Morocco in 1832 is well documented by the artist's own journals and the more than seven albums filled with drawings that he carried back to Paris. A good number of the sketches from dismembered albums have come into American collections—there are, for example, fifty-four drawings in the Pierpont Morgan Library (see Agnes Mongan, "Souvenirs of Delacroix's Journey to Morocco in American Collections," *Master Drawings*, I, 1963, pp. 20ff.). The Heinemann sheet is a particularly beautiful example of Delacroix's enthusiastic response to the color and exoticism of the Middle East.

PROVENANCE: Paris, Hôtel Drouot, Delacroix atelier sale, February 22–27, 1864 (Lugt 838).

EXHIBITIONS: London, Lefevre Gallery, "XIX and XX Century French Paintings and Drawings," 1963, no. 28, repr.

CLAUDE GELLÉE, called CLAUDE LORRAIN

CHAMAGNE near MIRECOURT 1600 – 1682 ROME

13 *Pastoral Landscape*

Pen and brown ink over black chalk, brown wash; divided diagonally into quadrants in black chalk. 5 3/16 × 8 ¼ inches (13.2 × 20.8 cm.).

This drawing is a preparatory study for the Berlin painting of 1642, the subject of which, although once identified as Mercury and Aglauros, is now simply thought to be a pastoral landscape with no special classical program (Röthlisberger, 1961, p. 207, fig. 135). As is most characteristic of his preliminary drawings, Claude has only indicated the broad outlines of the painting without any refinement of architectural detail or inclusion of figures, unlike the other drawing of the subject included in the *Liber Veritatis*, now in the British Museum, which he made as a record after he had completed the painting (Röthlisberger, 1968, no. 508, repr.).

PROVENANCE: The Reverend Henry Wellesley (Lugt 1384).

BIBLIOGRAPHY: Marcel Röthlisberger, *Claude Lorrain: The Paintings*, New Haven, 1961, pp. 207ff.; Marcel Röthlisberger, *Claude Lorrain: The Drawings*, Berkeley and Los Angeles, 1968, p. 210, no. 507, repr.

14 Ox

Pen and brown ink on paper tinted light brown. 3¼ × 4 inches (8.3 × 10.2 cm.).

This tiny drawing came from an album which Marcel Röthlisberger calls the Animal Album (Röthlisberger, 1968, pp. 57ff.) because, of the sixty-four nature studies it contained, the majority were of animals. In the possession of the Odescalchi family since at least the early eighteenth century (Röthlisberger, 1968, p. 55), the album was sold at auction in the late 1950's, subsequently broken up, and the drawings sold separately. Of the thirty-eight representations of cattle included in the album, very few relate to paintings.

PROVENANCE: Odescalchi family, Rome; sale, London, Sotheby's, November 20, 1957, part of lot 67.

BIBLIOGRAPHY: Marcel Röthlisberger, *Claude Lorrain: The Drawings*, Berkeley and Los Angeles, 1968, pp. 140f., no. 235, repr.

EXHIBITIONS: New York, M. Knoedler & Company, "The Artist and the Animal," 1968, p. 36, no. 34, repr.

CONSTANTIN GUYS
VLISSINGEN 1802 – 1892 PARIS

15 A Couple Promenading

Point of brush and some pen in brown ink, brown wash, and blue watercolor. 8⅞ × 7¼ inches (22.5 × 18.1 cm.).

This street scene is typical of the quick style Guys developed of necessity early in his career as a reporter-illustrator and which he managed to lift out of the ordinary by means of his special use of washes and watercolor. The contemporary character of his subject matter and summary technique caught the eye of both Manet and Charles Baudelaire, who characterized him as the "peintre de la vie moderne."

EXHIBITIONS: London, Marlborough, "Constantin Guys," 1956, no. 80.

JEAN-AUGUSTE-DOMINIQUE INGRES
MONTAUBAN 1780 – 1867 PARIS

16 Circular Portrait of Pierre-Guillaume Cazeaux

Black chalk stumped, heightened with brush and white gouache in the areas of the face and neckcloth, on buff paper. Sight measurements: 10 3/16 × 7¾ inches (25.8 × 19.8 cm.); diameter of design area: 7⅜ inches (18.7 cm.). Inscribed on tablet at lower left: *á mon trés cher pére* [sic].

This portrait was drawn, according to Galichon, in 1798 when the artist was eighteen years old, having arrived in Paris only the year before to study with David. It shows Ingres at the brief moment between his earlier miniaturist style and the famous linear pencil portrait technique which is so characteristic of him. In recent correspondence, Dr. Hans Naef has kindly supplied what little is actually known about M. Cazeaux, who must have been about twenty-three years old when he sat for Ingres since he "died at Pavilly near Rouen, November 27, 1850, aged 75. He worked some time in the shipping trade and ended his career rather poorly as an official." Dr. Naef, who is responsible for the detailed provenance given below, also confirms the date of the portrait as 1798.

PROVENANCE: Pierre-Guillaume Cazeaux (the sitter, d. in Pavilly, 1850); Mlle Hortense Cazeaux (the latter's daughter, d. unmarried, April 1903); Victorin de Joncières (the latter's nephew, d. in Paris, October 1903); Léonce de Joncières (the latter's son, d. unmarried, 1952); Mlle S. de Joncières (the former's niece).

BIBLIOGRAPHY: Émile Galichon, "Dessins de M. Ingres," *Gazette des Beaux-Arts*, XI, 1861, p. 46; Henri Delaborde, *Ingres, sa vie, ses travaux, sa doctrine*, Paris, 1870, p. 292, no. 268; Henry Lapauze, *Ingres, sa vie et son oeuvre*, Paris, 1911, repr. p. 29.

EXHIBITIONS: Paris, Salon des Arts-Unis, "Dessins [d'Ingres] tirés de collections d'amateurs," 1861; Paris, Salon d'Automne, Grand Palais, "Rétrospective-Ingres," 1905, no. 37; Paris, Galerie Georges Petit, "Exposition Ingres," 1911, no. 71.

17 *Portrait of the Architect Jean-Louis Provost*

Pencil, heightened with brush and white gouache (collar and corner of subject's left eye). 7⅛ × 4¹⁵⁄₁₆ inches (18 × 12.5 cm.). Signed and dated at lower right: *Ingres. Rome 1813*.

Even before the Bonapartes' fall from power in 1815 forced Ingres to turn to his skill as a portrait draughtsman for his livelihood, he had developed a considerable talent for portraiture. In early youth he had painted portrait miniatures but later in Paris he turned to different media and larger format. He continued his development in Rome after winning the *Prix de Rome*. Some of his most sympathetic portraits stem from these early Roman years, beginning in 1806, probably because the principal subjects were his friends and fellow *pensionnaires* at the French Academy in the Villa Medici, mostly young artists or architects. In 1812 he represented Jean-Louis Provost in the company of another young architect, Achille Leclère, in the drawing now at the Smith College Museum of Art. In this double portrait Jean-Louis' expression is reserved and he takes a back place in the composition. One feels that Ingres knew Provost, his near contemporary (1781–1850), much better a year later when he made the appealingly direct portrait shown here.

PROVENANCE: Sale, Paris, Maison Goupil et Cie, 1888, no. 343; Paul Mathey; Jacques Mathey (according to Seligmann label on back of frame).

BIBLIOGRAPHY: Henry Lapauze, *Ingres, sa vie, et son oeuvre*, Paris, 1911, repr. p. 128; Jacques Mathey, *Ingres dessins*, Paris, 1955, p. 11, no. 7, repr.; Cambridge, Mass., Fogg Art Museum,

"Ingres Centennial Exhibition, 1867–1967," 1967, under no. 23; Emilio Radius, *L'Opera completa di Ingres*, Milan, 1968, p. 122, repr.

EXHIBITIONS: Paris, Galerie Georges Petit, "Exposition Ingres," 1911, no. 84; Paris, Guirot, 1937, no. 8; Paris, Jacques Seligmann et fils, "Exposition de portraits par Ingres et ses élèves," 1934, no. 34.

18 *Portrait of General Louis-Étienne Dulong de Rosnay*

Pencil on wove paper. 17⅜ × 13⅜ inches (44.1 × 33.9 cm.). Signed and dated at lower left: *Ingres Deli. Rom. 1818.*

As in many other drawings of his Roman period, Ingres used the city as an effective setting for portraiture. In this case he chose to portray the distinguished young general, then aged thirty-eight, against a view of the Campidoglio and the Torre delle Milizie (see Naef, *Ingres in Rome*, under no. 72). The portrait was drawn in 1818, the same year that the artist drew the group portrait of his friends, the Stamatys (Fogg Art Museum). Later Atala Stamaty Varcollier was to base a lithograph of the general, who was Mme Stamaty's stepbrother, on Ingres' portrait. Dr. Hans Naef remarked that the impression of Atala's print now in the Heinemann collection was inscribed to Ingres by the general's son, Hermand Dulong de Rosnay: *À Monsieur Ingres, membre d. l'Institut & de la part et avec les nouveaux compliments de son / très dévoué serviteur / le C^{te} h. Dulong d. Rosnay.* The lithograph was perhaps made after the general's death in 1828.

PROVENANCE: Comte Joseph-Charles-René Dulong de Rosnay (according to exhibition catalogue, 1911).

BIBLIOGRAPHY: Émile Galichon, "Dessins de M. Ingres," *Gazette des Beaux-Arts*, XI, 1861, p. 46; Charles Blanc, *Ingres, sa vie et ses ouvrages*, Paris, 1870, p. 236; Henri Delaborde, *Ingres, sa vie, ses travaux, sa doctrine*, Paris, 1870, p. 295, no. 289; Henry Lapauze, *Les Dessins de J. A. D. Ingres au Musée de Montauban*, Paris, 1901, p. 265; Henry Lapauze, *Les Portraits dessinés de J. A. D. Ingres*, Paris, 1903, p. 47, no. 17, repr.; Henry Lapauze, *Ingres, sa vie, et son oeuvre*, Paris, 1911, p. 182, repr. p. 175; Henry Lapauze, *Jean Briant paysagiste, maître de Ingres, et le paysage dans l'oeuvre de Ingres*, Paris, 1911, p. 48, repr. opp. p. 8; Jean Alazard, *Ingres et l'Ingrisme*, Paris, 1950, p. 36; Hans Naef, "Ingres und die Familie Stamaty," *Schweizer Monatshefte*, December, 1967, p. 26; Washington, D.C., National Gallery of Art and elsewhere, "Ingres in Rome, A Loan Exhibition from the Musée Ingres, Montauban and American Collections," circulated by the International Exhibitions Foundation, 1971, under no. 72; [Marianne Feilchenfeldt] *25 Jahre Feilchenfeldt in Zürich*, 1948–1973, Zurich, 1973, repr.

EXHIBITIONS: Paris, École Impériale des Beaux-Arts, "Tableaux, études peintes, dessins et croquis de J.-A.-D. Ingres," 1867, no. 555; Paris, Galerie Georges Petit, "Exposition Ingres," 1911, no. 110; Paris, Chambre Syndicale de la Curiosité et des Beaux-Arts, "Exposition Ingres," 1921, no. 88; Paris, Galerie André Weil, "Exposition Ingres maître du dessin français," 1949, no. 73.

19 *Seated Female Nude Holding a Flower*

Pencil and black chalk on light brown paper. 15 × 11 ½ inches (38.1 × 28.6 cm.). Signed at lower right: *Ingres*.

Hans Naef has pointed out that this is a preparatory study for *The Age of Gold*, the fresco which the Duc de Luynes commissioned for the Château Dampierre near Paris in 1839. Before abandoning the project in 1850, Ingres fully worked out the broad symmetrical scheme in numerous sketches of "this lot of lazy and beautiful people," as he characterized them; more than four hundred sketches are preserved at the Musée Ingres, Montauban. What the artist envisaged for the subject is to be seen only in the reduced replica which he painted in 1862, now at the Fogg Art Museum, Cambridge. The Heinemann drawing specifically relates to a seated woman in a group to the left of the center of the composition and appears to be an early working sketch for the figure in that he first laid out the outline in pencil before working it up in the broader chalk medium. The long line in pencil at the upper right, for instance, would seem to indicate that he first considered a different position for the left arm and hand.

PROVENANCE: Étienne-François Haro (Lugt 1241).

20 *Study for "The Turkish Bath"*

Pen and brown ink, some pencil, the upper section squared in pencil. 6 ¼ × 4 ⅜ inches (15.9 × 10.6 cm.). Inscription on back of mount, apparently in hand of Lapauze, in pen and black ink: *Première pensée du "Bain Turc" / par J. A. D. Ingres. Donnée a M^elle Basquin / Respectueux homage / Mars 1917 Henry Lapauze.*

In 1852, long before deciding on a circular format for *The Turkish Bath*, the painting now in the Louvre which he completed in 1863, Ingres painted a rectangular version of it, known today only through a photograph taken by Marville in 1859 (see Georges Wildenstein, *J. A. D. Ingres*, London, 1954, p. 230, no. 312, fig. 195). That the Heinemann drawing is clearly preparatory for this earlier version is attested to not only by its rectangular form but also by the disposition of the figures within the composition. Although the artist did not change the essential relationships of the figures in the foreground of the composition—the woman having her hair perfumed, the lounging bathers, and the musician are all preserved in the Louvre roundel—he made subtle changes in the postures of two of the women and completely changed the orientation of the figure at the very foot of the composition (lower right corner) to suit the circular shape of the final version.

PROVENANCE: Henry Lapauze; Mlle Basquin (according to the inscription on the back of the mount cited above).

EXHIBITIONS: Montauban, "Exposition Ingres," 1917 (according to the inscription on the back of the mount).

21 *Seated Female Nude*

> Pencil and black chalk on three strips of paper pasted together and divided into quadrants. 9 × 13 inches (22.8 × 33.0 cm.). Various notations and measurements by the artist along the central vertical, *vienn / 2 – / panneau / 3 –* ; partial signature (?) at lower left, *In.*

This drawing, which carries the artist's inscription *vienn*[e], has been exhibited as a study for the "City of Vienna," one of a series of paintings showing conquered cities which were placed in the vaultings around the central composition of *The Apotheosis of Napoleon*, completed by Ingres in 1853 for the Hôtel de Ville, Paris. Unfortunately, however, the entire project was destroyed by fire on May 24, 1871, and is known only partially in the oil sketch of the central subject, now in the Musée Carnavalet, Paris. The pose of the woman is familiar in other Ingres compositions. While closely related to figures in *The Age of Gold*, for example, she is almost identical to the seated bather having her hair perfumed in *The Turkish Bath*, which dates from the same time (see No. 20).

PROVENANCE: Paris, Ingres sale, 1867 (Lugt 1477); M. Lerolle (according to the 1913 exhibition catalogue).

EXHIBITIONS: Paris, Palais des Beaux-Arts de la Ville de Paris, "David et ses élèves," 1913, no. 125.

German School

ADOLPH VON MENZEL
BRESLAU 1815 – 1905 BERLIN

22 *Woman in a Cap and Fur-Edged Jacket, Detail of Her Face*

> Graphite. 8 1/8 × 5 inches (20.6 × 12.7 cm.). Signed at lower right: *A. M.*

One of the most gifted draughtsmen of his century in Germany and for the most part self-taught, Menzel drew continuously throughout his long life. At his death, the twenty-nine portfolios found in his studio contained over four thousand drawings, among them myriads of studies after life and nature. It has not been ascertained whether the present direct study had a purpose other than the pleasure of transcribing the rounded forms of the face and figure of the woman who posed with downcast gaze and what appears to have been a certain sulky reluctance.

PROVENANCE: C. Groult.

23 *Two Profile Studies of the Head of a Young Man with a Moustache, and a Detail of His Chin*

> Graphite. 8 × 5 inches (20.3 × 12.7 cm.). Signed and dated at lower left: *A. M. / 10 März 84* (?).

Menzel, who was naturally left-handed, disciplined himself to draw with his right hand as well. His left-handedness is not always apparent as it is here in the shading along the line of the jaw. It is also obvious in the hatching of the face of the model in the previous drawing. If the date inscribed on this sheet has been properly read, the drawing demonstrates the undiminished strength and command of the draughtsman as he approached seventy.

Spanish School

FRANCISCO GOYA Y LUCIENTES
FUENDETODOS 1746 – 1828 BORDEAUX

24 *The Sawyers*

Brush and brown wash. 5 ⅞ × 3 ⅝ inches (14.7 × 9 cm.).

This appears to be a "separate" drawing that does not fit into any of the cycles of Goya drawings that recent scholarship has been reconstituting. Although it is executed in brown wash, Miss Eleanor Sayre reports that the paper differs from that of the brown or sepia wash series that she characterizes as "Journal Album F" (see *Bulletin*, Museum of Fine Arts, Boston, LVI, 1958, p. 133, no. 305) and the sheet lacks any of the other distinguishing marks of that series. The everyday subject matter, devoid of any satiric or tragic overtones, may be compared to the motifs of such drawings as *Three Men Digging* or *Construction in Progress* in the Metropolitan Museum.

PROVENANCE: Marqués de Casa Torres, Madrid.

EXHIBITION: Madrid, Sociedad española de amigos del arte, "Exposición de dibujos 1750 a 1860," [1922], no. 192c.

LUIS PARET Y ALCÁZAR
MADRID 1746 – 1799 MADRID

25 *Fête in a Park*

Watercolor and gouache over black chalk. Verso: Bearded man intruding on a ball scene. Brush and brown wash over black chalk. 11 ⅛ × 15 inches (28.2 × 38.2 cm.).

Paret, a versatile painter, designer, and engraver, is little known outside his own country, where he is ranked second only to Goya, who was his exact contemporary. His works range over every kind of subject matter, and he is variously labeled the "Spanish Watteau" and the "Spanish Vernet." It is his talent in the first category that has linked his name with this bright impression of a *fête galante*.

BIBLIOGRAPHY: H. M. Calmann catalogue [1964], no. 22, repr.

JACOPO AMIGONI
NAPLES 1682 – 1752 MADRID

26 *Composition Study for a Portrait*

Pen and brown ink, crimson wash, heightened with white on blue paper. 11 ⅛ × 9 inches (28.2 × 21.9 cm.).

This is a representative example of a considerable group of portrait drawings associated with the name of Amigoni, the Neapolitan-born decorator and portraitist who went to Venice early in his career and was later active in a number of European courts including Munich, London, and Madrid. A few of the drawings, including the present sheet, are related to documented painted portraits by Amigoni, but critical opinion varies as to the nature of this relationship. Some authorities consider the drawings as preliminary to the painted portraits, compositional sketches which could, if required, be perused by the sitter. Mr. Croft Murray (*Decorative Painting in England*, London, 1970, II, p. 163) regards them as probably by an assistant and "intended as memoranda of already executed oil paintings, fulfilling perhaps the same functions as the copies made by Edward Byng in Kneller's studio," i.e., "as a record of a portrait as a guide in repeating the original; and . . . as a model for a ready-made pose when painting a new sitter."

Amigoni spent the years 1729 to 1739 in England, working much of the time for the Court; the household accounts of Frederick, Prince of Wales, indicate that on March 31, 1736, he was paid for three portraits of the prince executed in 1735 (Oliver Millar, *Tudor, Stuart, and Early Georgian Pictures in the Royal Collection*, London, 1963, I, p. 176); all three survive, a full-length at Easton Neston, a smaller portrait at Buckingham Palace, and another full-length in the possession of the Barnard family, Raby Castle. It is to this last picture, painted for the prince's mistress, Anne Vane, daughter of Gilbert, second Lord Barnard, that the Heinemann drawing clearly relates. The differences in detail between drawing and painting (repr. *Burlington Magazine*, XCIX, 1957, p. 20, fig. 23) would seem to suggest that the drawing was not copied after the painting. The sketchy architecture of the drawing, the reversed direction of the ribbon across the sitter's chest, the different spatial relationship of the chair leg and the lower edge of the cape are all features that logically point to the primacy of the drawing. The entire group of drawings will be published shortly in *Master Drawings* by Elaine Claye who has linked further drawings in the series with painted portraits by Amigoni.

Prince Frederick, whose features were presumably studied in a separate drawing, was the eldest son of George II and Queen Caroline. An outstanding royal connoisseur and collector who frequently appeared personally in the auction room, he is responsible for the presence of a number of important seventeenth-century paintings in the Royal Collection. He died prematurely in 1751; his son became George III. Apropos the reversed direction of the ribbon noted above, Mr. Byam Shaw has observed recently that the "Garter ribbon, which the Prince would surely have worn, goes over the left shoulder." He inclines to the opinion of Mr. Croft Murray as to the purpose of this group of portrait drawings.

Attributed to JACOPO BASSANO

BASSANO 1516/1519 – 1592 BASSANO

27 *Head of an Old Man*

Black, red, and white chalks, light red wash, on blue paper. $6\frac{1}{8} \times 5\frac{1}{8}$ inches (15.6×13 cm.). Inscribed in pen and brown ink on old mount: *Tiziano Vecelli fece.*

While the relatively old inscription on the mount of this drawing is wide of the mark as to the specific artist's name, it may have some validity in pointing generally to the Veneto. In type and, broadly speaking, the use of the chalk medium on blue paper, the drawing might be connected with Jacopo Bassano, but the disciplined, rhythmic handling of the bold line and the strong plastic emphasis differs from the softer, broader pictorialism of those drawings that find general acceptance as his work. The old man with a short white beard—here slightly sinister in his hooded gaze—is a type for which parallels can be found in Bassano's earlier paintings. One sees a comparable type, for example, as Joseph in the *Flight into Egypt*, Museo Civico, Bassano, or as Joseph of Arimathaea in the *Deposition* in the parish church of Crosara San Luca, Vicenza (repr. P. Zampetti, *Jacopo Bassano*, Rome, 1958, pls. III and X). In a preliminary opinion based on a photograph, Professor Roger Rearick states that he is "inclined to accept Jacopo's authorship."

PROVENANCE: Unidentified stamp in brown showing letter *M* within an oval.

DOMENICO BECCAFUMI

VALDIBIENA about 1486 – 1551 SIENA

28 *River God, Standing Apostle, Bird, and Other Sketches*

Pen and brown ink; a few smudges in red chalk. Verso: Frames for ceiling paintings and a leg. $8 \times 5\frac{1}{4}$ inches (20.3×13.8 cm.). Old inscription at upper left margin: *Molto Magre.*

This drawing with its variety of motifs is a leaf from a dismembered sketchbook numbering thirty-seven folios. When it first came to light in the 1920's, the sketchbook bore an old attribution to Michelangelo, probably because echoes of the great artist occur here and there. When the sketchbook was studied by de Liphart Rathshoff in 1935, it was assigned to Beccafumi and this attribution was accepted by Donato Sanminiatelli (*Burlington Magazine*, XCIV, 1957, p. 405, note 9) and others. Sanminiatelli, however, has since rejected Beccafumi's authorship, proposing instead the name of Marco Pino (*Domenico Beccafumi*, Milan, 1967, pp. 186, 189). He states that for all those drawings in the sketchbook which seem to be first thoughts for known works of the artist there exist prototypes among other drawings by Beccafumi of superior quality. In this connection, it may be pointed out that the figure of the standing apostle or prophet holding a book in the Heinemann drawing is also found on a sheet in the Biblioteca Comunale at Siena (Vol. S.III.2 folio 16v; repr. Sanminiatelli, 1967, V. cat. Disegni N. 112v) where interestingly enough there is also a bird, if a rather different one. It is at least arguable that the standing figure on the New York leaf is better realized or understood in details of the pose and the drapery than that of the Siena sheet, which Sanminiatelli accepts as Beccafumi's although he assigns

31

other drawings in the same group to Marco Pino. Other leaves of the sketchbook have found their way to the Rijksmuseum, Amsterdam, and the Fondation Custodia, Institut Néerlandais, Paris.

PROVENANCE: Mr. Hibbert; Coghlan Briscoe, Dublin, 1928; Dr. W. M. Crofton, 1940; sale, London, Christie's, July 17, 1959, p. 32 of no. 95 (to Agnew).

BIBLIOGRAPHY: R. de Liphart Rathshoff, "Un Libro di schizzi di Domenico Beccafumi," *Rivista d'arte*, XVII, 1935, pp. 184ff., figs. 41 (verso), 52.

EXHIBITIONS: London, Thomas Agnew and Sons, "Domenico Beccafumi, 1486–1551: Drawings from a Sketch Book," November 1–27, 1965, no. 17.

ANTONIO CANAL, called CANALETTO
VENICE 1697 – 1768 VENICE

29 *St. Mark's Square from the Arcade of the Procuratie Nuove*

Pen and brown ink, brown and gray washes; scattered "pin-pointing," for example, in the roofline of the buildings at the left. 9 1/8 × 13 3/8 inches (23.2 × 34.1 cm.).

It was not unusual for Canaletto to duplicate his own drawings, and in this instance he produced not two but three versions with only slight variations. All show the Piazza San Marco as one looks east from the southwest corner of the square, with the east end of the Procuratie Vecchie and the Torre dell'Orologio on the left, and the cathedral and campanile in the center. On the right one looks down the long perspective of the arcade of the Procuratie Nuove with a glimpse of the famous Café Florian and its patrons. The other versions are in the Royal Library at Windsor Castle (repr. Parker, pl. 37) and in the Robert Lehman Collection, Metropolitan Museum (repr. London, Royal Academy, "Drawings by Old Masters," 1953, no. 18). There is a late painting of the subject in vertical format in the National Gallery, London (repr. Constable, pl. 15), which omits that section of the drawings to the left of St. Mark's; the National Gallery also owns a drawing of the two figures seated in conversation, observed by a third, in the right foreground of the drawings and the painting. It may be significant for the dating of the drawings that all three show the side wings of the clock tower without the final story that was added about 1755. Constable (I, p. 154) also points out that there is a clue to the terminal date of the Windsor sheet in that it was among the drawings acquired by George III from Joseph Smith in 1763. Parker (p. 22) explains the "pin-pointing" noted above in the description of this sheet as a device "to plot the principal points of an architectural composition before beginning it in ink; and it does not seem likely that the process involved anything in the nature of a transfer."

PROVENANCE: Henry Reveley (Lugt 1356); Algernon Jelf-Reveley.

BIBLIOGRAPHY: *The Reveley Collection of Drawings*, London, 1858, pl. 19; K. T. Parker, *The Drawings of Antonio Canaletto in the Collection of His Majesty the King at Windsor Castle*, Oxford and London, 1948, p. 40, under no. 57; W. G. Constable, *Canaletto*, Oxford, 1962, I, pp. 153, 191; II, under no. 525; Venice, Fondazione Giorgio Cini, "Canaletto e Guardi," exhibition catalogue by K. T. Parker and J. Byam Shaw, 1962, under no. 28.

SEBASTIANO CONCA
GAETA 1680 – 1764 NAPLES

30 *Clorinda Rescuing Sofronia and Olindo from the Stake in Jerusalem*

Pen and brown ink, brown wash, heightened with white and yellow gouache, over black chalk, on paper tinted brown. 8 1/8 × 12 5/8 inches (20.6 × 31.2 cm.).

This elaborate composition was first properly attributed to Conca by Jacob Bean in 1968. In its easy manipulation of vast architecture and crowds of figures, it is entirely characteristic of the artist, a longtime pupil of Francesco Solimena in Naples and eventually one of the foremost exponents of the rococo in Rome; his distinctive use of yellow gouache to highlight his drawings is almost a hallmark of his authorship. The subject, an episode from Tasso's *Gerusalemme Liberata* (II, 32–45), depicts the Amazon warrior Clorinda riding in to offer her services against the Christians to the infidel king of Jerusalem in exchange for the lives of the Christian maiden Sofronia and her lover Olindo. Sofronia had offered to die at the stake to save the entire Christian community of Jerusalem which had been threatened with execution when a statue of the Virgin was stolen at the moment the enchanter Ismeno had counseled King Aladino that its removal from a Christian church to a mosque would prevent the capture of Jerusalem by the Crusaders. When the king accepts Clorinda's offer, Sofronia and Olindo, who had also confessed to the theft of the statue in hopes of saving Sofronia, are freed and wed.

FRANCESCO GUARDI
VENICE 1712 – 1793 VENICE

31 *Four Gondolas*

Pen and brown ink, brown wash, over a few faint indications in black chalk. Sight measurements: 5 1/2 × 14 1/2 inches (14 × 36.9 cm.).

Whether or not the artist observed the diagonal patterning of the oars as he watched the gondola traffic on the canals or whether he created it for the purposes of this sketch, the resulting composition is highly effective and he used it in his paintings. The configuration of four gondolas appears quite unchanged in the foreground of the *View of the Dogana*, one of the paintings by Guardi in the Wallace Collection, London (repr. Vittorio Moschini, *Francesco Guardi*, Milan, 1952, pl. 139). The gondola manned by two boatmen also occurs alone in several paintings, among them the view of the Church of the Salute in the National Gallery, Edinburgh (repr. Venice, Palazzo Grassi, "Mostra dei Guardi," 1965, opp. p. 176).

GIOVANNI PAOLO PANNINI

PIACENZA 1691/1692 – 1765 ROME

32 *The Piazza Colonna*

> Pen and black ink, gray wash, and watercolor in blue, green, rose, and yellow. 9 7/8 × 13 1/8 inches (25 × 35.4 cm.). Signed (?) at lower left with initials: *G P P.*

It is a *veduta esatta*, an accurate topographical view, which Pannini drew here, showing the Piazza Colonna and the Column of Marcus Aurelius, from which the square takes its name. A similar view, taken from a slightly different vantage point, appears in the second book of Giuseppe Vasi, *Delle Magnificenze di Roma antica e moderna*, published in 1752. On the basis of Vasi's text and engraving, it is possible to label the buildings on the three sides of the square with the names they probably carried at the time Pannini made his drawing. In the foreground at the extreme right, there is a glimpse of a narrow strip (three windows wide) and the rusticated corner of the "Palazzo Ghigi," i.e., the Chigi palace, recalling that it was under the Chigi pope Alexander VII that the systematization of the Piazza Colonna had been undertaken in the previous century; immediately adjoining the palace is the "Curia Innocenziana." At the back of the square is the imposing "Residenza di Monsign. Vicegerente," and at the left, marked with a cross, is the façade of the "Ch. della nazione de Bergamaschi." It has not been possible to trace a separate painting of this subject, but it is interesting that one of the pictures represented as hanging at the right of the lofty gallery in the *Views of Modern Rome*, one of Pannini's paintings in the Louvre (Inv. R.F. 44.22; repr. Ferdinando Arisi, *Gian Paolo Panini*, Piacenza, 1961, no. 253, fig. 316), which is signed and dated 1759, shows much the same view of the Piazza Colonna as the Heinemann drawing.

PROVENANCE: Unidentified collector with initials *P. H.* (Lugt 2084).

GIOVANNI BATTISTA PIAZZETTA

VENICE 1682 – 1754 VENICE

33 *St. James Major*

> Black and white chalk on buff paper. 15 3/4 × 13 inches (40.1 × 33.1 cm.).

The luminous countenance of the saint, partly silhouetted in profile against the standard or banner he holds in his right hand, a large, round pilgrim's hat across his shoulders, is that of the apostle St. James Major. He is identified in the inscription of the related print by Marco Pitteri, one of a series—the Twelve Apostles, God the Father, Christ, and the Virgin—that he engraved in life size after the heads of Piazzetta, having requested that privilege in 1742 (Pignatti, p. 172). Drawing and engraving are almost exactly the same size and executed in the same direction, but their relationship is not clear. Also in the same direction as the print but somewhat smaller (13 7/8 × 11 1/2 inches) is the drawing in the collection of Mr. F. J. B. Watson, London, which is more precise in its definition of details than the Heinemann version. When the Watson sheet was exhibited at the Whitechapel Art Gallery, London, in 1951 ("Eighteenth Century Venice," no. 86), it was

described as the original Piazzetta drawing that Pitteri used for his engraving. It may be noted that the engraving's inscription, "Joannes Baptã Piazzetta Pinxit," implies that Pitteri had access to a painting of the subject by Piazzetta, but there may well have been a drawing intermediate between painting and print. The Heinemann drawing in its pictorial freedom does not seem typical of a preparation for a print and may stand as an independent work.

BIBLIOGRAPHY: Terisio Pignatti, *I Disegni veneziani del settecento* [Milan, 1966], p. 172, pl. 49 (as St. John the Baptist).

34 *St. Stephen*

Black and white chalk on faded blue paper. 15 ⅞ × 13 ⅞ inches (40.4 × 35.4 cm.).

The martyr's palm and the stone in his left hand identify the subject of this expressive characterization as St. Stephen, reputedly the first deacon and the first martyr of Christianity, who was stoned to death.

35 *Young Man in a Large Hat*

Black and white chalk on faded blue paper. Sight measurements: 15 ⅝ × 11 ½ inches (39.7 × 29.2 cm.).

The most sought-after drawings by Piazzetta from his own day onward have been the large-scale heads in black and white chalk on blue paper. Appealing in their representation of Venetian types and in their soft, rich chiaroscuro, they were executed in considerable numbers by Piazzetta over a long period beginning as early as 1717, and the possibilities of the genre were not overlooked by his numerous pupils. Modern connoisseurship is still concerned with the problem of sorting the drawings of the master and those of his followers.

PROVENANCE: Marquis de Biron.

36 *Head of a Girl*

Black, red, and white chalk on faded blue paper. 14 ⅜ × 10 ⅞ inches (36.6 × 27.7 cm.). Inscribed in pen and brown ink at lower right corner: *Piazzetta*.

The girl is a recurring type, perhaps most familiar in the painting *Idyll at the Seashore*, Wallraf-Richartz Museum, Cologne. The use of red chalk here is not typical of Piazzetta. See also No. 35.

GIOVANNI BATTISTA TIEPOLO
VENICE 1696 – 1770 MADRID

37 *The Annunciation*

Pen and brown ink, brown wash, over black chalk. 17×12 inches (43.2×30.5 cm.).

This impeccably preserved sheet was one of seven versions of the Annunciation in the Orloff Tiepolo album before it was dismembered prior to its sale in 1920. Like most of the Orloff drawings, it is an independent composition and not connected with a painting. One can still detect traces of the artist's lightly indicated first thoughts in the preliminary placement of the arch just above the angel's upraised hand and in the faint chalk outlines of another head and hand in the area of the temple, showing that he originally considered representing the Virgin looking up to the angel from a position higher on the sheet. The drawing is an early work; Knox places it between 1725 and 1735.

PROVENANCE: Prince Alexis Orloff (sale, Paris, Galerie Georges Petit, April 29–30, 1920, no. 70); Richard Owen, Paris; Tomas Harris, London.

BIBLIOGRAPHY: Hadeln I, no. 93; Otto Benesch, *Venetian Drawings of the Eighteenth Century in America*, New York, 1947, under no. 16; Knox, *The Orloff Album*, pp. 273, 275, no. 17; Terisio Pignatti, *I Disegni veneziani del settecento* [Milan, 1966], p. 178, pl. 60.

EXHIBITIONS: London, Royal Academy, 1953, no. 188; London, Arts Council, Tiepolo Exhibition, 1955, no. 6.

38 *Psyche Transported to Olympus*

Pen and brown ink, brown wash, over black chalk. 9¾×9 inches (24.7×22.9 cm.).

It has been suggested that this brilliant sheet may have been part of a series of drawings devoted to the story of Psyche although no paintings of the subject are known. A drawing in the Metropolitan Museum similarly represents Psyche borne to Olympus after she has completed her tasks, and one in the collection of Mrs. Vincent Astor, New York (Cailleux, 1952, no. 17) shows her with the blindfolded Cupid. The vibrant blend of fine, flickering line and strong accents of dark wash punctuating broad areas of a lighter wash are characteristic of Giambattista's exuberant draughtsmanship around 1740, a period when he produced some of his most beautiful drawings.

PROVENANCE: Victor de Cock; A. Doucet; José Maria Sert (according to labels on back of frame).

EXHIBITIONS: Paris, Galerie Cailleux, "Tiepolo et Guardi," 1952, no. 16, pl. 12; New York, Metropolitan Museum, Drawings from New York Collections III, 1971, no. 100.

39 *Zephyr and Flora*

Pen and brown ink, brown wash, over black chalk. 9 × 8 ⅜ inches (21.9 × 21.3 cm.).

Giambattista penned many variations on the theme of Zephyr and Flora, some of them linked to the elliptical ceiling painting in the Palazzo Labia (see New York, Metropolitan Museum, *Drawings from New York Collections* III, 1971, under no. 115). This sheet, however, appears to be an independent exercise.

PROVENANCE: G. Bellingham Smith, London.

BIBLIOGRAPHY: Hadeln I, no. 81.

40 *Virgin and Child Seated on a Globe*

Pen and brown ink, brown and yellow-brown wash, over black chalk. 17 ¾ × 12 ⅛ inches (45.1 × 30.8 cm.).

When it was exhibited in Venice in 1951, this extraordinary drawing was identified as a design for the head of a processional staff or wand, and a decade later Knox very plausibly associated it with Tiepolo's important commission for the Scuola dei Carmini (1740–43). The design for the processional staff contains many of the elements of the large ceiling canvas for the assembly room of the Carmelite Confraternity, which depicts the Virgin and Child with an Angel extending the devotional scapular to St. Simon Stock, who kneels above an opened tomb showing an assemblage of skulls and bones, an allusion to the Purgatory from which wearers of the scapular will be liberated through the Virgin's intercession. Tiepolo may have had a special interest in designing such a processional staff for the Confraternity since he was elected to its membership on the completion of his commission.

PROVENANCE: Prince Alexis Orloff (sale, Paris, Galerie Georges Petit, April 29–30, 1920, no. 138, repr.); Richard Owen, Paris; Tomas Harris, London.

BIBLIOGRAPHY: Knox, *The Orloff Album*, pp. 273, 275, no. 44, fig. 102.

EXHIBITIONS: Venice, Palazzo dell'Esposizione, Giardini, "Mostra del Tiepolo," 1951, p. 179, no. 34; London, Royal Academy, 1953, no. 166; London, Arts Council, Tiepolo Exhibition, 1955, no. 1, repr., pl. IV; New York, Metropolitan Museum, *Drawings from New York Collections* III, 1971, no. 102.

41 *Three Angels*

Pen and brown ink, brown wash, over black chalk. 11 ⅞ × 7 ¼ inches (30.2 × 18.4 cm.). Corners trimmed diagonally.

While they are singularly expressive in their own right as a separate composition, it is not difficult to think of these figures as angelic spectators gazing in worshipful adoration at the Child in a

scene of the Nativity. They might also be witnesses in a composition of the Pietà although their mood seems better suited to the happier theme.

PROVENANCE: Prince Alexis Orloff (sale, Paris, Galerie Georges Petit, April 29–30, 1920, no. 115); Mme Z. Birtschansky, Paris; Tomas Harris, London.

BIBLIOGRAPHY: Knox, *The Orloff Album*, no. 115.

EXHIBITIONS: Venice, Palazzo dell'Esposizione, Giardini, "Mostra del Tiepolo," 1951, p. 183, no. 83; London, Royal Academy, 1953, no. 182; London, Arts Council, Tiepolo Exhibition, 1955, no. 7.

42 *Seated Bishop Holding a Crozier and a Book*

Pen and brown ink, brown wash, over black chalk. 11 5/8 × 8 1/4 inches (28.6 × 20.3 cm.). Lower right corner replaced.

Although not specifically linked with a known painting, the elderly bishop saint with his angel-tipped crozier may be compared to the representations of St. Maximus and the acolyte holding his mitre in the altarpiece of S. Massimo, Padua, and the related oil sketches (Morassi, 1962, figs. 137–42). The neighbor of the Heinemann sheet in the Orloff album (no. 122; Hadeln II, no. 101) is probably also to be grouped with these. The present drawing and the following one are most likely works of the same period.

PROVENANCE: Prince Alexis Orloff (sale, Paris, Galerie Georges Petit, April 29–30, 1920, no. 121, repr.); Tomas Harris, London.

BIBLIOGRAPHY: Knox, *The Orloff Album*, p. 275, no. 73.

EXHIBITIONS: London, Royal Academy, 1954–55, no. 564; London, Arts Council, Tiepolo Exhibition, 1955, no. 9; New York, Metropolitan Museum, Drawings from New York Collections III, 1971, no. 137.

43 *Christ Shown to the People*

Pen and brown ink, brown wash, over red chalk. 11 1/4 × 8 3/16 inches (28.6 × 20.3 cm.).

Comparison with the painting *Ecce Homo* in the collection of A. Pereire, Geneva (Morassi, 1962, fig. 53) would seem to suggest that Byam Shaw in 1955 was correct in identifying the subject of this drawing as Christ presented to the people. The bent, half-draped figure of the Christ in the painting is surely similar in type and pose to that of this drawing; in any case the figure of the drawing does not appear to be feminine as described in the Orloff catalogue. While there is no direct connection between the Geneva painting and this drawing, Morassi's date of the 1750's for the painting is also appropriate for the drawing.

PROVENANCE: Prince Alexis Orloff (sale, Paris, Galerie Georges Petit, April 29–30, 1920, no. 145, repr.); Tomas Harris, London.

BIBLIOGRAPHY: Knox, *The Orloff Album*, pp. 274, 275, no. 75.

EXHIBITIONS: London, Royal Academy, 1954–55, no. 560; London, Arts Council, Tiepolo Exhibition, 1955, no. 8; New York, Metropolitan Museum, Drawings from New York Collections III, 1971, no. 138.

44 *Bearded Oriental Wearing a Chain and Seal, and a Broad Sash*

Pen and brown ink, brown wash. Sight measurements: 8 1/8 × 4 3/16 inches (20.6 × 10.6 cm.).

This drawing and the following six are examples of Giambattista's *sole figure vestite*, so called from the title of the album of eighty-nine such sheets in the Victoria and Albert Museum, London. Around two hundred of these interesting studies of single clothed figures, always in standing pose and more often than not male, are known. Very few can be associated directly with paintings, but as types, particularly the "orientals" (probably Turks) in turbans and slippers, striped mantles, tunics, and long cloaks, they are everywhere in the finished works in scenes of the Nativity, the Adoration of the Magi, and the Passion. The series is usually dated in the 1750's. There are five other drawings of this category in the Heinemann collection.

PROVENANCE: Possibly A. E. M. Paff, New York.

EXHIBITIONS: According to old label on back of frame, possibly Hartford, Connecticut, Wadsworth Atheneum, "Exhibition of Italian Painting of the Sei- and Settecento," 1930, no. 51.

45 *Bearded Oriental, His Right Hand across His Chest*

Pen and brown ink, brown wash. 8 1/4 × 5 3/16 inches (21.0 × 13.2 cm.).

See No. 44.

46 *Young Man Holding a Book*

Pen and brown ink, brown wash. 8 5/8 × 5 7/16 inches (21.1 × 13.8 cm.).

See No. 44.

47 *Bearded Man Wearing a Striped Mantle*

Pen and brown ink, brown wash. 8 3/4 × 5 3/4 inches (22.3 × 14.6 cm.).

See No. 44.

PROVENANCE: Tomas Harris, London.

EXHIBITIONS: London, Arts Council, Tiepolo Exhibition, 1955, no. 24.

48 *Man with a Dark Beard, Wearing a Chain and Seal*

Pen and black-brown ink, gray wash. 9 ¾ × 6 ⅜ inches (24.8 × 17.2 cm.). Corners rounded.

See No. 44.

PROVENANCE: C. R. Rudolf (Lugt S. 2811b); Tomas Harris, London.

EXHIBITIONS: London, Arts Council, Tiepolo Exhibition, 1955, no. 25.

49 *Bearded Oriental Wearing a Flat Cap and Cloak*

Pen and brown ink, brown wash. 8 ¾ × 5 ⅛ inches (22.3 × 13 cm.).

See No. 44.

PROVENANCE: Tomas Harris, London.

EXHIBITIONS: London, Arts Council, Tiepolo Exhibition, 1955, no. 26.

50 *Bearded Oriental Resting His Right Hand on a Capital*

Pen and brown ink, brown wash. 9 9/16 × 6 ⅜ inches (24.3 × 16.1 cm.). Pen trials at upper left.

See No. 44.

PROVENANCE: William Bateson (Lugt S. 2604a; sale, London, Sotheby's, April 23–24, 1929, no. 96); Tomas Harris, London.

EXHIBITIONS: London, Arts Council, Tiepolo Exhibition, 1955, no. 27.

51 *Two Orientals, One Standing, One Seated*

Pen and brown ink. 11 ¼ × 8 inches (28.6 × 20.3 cm.).

In executing these studies, the draughtsman dispensed with his customary wash and used the pen alone. The effect is almost like that produced by the etching needle, particularly in the face of the standing man, who brings to mind a comparable figure in the *Scherzi* (T. Pignatti, *Le Acqueforti dei Tiepolo*, Florence, 1965, no. XXXI).

PROVENANCE: Tomas Harris, London.

EXHIBITIONS: London, Arts Council, Tiepolo Exhibition, 1955, no. 29.

52 *Young Woman in Classical Drapery and Wreath*

Pen and brown ink, brown wash, over faint traces of black chalk; the paper lightly rubbed with red chalk. Sight measurements: 12 × 8 ⅛ inches (30.6 × 20.6 cm.).

It is possible, but not at all certain, that this drawing is to be grouped with the *sole figure vestite* (see No. 44). The positioning of the figure, which may represent Flora, suggests that it may have been destined to be seen from below, either as real or painted garden sculpture.

53 *Reclining Female Faun*

Pen and brown ink over black chalk. Verso: Sketches of male faun and other figures. 6 ½ × 10 ¼ inches (16.5 × 26 cm.). Inscribed along the right margin apparently in the artist's hand: *anco questa variar*.

The provocatively indolent creature of this rapid pen sketch, somehow exceptionally personal, has no counterpart among the numerous fauns who recline along the edges of so many of the artist's ceiling decorations. The drawing might well be titled "L'Après-midi d'une faunesse." It is perhaps later in date than the sequence of pairs of fauns in the Horne Foundation in Florence. If the inscription has been accurately transcribed, it could be translated as "also change this."

54 *Four Masks and a Swag of Fruit*

Pen and brown ink, brown wash, over black chalk. 9 ¼ × 7 ⅜ inches (23.5 × 18.7 cm.).

Masks such as these, some animal, some human, are to be found throughout the paintings, ornamenting architecture, vases, altars, fountains. There are several sheets of masks in the Musée Atger at Montpellier and also among the large group of ornamental designs in the Museo Civico in Trieste (Giorgio Vigni, *Disegni del Tiepolo*, rev. ed., Trieste, 1972, figs. 13–21). Such drawings are generally regarded as works of the late 1730's or early 1740's.

55 *Young Man Seated on a Cloud*

Pen and brown ink, brown wash. 6 ¼ × 5 ¾ inches (15.7 × 14.6 cm.).

This drawing and the following six, plus an additional seven in the Heinemann collection that are not shown, must have come from the considerable group once together in an album labeled *Sole figure per soffitti*, which was sold at Christie's, London, on July 14, 1914, as lot 49 and later dismembered in the 1920's. Rendered with effortless facility, the drawings all display single figures posed in sharply foreshortened attitudes, constituting an extraordinary repertory of cloud-borne figures suitable for use in ceiling compositions. They are, however, seldom encountered there. Knox speculates that their making may have diverted Giambattista when he was suffering from the gout in the last years of the 1750's.

PROVENANCE: Count Algarotti-Corniani; Edward Cheney (sale, London, Sotheby's, April 29, 1885, lot 1024); Irish collection; William Fagg, Sydenham; Messrs. B. T. Batsford; sale, London, Christie's, July 14, 1914, lot 49, bought by E. Parsons.

EXHIBITIONS: New York, Metropolitan Museum, Drawings from New York Collections III, 1971, no. 128.

56 Young Woman Seated on a Cloud

Pen and brown ink, brown wash. $8\frac{1}{16} \times 5\frac{15}{16}$ inches (20.8 × 15.1 cm.).

See No. 55.

PROVENANCE: Same as No. 55.

BIBLIOGRAPHY: Anna Pallucchini, *Giambattista Tiepolo*, Milan, 1971, no. 53, repr.

EXHIBITIONS: New York, Metropolitan Museum, Drawings from New York Collections III, 1971, no. 129.

57 Young Girl with a Vase

Pen and brown ink, brown wash. $7\frac{5}{8} \times 5\frac{3}{16}$ inches (19.4 × 13.2 cm.).

See No. 55.

PROVENANCE: Same as No. 55; Burat.

58 Seated Warrior Holding Shield and Sword

Pen and brown ink, brown wash. $10\frac{3}{16} \times 7\frac{3}{8}$ inches (25.8 × 18.7 cm.). Numbered in pen and gray ink at lower left: *72*.

See No. 55.

PROVENANCE: Same as No. 55.

59 Warrior Brandishing a Short Sword

Pen and brown ink, brown wash, over black chalk. Sight measurements: $7\frac{1}{4} \times 6$ inches (19.4 × 15.3 cm.).

See No. 55.

PROVENANCE: Same as No. 55.

60 *Young Woman Standing on a Cloud, Holding a Short Wand*

Pen and brown ink, brown wash. Sight measurements: 9 ⅝ × 7 ½ inches (24.5 × 19 cm.).

See No. 55.

PROVENANCE: Same as No. 55.

61 *Man Pulling on a Rope*

Pen and brown ink, brown wash. Sight measurements: 8 ¼ × 5 ¾ inches (21 × 14.6 cm.).

See No. 55.

PROVENANCE: Same as No. 55.

62 *Holy Family with St. Joseph Kneeling*

Pen and black-brown ink, gray wash. 13 ⅞ × 9 ¼ inches (35.2 × 23.5 cm.). Corners rounded. Signed in pen and black-brown ink at lower left: *Giovanni Battista Tiepolo.*

As the frontispiece of an album that seems to have contained, among other drawings, some seventy variations on the theme of the Holy Family, this sheet appropriately bears one of Giambattista's infrequent signatures. The early provenance of the album, which was left with the Library of the Somasco Convent when the Tiepolos went to Spain, is established by an inscription written inside the front cover by the English collector Edward Cheney at the time he acquired the album in 1842 (repr., George Knox, *Catalogue of the Tiepolo Drawings in the Victoria and Albert Museum*, London, 1960, p. 6, fig. 1). The drawings of this appealing series are usually dated in the latter half of the 1750's. In the Heinemann composition Joseph appears in a particularly tender and intimate relation to the Virgin and Child. The horizontal format is exceptional.

PROVENANCE: The Library of the Somasco Convent (S. Maria della Salute), Venice; Count Leopoldo Cicognara; Antonio Canova, the sculptor; his half-brother, Monsignor G. B. Sartori-Canova; Francesco Pesaro (*Posaro* in Cheney's inscription); Edward Cheney (sale, London, Sotheby's, April 29, 1885, lot 1024); E. Parsons; Mark Oliver; Tomas Harris, London.

EXHIBITIONS: London, Savile Gallery, Tiepolo Exhibition, 1928, no. 10, repr.; London, Royal Academy, 1953, no. 171; London, Arts Council, Tiepolo Exhibition, 1955, no. 2; New York, Metropolitan Museum, Drawings from New York Collections III, 1971, no. 135.

63 *Holy Family under a Tree with St. Joseph Standing at a Pedestal*

Pen and brown ink, brown wash, over black chalk. 11 ½ × 8 ⅜ inches (29.2 × 21.3 cm.).

See No. 62.

PROVENANCE: Same as No. 62.

BIBLIOGRAPHY: Terisio Pignatti, *Tiepolo*, Milan, 1951, p. 99, fig. 76; Anna Pallucchini, *Giambattista Tiepolo*, Milan, 1971, no. 61, repr.

EXHIBITIONS: London, Savile Gallery, Tiepolo Exhibition, 1928, no. 11, repr.; Venice, Palazzo dell'Esposizione, Giardini, "Mostra del Tiepolo," 1951, no. 35; London, Arts Council, Tiepolo Exhibition, 1955, no. 3, pl. V; New York, Metropolitan Museum, Drawings from New York Collections III, 1971, no. 134.

64 *Holy Family with the Young St. John*

Pen and brown ink, brown wash. Sight measurements: 9 ⅞ × 6 ⅞ inches (25.1 × 17.5 cm.). See No. 62.

PROVENANCE: Presumably the same as No. 62 through E. Parsons; Lady Elliott.

EXHIBITIONS: New York, Knoedler and Company (for Columbia University), "Great Master Drawings of Seven Centuries," 1959, p. 47, no. 38a, pl. XXXIX.

65 *Virgin and Child with St. Anne and St. John*

Pen and black ink, gray wash, over black chalk. 12 × 8 ⅜ inches (30.6 × 21.3 cm.). In the opposite direction of the sheet, there is a faint black chalk sketch of a head. Corners rounded.

In this beautiful drawing the artist departed from the customary *dramatis personae* of the Holy Family series and represented the Virgin with the Child and her mother, St. Anne, as well as the young St. John. The slight sketch of a large head was obviously already on the sheet when the artist picked it up and used the other end for the present drawing.

PROVENANCE: Same as No. 62 through E. Parsons; P. & D. Colnaghi; Richard Owen, Paris; Andoga (antiquarian); Federico Gentili, Paris; sale, London, Sotheby's, June 9, 1955, no. 67.

BIBLIOGRAPHY: A. M. Brizio, "Unpublished Drawings by G. B. Tiepolo," *Old Master Drawings*, VIII, 1933, no. 30, p. 17, pl. 23.

EXHIBITIONS: Fogg Art Museum, Tiepolo Exhibition, 1970, no. 90, repr.

66 *Holy Family with the Child Asleep*

Pen and brown ink, brown wash. 11 ⁷⁄₁₆ × 8 inches (29.2 × 20.3 cm.).

While this sheet was never part of the album once in the Somasco Convent in Venice (see No. 62), it is connected in style and subject with the drawings of the album and must likewise date

from the late 1750's. The Holy Family appear to be resting in the course of their Flight into Egypt. Joseph's staff and basket lie at the feet of the Virgin who attends her angelic comforters.

PROVENANCE: Prince Alexis Orloff (sale, Paris, Galerie Georges Petit, April 29–30, 1930, no. 78, repr.); Tomas Harris, London.

BIBLIOGRAPHY: Knox, *The Orloff Album*, p. 275, no. 77.

EXHIBITIONS: London, Royal Academy, 1953, no. 179; London, Arts Council, Tiepolo Exhibition, 1955, no. 4; New York, Metropolitan Museum, Drawings from New York Collections III, 1971, no. 136.

67 *Holy Family, Half Length*

Pen and brown ink, brown wash, over black chalk. 8 ⅛ × 7 ½ inches (21.6 × 19.1 cm.).

Drawings of this type with relatively large-scale figures veiled in dark wash are somewhat rare. There are other examples at the Ashmolean Museum, Oxford (*Report of the Visitors*, 1962, pl. x) and at the Museo Civico, Bassano (Anna Pallucchini, *Giambattista Tiepolo*, Milan, 1971, pl. 39). It is interesting that the English painter Sir Joshua Reynolds, who did not even mention Tiepolo in his celebrated *Discourses*, once owned this drawing. He may have acquired it when he was in Italy in 1752; another souvenir of his journey is the sketch he made of Tiepolo's *Meeting of Antony and Cleopatra*, Palazzo Labia, Venice, which is now in the British Museum (see F. J. B. Watson in *Connoisseur*, CXXXVI, no. 54, p. 212). Few eighteenth-century English collectors owned either paintings or drawings by Tiepolo.

PROVENANCE: Sir Joshua Reynolds (Lugt 2364); Tomas Harris, London.

BIBLIOGRAPHY: Terisio Pignatti, *I Disegni veneziani del settecento* [Milan, 1966], pp. 178–79, pl. 61.

EXHIBITIONS: London, Royal Academy, 1953, no. 167; London, Arts Council, Tiepolo Exhibition, 1955, no. 5.

68 *Head of an Old Man in Profile*

Pen and brown ink, brown wash. Sight measurements: 8 ¼ × 6 ⅞ inches (21 × 17.5 cm.).

This head and its two companions in the exhibition (Nos. 69, 70) represent yet another extensive category of the artist's drawings. They come from the same album as the series devoted to the representation of the Holy Family (see No. 62). A few of these drawings of heads of venerable patriarchs and philosophers were etched by Domenico Tiepolo in his *Raccolta di teste* (see G. Knox, *Domenico Tiepolo: Raccolta di teste*, Milan, 1970). The important series of heads in the Musée Atger, Montpellier, several of which were etched in the *Raccolta*, does not come from the Cheney album but from another which was presented by Xavier Atger to Montpellier as early as 1823 (see Paris, Orangerie des Tuileries, "Venise au dix-huitième siècle," 1971, nos. 260–61).

PROVENANCE: Same as No. 62 through E. Parsons; Richard Owen, Paris.

69 *Head of an Old Bearded Man*

Pen and brown ink, brown wash. 11 × 8 inches (28 × 20.3 cm.). Numbered at lower left in gray ink in an old hand: *79*.

See No. 68.

PROVENANCE: Same as No. 62 through E. Parsons; Richard Owen, Paris; Tomas Harris, London.

EXHIBITIONS: London, Arts Council, Tiepolo Exhibition, 1955, no. 20.

70 *Head of an Oriental*

Red chalk and wash. 10⅝ × 8 inches (27 × 20.3 cm.).

A limited number of the drawings in Giambattista's series of heads are, like this one, executed with great bravura in red chalk and wash. The example in the Fogg Art Museum, Harvard University, was Domenico's model for one of the etchings of the *Raccolta di teste* (II, no. 11).

PROVENANCE: Same as No. 62 through E. Parsons; Countess Wachtmeister (sale, London, Sotheby's, December 15, 1954, no. 117); Tomas Harris, London.

EXHIBITIONS: London, Arts Council, Tiepolo Exhibition, 1955, no. 30.

71 *Portrait of Palma Giovane*

Red and white chalk on blue paper. Verso: Drapery study. 9¼ × 6 inches (23.5 × 15.3 cm.).

In keeping with the Venetian tradition, earlier exemplified by the atelier of Tintoretto, of studying sculptural models from various angles and in varying light, the Tiepolo studio made use of Alessandro Vittoria's terra-cotta bust of the late sixteenth-century Venetian painter Palma Giovane. Whether or not Giambattista and his sons Domenico and Lorenzo had access to the original bust, now in the Kunsthistorisches Museum, Vienna, or to a plaster cast, is not known. The Heinemann head is the most imposing of the fourteen drawings after the bust that the researches of Sir Karl Parker and the late K. E. Maison have tallied.

PROVENANCE: Hans Wendland, Lugano; sale, Berlin, Hermann Ball, Paul Graupe, April 24, 1931, no. 102; Tomas Harris, London.

BIBLIOGRAPHY: Hadeln II, no. 164, repr.; Ugo Ojetti, ed., *Il Settecento italiano*, I, Milan, 1932, no. 277, pl. CLXXXV; K. T. Parker, "?Lorenzo Tiepolo," *Old Master Drawings*, IX, 1935, no. 36, p. 62, fig. 13; Morassi, 1955, p. 146, under no. 39; K. E. Maison, "The Tiepolo Drawings after the Portrait Bust of Palma Giovane by Alessandro Vittoria," *Master Drawings*, VI, 1968, pp. 392–94, pl. 34.

EXHIBITIONS: London, Savile Gallery, "Drawings by Giovanni Battista Tiepolo," 1930, no.

37; London, Royal Academy, 1953, no. 168; London, Arts Council, Tiepolo Exhibition, 1955, no. 17, pl. 1; New York, Metropolitan Museum, *Drawings from New York Collections* III, 1971, no. 151.

72 *Head of an Executioner*

Black and white chalk on blue paper; extraneous deposits of red chalk throughout. Sight measurements: 12×7⅝ inches (30.6×19.4 cm.).

If one thinks of the preceding drawing as a "touchstone" for the quality of Giambattista's draughtsmanship as Byam Shaw describes it in the Introduction of the catalogue, one hesitates to ascribe the present sheet to his hand without a query. It is perhaps best considered a borderline case between father and son. The snub-nosed, moustachioed man with a band holding back his hair is a somewhat brutish type both father and son cast in the role of executioner in scenes of martyrdom and the Passion.

73 *Man in a Domino Holding a Tricorne and a Muff*

Pen and black ink, gray wash. Sight measurements: 7⅝×5¼ inches (19.4×13.8 cm.).

There is evidence that the caricatures of the Tiepolos once filled at least three albums. Two of these are known only through the reference to "due grossi libri" containing "una copiosa collezione di disegni umoristici del Tiepolo" in the 1754 edition of the catalogue of the collection of Count Bernardino Corniani degli Algarotti (see Michael Levey, "Two Footnotes to any Tiepolo Monograph," *Burlington Magazine*, CIV, 1962, p. 119). These large books presumably were broken up at an early date, but a third volume survived intact until 1943 when an album entitled *Tomo terzo de caricature* that had belonged to Arthur Kay was dismembered and sold at Christie's on April 9. At least one of the Heinemann caricatures (No. 76) was definitely among the 106 drawings of the *Tomo terzo*. The present drawing may likewise have come from the album as several sheets in lots 244 and 245 are described as representing men with muffs. Four of the seven caricatures in the Heinemann collection are shown in the exhibition; among those not shown is another masquerader (London, Arts Council, Tiepolo Exhibition, 1955, no. 31).

74 *Short Man in a Tricorne Resting Both Hands on His Stick*

Pen and black ink, gray wash. 7⅝×5¼ inches (19.4×13.8 cm.).

This caricature is possibly to be identified with that described among those sold under lot 249 in the Kay sale, Christie's, April 9, 1943, as "A Dwarf, with both hands resting on a stick." See No. 73 above.

75 *Tall Man with a Long Walking Stick, His Sword at His Side*

Pen and black ink, gray wash; unrelated indications in black chalk. 7⅝×5¼ inches (19.4×13.8 cm.).

See No. 73.

76 *The Cook*

Pen and black ink, gray wash; unrelated indications in black chalk. Sight measurements: 8⅜×5¼ inches (21.3×13.8 cm.).

While the authorship of certain of the Tiepolo caricatures is disputed between father and son, this masterly rendering of a fat, hulking cook in his apron, proffering a fowl on a platter, surely brooks no difference of opinion. The ease and economy of line and accent with which the great weight and fleshy bulk of the man are suggested are Giambattista's. As noted above under No. 73, this sheet comes from the *Tomo terzo de caricature*, where there was also a "profile portrait of the same cook." For the evidence in support of the provenance noted below, prior to the Christie sale, see Professor Knox's catalogue of the 1970 Tiepolo exhibition at the Fogg Art Museum (under no. 87).

PROVENANCE: Count Bernardino Corniani degli Algarotti (?); Breadalbane (?); Langton House, Duns, Berwickshire; sale, Edinburgh, Dowells, March 25, 1925, lot 1004, bought by John Grant, bookseller, Edinburgh; Arthur Kay, Edinburgh (sale, London, Christie's, April 9, 1943, lot 244 (e) bought by Arcade Gallery).

BIBLIOGRAPHY: Osbert Lancaster, *Giovanni Battista Tiepolo: Twenty-Five Caricatures*, Arcade Gallery Ltd., London [1943], no. 25.

77 *Study for a Family Group in a Villa Garden*

Pen and black-brown ink, gray and some brown wash (in figure behind standing child), over black chalk. Verso: Seated man holding a large book. Black chalk. 10⅞×16½ inches (27.7×41.8 cm.).

Regrettably no painting of the charming family group portrayed here exists, but there are equally delightful variant compositional drawings in the Horne Foundation, Florence, (Hadeln II, no. 95) and with Wildenstein & Co., New York (Fogg, no. 95). It has been proposed that the family may be the Pisani, whose villa at Strà Giambattista decorated in 1761–62; there several children and adult members of that family appear in the fresco of the ballroom ceiling (Morassi, 1955, pl. 78; 1962, fig. 339, the *modello* at Angers). As Knox has suggested, Tiepolo may have been contemplating the execution of a group portrait of the family before he was called to Spain; this seems especially plausible in the light of the fact that the artist appears to have departed for Madrid two years before his employment with the Pisani was originally scheduled to terminate

(Morassi, 1962, p. 49). Domenico used these drawings by his father as a point of departure for his own drawing *Family Party in a Villa Garden* (Byam Shaw, no. 70, repr.), repeating the pose of the woman and child seated on the ground at the left of the Heinemann composition with little alteration.

PROVENANCE: Tomas Harris, London.

BIBLIOGRAPHY: Byam Shaw, *Domenico Tiepolo*, under no. 70; Fogg Art Museum, Tiepolo Exhibition, 1970, under no. 95; Anna Pallucchini, *Giambattista Tiepolo*, Milan, 1971, no. 64, repr.

EXHIBITIONS: London, Royal Academy, 1953, no. 174; London, Arts Council, Tiepolo Exhibition, 1955, no. 10, pl. II; New York, Metropolitan Museum, Drawings from New York Collections III, 1971, no. 149.

78 *Design for an Overdoor with Cherubs*

Pen and brown ink, brown wash, over black chalk, on gray paper. 15 3/16 × 11 1/4 inches (38.6 × 28.6 cm.).

Until recently this drawing was thought to be a design for an overmantel but as Knox has recently observed, it is rather the preparatory sketch for one of the overdoors of the Throne Room in the Royal Palace at Madrid (Guido Piovene, *L'Opera completa di Giambattista Tiepolo*, Milan, 1968, fig. 279 B). It joins the Cooper-Hewitt Museum's *Design for a Dedication Page to Charles III* as one of the very few known drawings in pen and wash unquestionably from Tiepolo's Spanish period. The design, except for the oval painting, was executed in plaster. It is interesting that in the overdoor itself the most important changes were made in the cherub on the right, and the *pentimento* in the legs of this small figure in the drawing indicates the draughtsman was already considering revising his ideas at this stage.

PROVENANCE: J. Böhler, Lucerne; Tomas Harris, London.

BIBLIOGRAPHY: George Knox, "Italian Drawings in New York," *Burlington Magazine*, CXIII, 1971, p. 291.

EXHIBITIONS: London, Royal Academy, 1953, no. 202; London, Arts Council, Tiepolo Exhibition, 1955, no. 16, repr.; New York, Metropolitan Museum, Drawings from New York Collections III, 1971, no. 130.

GIOVANNI DOMENICO TIEPOLO
VENICE 1727 – 1804 VENICE

79 *Details of "The Death of Hyacinth"*

Red and white chalk on blue paper. 9 1/4 × 15 1/2 inches. (23.5 × 39.4 cm.).

The details carefully set down on this sheet have reference to *The Death of Hyacinth*, the picture now in the Thyssen-Bornemisza Collection at Lugano, Switzerland, painted by Giambattista

during his stay in Würzburg (1750–53) for the Prince von Bückeburg for the sum of 200 gold sequins (Rudolf Heinemann, ed., *Stiftung Sammlung Schloss Rohoncz*, Lugano-Castagnola, 1932–41, I, no. 413, II, pl. 228). The head and leg on this sheet are those of the dead Hyacinth of the painting; the arm and hand, those of the grief-stricken Apollo who has just accidentally killed his young favorite (Ovid, *Metamorphoses*, X, 162–219). A sheet of similar dimensions among the long series of chalk drawings at Stuttgart (no. 84 of the 1971 catalogue) shows the body of Hyacinth to the right knee, significantly the point at which the Heinemann sketch of the right leg begins. The Stuttgart sheet also incorporates sketches of details of the staircase ceiling of the Residenz at Würzburg.

Like the heads of No. 80, such drawings are today usually accepted as the young Domenico's copies after his father's finished works, constituting a handsome record of details of certain of Giambattista's commissions, among them the great projects in Germany. Knox's arguments to the contrary, i.e., in favor of Giambattista's execution of these drawings as the final preparatory studies for the paintings, are set forth at length in the catalogue of the Stuttgart exhibition of 1971 and rebutted by Byam Shaw in his review of the catalogue in *Master Drawings*, IX, 1971, pp. 271ff. It might be noted that there is no dispute as to the authorship of the various spirited drawings in pen and wash that undeniably embody Giambattista's exploratory compositional ideas for *The Death of Hyacinth* (see Giorgio Vigni, *Disegni del Tiepolo*, rev. ed., Trieste, 1972, no. 167; George Knox, *Catalogue of the Drawings in the Victoria and Albert Museum*, London, 1961, nos. 185–86; Stuttgart, Tiepolo Exhibition, 1971, nos. 188–89, 191).

As was his wont, Domenico made use of the figure of Hyacinth at a later date in very different context. He adopted the contrapposto of the pose for the satyress in the *Swing* and reversed it for a sleeping punchinello in *Punchinellos on a Country Holiday*, both being among the grisaille frescoes of the Tiepolo family villa at Zianigo, now in the Ca' Rezzonico, Venice (Terisio Pignatti, ed., *Il Museo Correr di Venezia: Dipinti del XVII e XVIII secolo*, Venice, 1960, p. 360, fig. 1775; p. 373, fig. 1752).

80 *Three Heads*

Red and white chalk on blue paper. Sight measurements: 4¾ × 10 inches (12.1 × 25.4 cm.).

In the catalogue of the Tiepolo exhibition at the Fogg Museum, Knox, noting George Mras's connection of the drawing of a helmeted guardsman in the Princeton Art Museum (Princeton, *Record of the Art Museum*, XV, 1956, pp. 55ff., fig. 18) with Giambattista's fresco (1752) the *Investiture of Bishop Harold von Hochheim as Duke of Franconia by the Emperor* (Kaisersaal, Würzburg), remarked that the same guardsman appeared in the present drawing. It may be added that the two other heads of the Heinemann sheet are studied from the same fresco as well. All three heads occur on the left side of the *Investiture*; the first (reading the drawing from left to right) is studied after the chamberlain reading the patent of nobility and the head at the right of the sheet is that of the halberdier kneeling at the extreme left edge of the fresco. Although Knox takes the view that the Princeton drawing is by Giambattista and that therefore the Heinemann sheet is by Domenico or more likely Lorenzo, the compilers share Mras's opinion that the

Princeton sheet is not by Giambattista and also feel that the Heinemann drawing is more plausibly attributed to Domenico than to Lorenzo.

BIBLIOGRAPHY: Fogg Art Museum, Tiepolo Exhibition, 1970, under no. 54.

81 S. Faustino Carried to Heaven

Red and white chalk on blue paper. 10 ¼ × 14 ⅛ inches (26 × 35.9 cm.). Corners trimmed diagonally. Numbered on the verso: *No. 3079 Xrs 30.*

This drawing is one of three drawings which are connected with Domenico's ceiling frescoes for the church of SS. Faustino and Giovita in Brescia, dating most probably about 1754 and 1755. As such it is important as one of the few early drawings surely from his hand. Although Byam Shaw is inclined to regard the drawing as preliminary to the fresco, he does not exclude the possibility of its being a record drawing, noting that it is closer to the fresco than to an oil sketch of the same subject. The British Museum owns the sketch of S. Faustino's brother, S. Giovita, being borne off to heaven, and a drawing showing the citadel of Brescia was at one time in the Wendland collection in Lugano (repr. Hadeln II, nos. 189, 190). (For another drawing connected somewhat differently with the Brescia project, see the following entry.)

Both the present drawing and No. 84 bear the old Bossi-Beyerlen code numbers which Knox has commented on extensively in the catalogue of the Stuttgart Tiepolo exhibition (pp. 7ff.) in connection with Stuttgart's acquisition of twenty percent of the more than eight hundred drawings from the auction of that collection in 1882. Part of the number appears to be a valuation of each drawing in terms of Austrian florins and kreutzers which—at least at the end of the eighteenth century—were a viable currency in Venice. (Mr. Janos Scholz recently remarked in a lecture at the Frick Collection that the letters *C. M.* that are sometimes a part of an inscription like that on this drawing have reference to the term *Conventions Müntze*, having to do with monetary regulations of the Napoleonic era in Austria and more or less approximating the English term "legal tender.")

PROVENANCE: Giovanni Domenico Bossi; his daughter, Maria Theresa Karoline Bossi; her husband, Christian Friedrich Beyerlen; sale, Stuttgart, Gutekunst, March 27, 1882; Hans Wendland, Lugano; Tomas Harris, London.

BIBLIOGRAPHY: Byam Shaw, *Domenico Tiepolo*, pp. 27f., 74, no. 10, repr.; Adriano Mariuz, *Giandomenico Tiepolo*, Venice, 1971, p. 114; Stuttgart, Tiepolo Exhibition, 1971, under no. 147.

EXHIBITIONS: London, Arts Council, Tiepolo Exhibition, 1955, no. 63.

82 Fallen Warrior

Red and white chalk on blue paper. Sight measurements: 6 9/16 × 11 ¾ inches (16.6 × 29.8 cm.).

This dramatically foreshortened figure occurs in the foreground of the *Capture of Carthage* (Morassi, 1962, fig. 306), one of the ten paintings depicting episodes in the history of Rome

executed by Giambattista in the late 1720's for the great hall of the Ca' Dolfin in Venice. The *Capture of Carthage* and two others of the series were acquired by the Metropolitan Museum of Art in 1966. However, this fine sheet cannot very well be a study made by Giambattista in preparation for the painting as it does not accord with his style of drawing at this early date. It must, therefore, be a drawing made by Domenico after his father's painting, probably at the time Domenico received his commission for the fresco decoration of the church of SS. Faustino and Giovita at Brescia, executed 1754–55 after the family's return from Germany. Given a battle subject to design—the intervention of SS. Faustino and Giovita in the siege of Brescia (Mariuz, fig. 75)—Domenico, then about twenty-seven, appears to have turned to his father's famous early series for inspiration, recording at least three motifs. In addition to the fallen warrior of the Heinemann sheet, he recorded the great horse and rider at the right of his father's Carthage composition in a drawing at Stuttgart (Inv. no. 1469. Stuttgart, Tiepolo Exhibition, fig. 146), and from the *Battle of Vercellae*, another painting in the series by Giambattista which is also at the Metropolitan Museum, he drew a further rider in a sheet in the collection of Baron von Hirsch, Basel. All three details were incorporated with only minor changes in the *Siege of Brescia*, the fallen warrior appearing singularly unaltered.

Knox, who assigns these drawings to Giambattista with a query, notes that other drawings by Domenico for the S. Faustino decoration differ in style (see No. 81); such divergence, however, is not unusual between a *ricordo* and a working drawing. And the Heinemann drawing agrees perfectly with the style of the red chalk drawings at Stuttgart and elsewhere that most authorities, with the exception of Knox, regard in the main as Domenico's transcriptions of his father's great works. (See No. 79 above.)

BIBLIOGRAPHY: Stuttgart, Tiepolo Exhibition, 1971, under no. 146.

83 *Horatius Holding the Bridge*

Pen and dark brown ink. Sight measurements: 11 1/16 × 17 inches (28.1 × 43.2 cm.).

This drawing belongs to a group of early pen drawings, many of which are now in the Berlin Print Room. As they derive stylistically from Giambattista's *Scherzi di Fantasia* which were designed in the late 1740's, scholars agree that they must have been executed about the same time.

PROVENANCE: De Vries, Amsterdam, 1929 (according to owners' records).

EXHIBITIONS: Fogg Art Museum, Tiepolo Exhibition, 1970, no. 50, repr.

84 *Boatman and Crowd at the Shores of a Lake*

Pen and brown ink, brown and gray wash, over black chalk; extraneous smudge of red chalk. 7 1/8 × 10 1/2 inches (18.1 × 26.7 cm.). Signed at lower left: *Dom.º Tiepolo f.* Numbered on the verso: *No. 3560. X^rs 24.*

While the precise subject is not clear because the composition appears to have been cut off at the left, this drawing is related in both style and subject to drawings of St. Anthony of Padua

Preaching on the Shore of Rimini and Christ at the Sea of Galilee (see Stuttgart, Tiepolo Exhibition, 1971, under no. 21). Byam Shaw has suggested that it may represent the Preaching of the Baptist. This drawing, like No. 81, carries the Bossi-Beyerlen code number on the verso.

PROVENANCE: Giovanni Domenico Bossi; his daughter, Maria Theresa Karoline Bossi; her husband, Christian Friedrich Beyerlen; sale, Stuttgart, Gutekunst, March 27, 1882; Sir Robert Witt; Tomas Harris, London.

EXHIBITIONS: London, Arts Council, Tiepolo Exhibition, 1955, no. 43.

85 Two Orientals

Brush and brown wash, some pen and brown ink. $9\frac{5}{8} \times 7\frac{1}{2}$ inches (24.5 × 19 cm.). Corners trimmed diagonally.

The present sheet is an excellent example of the type of strong, spontaneous drawings that were once given to Giambattista. Now, however, many scholars attribute them to Giandomenico. (For other examples of this type of drawing, see Byam Shaw, *Domenico Tiepolo*, nos. 6a, 6b, 7.)

PROVENANCE: Sir Gilbert Lewis; Henry Duff Gordon; Tomas Harris, London.

BIBLIOGRAPHY: A. P. Oppé, "A Fresh Group of Tiepolo Drawings," *Old Master Drawings*, v, 1930, no. 18, p. 31, pl. 11 (as Giambattista).

EXHIBITIONS: London, Arts Council, Tiepolo Exhibition, 1955, no. 28; New York, Metropolitan Museum, Drawings from New York Collections III, 1971, no. 250.

86 Cherubs Playing in the Clouds

Pen and brown ink, brown wash. 8 × 11 inches (20.3 × 28 cm.). Signed at lower right, *Dom. Tiepolo f*; numbered in a different brown ink in an old hand at upper left, *30*; inscribed in pencil at upper right, *J. M. H.*

Like his father, Domenico produced a number of drawings in series; many of the sheets are numbered in a contemporary hand, perhaps by the artist himself or a member of his family. Several series are represented in the exhibition, the first being the cherub or cupid group (Nos. 86–89) with a sacred or profane context varying from drawing to drawing. While it is not easy to establish a clear chronology for Domenico's drawings, it may well be as Byam Shaw has suggested, that the artist's work in the Foresteria, Villa Valmarana (1757), provided the momentum for this particular series. Nine examples of cupids or cherubs are to be found in the Heinemann collection, although only four are included here.

PROVENANCE: Tomas Harris, London.

EXHIBITIONS: London, Arts Council, Tiepolo Exhibition, 1955, no. 52.

87 *Cherubs Playing in the Clouds*

Pen and brown ink, brown wash. 7¼×9¾ inches (18.4×24.8 cm.). Signed at lower right: *Domo Tiepolo.*

It is interesting to note that this sheet once belonged to Eduard Sack (1857–1913) whose monograph laid so much of the groundwork for modern Tiepolo scholarship. Other Heinemann drawings formerly owned by Sack are the *Caparisoned Camel* (No. 120) and three drawings on blue paper that are not included in the present exhibition (see Eduard Sack, *Giambattista und Domenico Tiepolo*, Hamburg, 1910, pp. 255f., nos. 157, 163, and 167; for further information on Sack no. 157, see George Knox, "G. B. Tiepolo and the Ceiling of the Scalzi," *Burlington Magazine*, CX, 1968, p. 398, fig. 52).

PROVENANCE: Eduard Sack, Hamburg (stamp in blue ink at lower center is not listed under Lugt S. 903a); Tomas Harris, London.

EXHIBITIONS: London, Arts Council, Tiepolo Exhibition, 1955, no. 54.

88 *Cupid and Cherubs in the Clouds*

Pen and brown ink, gray wash, over black chalk. Sight measurements: 6⅝×10³⁄₁₆ inches (16.8×25.9 cm.). Signed in black ink at lower right: *Dom⁰ Tiepolo f.*

See No. 86.

BIBLIOGRAPHY: Possibly W. R. Jeudwine, "Old Master Drawings of the 16th to 19th Centuries," London [1955?], no. 62.

89 *Cupid and Cherubs Playing with Doves*

Pen and brown ink, brown wash. 7⁷⁄₁₆×10⅛ inches (18.9×25.7 cm.). Signed at lower left, partially cut off, *Dom. Tiepolo f*; numbered in brown ink at upper left in an old hand, *119.*

The presence of the doves and mirror, and the armor hung outside the tent, are probably an allusion to Venus and Mars.

PROVENANCE: Tomas Harris, London.

EXHIBITIONS: London, Arts Council, Tiepolo Exhibition, 1955, no. 62.

90 *God the Father Supported by Angels and Cherubs*

Pen and gray-black ink, gray wash, over black chalk. 9½×6¾ inches (24.2×17.2 cm.). Signed in brown ink at lower right, *Dom. Tiepolo f*; numbered in brown ink in an old hand at upper left (barely legible), *27.*

In his monograph on Domenico Tiepolo, Byam Shaw reported that he had seen sixty drawings from a group which—if the old numbering on the drawings is accurate—consisted of at least one hundred and two variations on the theme of God the Father Supported by Angels and Cherubs, inspired by Giambattista's Este altarpiece of 1759; the largest number of them is now in the Museo Correr, Venice. The present drawing is "27" in the old numbering; number "26" (not shown) is also in the Heinemann collection.

PROVENANCE: Tomas Harris, London.

EXHIBITIONS: London, Arts Council, Tiepolo Exhibition, 1955, no. 49.

91 *Christ Received into Heaven*

Pen and brown ink, gray-brown wash, over faint traces of black chalk. Sight measurements: 10 5/8 × 7 5/8 inches (27 × 19.4 cm.). Signed at lower right, partially cut off, *Do. Tiep[olo]*; numbered in brown ink in an old hand at upper left, *41*.

This and the following drawing are from the series sometimes grouped under the title of the Trinity in the Clouds. The type may be connected with the fresco in the church of the Pietà in Venice, 1755, on which Domenico collaborated with his father, and the fresco in S. Lio, Venice, which he himself painted in 1783 (see Byam Shaw, *Domenico Tiepolo*, pp. 32f., no. 23). Sometimes, as in the case of this drawing, apparently variation "41," Christ is shown gazing up at God the Father, but he is often represented dead as in No. 92 and the two other Heinemann drawings from this series (including variation "16") that are not included in the exhibition.

92 *Christ Received into Heaven*

Pen and brown ink, brown wash, over black chalk. 9 7/8 × 6 7/8 inches (25 × 17.5 cm.). Signed at lower right, *Dom.º Tiepolo f*; numbered at upper left, possibly in the artist's hand, *144* (crossed out), and in a slightly later hand, *115*.

See No. 91. As Byam Shaw has observed, there do not appear to be any drawings in this series bearing numbers higher than that of this sheet, which is variation "144."

PROVENANCE: Tomas Harris, London.

BIBLIOGRAPHY: J. Byam Shaw, "A Sketch for a Ceiling by Domenico Tiepolo," *Burlington Magazine*, CI, 1959, p. 448, note 10; Byam Shaw, *Domenico Tiepolo*, p. 32, note 8.

EXHIBITIONS: London, Arts Council, Tiepolo Exhibition, 1955, no. 51.

93 *St. Anthony Holding the Christ Child before an Altar*

Pen and brown ink, brown wash. 10 5/8 × 7 1/4 inches (27 × 18.4 cm.). Signed at lower right center, *Dom.º Tiepolo f.*; numbered in brighter brown ink in an old hand at upper left, *44*.

Dr. and Mrs. Heinemann own six drawings from the series of St. Anthony and the Christ Child. This variation, which is numbered "44" in a contemporary hand, and variation "70" (not shown) belong to the type showing the saint before an altar. The other four, including No. 94, depict St. Anthony and the Christ Child in the Clouds. While Byam Shaw definitely related the series to Giovanni Battista's altarpiece of the 1770's, now in the Prado, Knox and Thiem in the Stuttgart catalogue have since been able to confirm a date in the seventies for the drawings as well because of the appearance of twenty St. Anthony subjects in the Beauchamp Album (sale, London, Christie's, June 15, 1965), which is known to have been put together before 1780.

PROVENANCE: Tomas Harris, London.

BIBLIOGRAPHY: Byam Shaw, *Domenico Tiepolo*, p. 34; Stuttgart, Tiepolo Exhibition, 1971, under no. 57.

EXHIBITIONS: London, Arts Council, Tiepolo Exhibition, 1955, no. 44.

94 *St. Anthony and the Christ Child in the Clouds*

Pen and brown ink, brown wash, over faint traces of black chalk. Sight measurements: 9×6¾ inches (22.9×17.2 cm.). Signed at lower left center: *Dom? Tiepolo f.*

See No. 93.

PROVENANCE: Henry S. Reitlinger (sale, London, Sotheby's, December 19, 1953, no. 103).

95 *Juno with Jupiter's Eagle*

Pen and brown ink, brown wash, over black chalk. Sight measurements: 10×5⅞ inches (25.4×14.9 cm.). Signed at lower right, *Domo Tiepolo f;* numbered in brown ink in an old hand at upper left, *32.*

Juno belongs to the series of pagan gods and goddesses, and mythological heroes which—although most likely of later date—are probably connected in some way with Giambattista's work in the Villa Cordellina. Domenico's lengthy series—this sheet is number "32"—includes other Junos (see, for example, Hadeln II, no. 104) as well as Leda, Hebe, Diana, Amphitrite, and Ceres, along with Apollo, Bacchus, Ganymede, and Neptune, to name but a few. The series is distinguished by the rendering of the figures as if they were designs for or copies after statuary.

PROVENANCE: Henry S. Reitlinger (sale, London, Sotheby's, December 19, 1953, no. 100).

96 *Hercules and Antaeus*

Pen and black ink, gray wash, over black chalk. 7⅞×5½ inches (20×14 cm.). Signed on base at lower right: *Dom Tiopolo* [sic].

The theme of the struggle between Hercules and Antaeus was obviously a favorite of Domenico's for he produced an amazing number of variations. Here the *pentimenti* would indicate that the artist had ideas for still other possibilities for the arrangement of the legs of the opponents. In addition to the two examples shown, an album of thirty-eight drawings of Hercules and Antaeus was sold piecemeal in London (see Byam Shaw, *Domenico Tiepolo*, p. 38), and other examples were included in the Beauchamp Album (sale, London, Christie's, June 15, 1965, nos. 149–52). Byam Shaw believes that Domenico may have contemplated using the subject for the decoration of the Tiepolo villa at Zianigo.

PROVENANCE: Tomas Harris, London.

EXHIBITIONS: London, Arts Council, Tiepolo Exhibition, 1955, no. 60.

97 *Hercules and Antaeus*

Pen and black-brown ink, gray-brown wash, over black chalk. 8½×6 inches (21.7× 15.3 cm.). Signed at lower left, partly cut off: *polo Dom.° Tiepolo f.*

See No. 96.

PROVENANCE: O. Falk; Tomas Harris, London.

EXHIBITIONS: London, Arts Council, Tiepolo Exhibition, 1955, no. 61.

98 *Centaurs Abducting a Woman, with Cupid and Satyrs*

Pen and brown ink, brown wash. 10⅝×12⅛ inches (27×30.8 cm.). Signed at lower right: *Dom. Tiepolo f.*

Satyrs and centaurs seem to have held a special fascination for Domenico who depicted them in a variety of attitudes and occupations. He not only included them in such commissioned works as the friezes of the Palazzo Correr (1758–60) and the Palazzo Contarini (1784), but devoted entire rooms in the family villa at Zianigo to satyr and centaur cycles—the frescoes of the Camerino dei Centauri and the Camera dei Satiri are now to be seen in the Palazzo Rezzonico, Venice. There is a series of at least one hundred and two drawings (see Byam Shaw, *Domenico Tiepolo*, p. 41), four of which are now part of the Heinemann collection. The present drawing as well as two other Heinemann examples depict scenes of abduction in contrast to the tender pastoral before a thatched cottage represented in the following drawing.

PROVENANCE: Tomas Harris, London.

EXHIBITIONS: London, Arts Council, Tiepolo Exhibition, 1955, no. 58.

99 *Centaur and Faun in a Landscape*

Pen and brown ink, brown wash, over slight preliminary indications in black chalk. Sight measurements: 7¼ × 10½ inches (18.4 × 26.7 cm.). Signed in pen and brown ink at lower right: *Dom.° Tiepolo f.*

See No. 98.

100 *Joachim and Anna in the Temple*

Pen and brown ink, brown wash, over black chalk. 18⅜ × 14¼ inches (46.7 × 36.2 cm.). Signed twice: at lower left, *Dom.° Tiepolo / f*; at right, on column, *Domo / Tiepolo / f*.

This and the following eleven drawings are part of the Large Biblical Scenes, the sequence of drawings for the most part illustrating the New Testament, that Domenico produced after his return from Spain. Probably the most numerous of his various series as well as the largest in size, they number, according to J. Byam Shaw, at least two hundred and fifty sheets, the largest single group today being the Recueil Fayet in the Cabinet des Dessins at the Louvre. At least ten of the Heinemann drawings come via the collections of the Duc de Trévise and Tomas Harris from another large sequence of eighty-two sheets in the collection of M. Cormier of Tours, dispersed in 1921. Because the subjects are not always clear (some may be taken from the Apocryphal New Testament), several of the drawings shown here have been exhibited under other titles. The drawings cannot always be matched with the titles given in the Cormier and Trévise sale catalogues, the latter's collection being dispersed in a number of sales. Another Heinemann drawing from this series, the *Betrothal of the Virgin*, is not included in the exhibition.

PROVENANCE: Luzarche, Tours; Roger Cormier, Tours (sale, Paris, Galerie Georges Petit, April 30, 1921, no. 12); Duc de Trévise; Tomas Harris, London.

EXHIBITIONS: London, Whitechapel Art Gallery, "Eighteenth Century Venice," 1951, no. 134a; London, Arts Council, Tiepolo Exhibition, 1955, no. 33.

101 *Announcement of the Birth of St. John to Zacharias*

Pen and brown ink, brown wash, over black chalk. Sight measurements: 18¾ × 14⁷⁄₁₆ inches (47.6 × 36.7 cm.). Signed at lower left: *Domo Tiepolo f.*

This drawing has been exhibited under several titles, including the "Annunciation of the Coming of Christ to Abraham" (sale, Paris, Hôtel Drouot, May 20, 1935, no. 181) and "An Angel Announcing the Nativity to the High Priest" (London, Whitechapel Art Gallery, "Eighteenth Century Venice," 1951, no. 134b), probably because the setting is not the customary one for the Annunciation to Zacharias, who usually receives his news in the temple. The richly appointed room with a canopied bed duplicates the setting of one of Domenico's etchings of the Flight into Egypt (De Vesme 4). See also No. 100.

PROVENANCE: Luzarche, Tours; Roger Cormier, Tours (sale, Paris, Galerie Georges Petit, April 30, 1921, no. 13); Duc de Trévise; sale, Paris, Hôtel Drouot, May 20, 1935, no. 181; Tomas Harris, London.

EXHIBITIONS: London, Whitechapel Art Gallery, "Eighteenth Century Venice," 1951, no. 134b; London, Arts Council, Tiepolo Exhibition, 1955, no. 34.

102 *Circumcision of St. John the Baptist*

Pen and brown ink, brown wash, over black chalk. Sight measurements: 18 ¾ × 14 ½ inches (47.6 × 36.8 cm.). Signed at lower left: *Dom.° Tiepolo f.*

See No. 100.

PROVENANCE: Luzarche, Tours; Roger Cormier, Tours (sale, Paris, Galerie Georges Petit, April 30, 1921, no. 3); Prince W. Argoutinsky-Dolgoroukoff (Lugt S. 2602d; sale, London, Sotheby's, July 4, 1923, no. 19, repr.); Duc de Trévise; Tomas Harris, London.

BIBLIOGRAPHY: Byam Shaw, *Domenico Tiepolo*, p. 62.

EXHIBITIONS: London, Arts Council, Tiepolo Exhibition, 1955, no. 36.

103 *Mary Disclosing the Angel Gabriel's Message to Joseph*

Pen and brown ink, brown wash, over black chalk. Sight measurements: 18 ¾ × 14 ½ (47.6 × 36.8 cm.). Signed at lower right: *Dom.° Tiepolo f.*

When the drawing was shown at the Whitechapel Art Gallery, it was titled "St. Joseph Embarrassed by Mary's Disclosure." While the subject was probably drawn from Matthew 1:19, further explication can be found in Chapters XIII and XIV of the Book of James or Protevangelium (see M. R. James, *The Apocryphal New Testament*, Oxford, 1924, p. 44). See also No. 100.

PROVENANCE: Luzarche, Tours; Roger Cormier, Tours (sale, Paris, Galerie Georges Petit, April 30, 1921, possibly no. 24); Duc de Trévise (sale, Paris, Hôtel Drouot, December 8, 1947, possibly no. 32); Tomas Harris, London.

EXHIBITIONS: London, Whitechapel Art Gallery, "Eighteenth Century Venice," 1951, no. 134c; London, Arts Council, Tiepolo Exhibition, 1955, no. 35.

104 *Flight into Egypt and the Massacre of the Innocents*

Pen and brown ink, brown wash, over black chalk. Sight measurements: 18 ⅜ × 14 ¼ inches (46.7 × 36.2 cm.). Signed twice at lower right: *Dom.° Tiepolo f.*

This variant of the Flight into Egypt, in which angels appear to save the Holy Family from Herod's soldiers, is unusual in its combination of two subjects. The biblical reference is Matthew II:14–18. See also No. 100.

PROVENANCE: Luzarche, Tours; Roger Cormier, Tours (sale, Paris, Galerie Georges Petit, April 30, 1921, no. 6); Duc de Trévise; Tomas Harris, London.

EXHIBITIONS: London, Arts Council, Tiepolo Exhibition, 1955, no. 37.

105 *Christ Curing St. Peter's Mother-in-Law of a Fever*

Pen and brown ink, brown wash, over black chalk. Sight measurements: 18 ¾ × 14 ½ inches (47.6 × 36.8 cm.). Signed at lower left: *Dom° Tiepolo f.*

While the miracle depicted in this drawing is mentioned in Matthew VIII:14–15 and Mark I:30–31, Domenico most probably based his representation on Luke's description of the event (IV: 38–39). It is apparently to be identified with the drawing in the Cormier sale (no. 76) described as "un Apôtre opérait la guérison miraculeuse d'une femme malade." See also No. 100.

PROVENANCE: Luzarche, Tours; Roger Cormier, Tours (sale, Paris, Galerie Georges Petit, April 30, 1921, probably no. 76); Duc de Trévise; Tomas Harris, London.

EXHIBITIONS: London, Whitechapel Art Gallery, "Eighteenth Century Venice," 1951, no. 134d; London, Arts Council, Tiepolo Exhibition, 1955, no. 38.

106 *Death of Judas*

Pen and brown ink, brown wash, over black chalk. Sight measurements: 18 ¾ × 14 ⅜ inches (47.6 × 36.5 cm.). Signed at lower right: *Domo Tiepolo f.*

In this drawing Domenico has condensed the sequence of events so that Judas, instead of leaving the temple precincts after his repentance and his return of the thirty pieces of silver, actually hangs himself just outside in full view of the priests (Matthew XXVII:3–5). His figure is singled out by the brilliant highlight provided by the reserved area of the white paper. See also No. 100.

PROVENANCE: Luzarche, Tours; Roger Cormier, Tours (sale, Paris, Galerie Georges Petit, April 30, 1921, no. 78); Duc de Trévise (sale, Paris, Hôtel Drouot, December 8, 1947, no. 50); Tomas Harris, London.

EXHIBITIONS: London, Arts Council, Tiepolo Exhibition, 1955, no. 39.

107 *St. Peter and St. John before Annas*

Pen and brown ink, brown wash. 18 ⅜ × 14 ¼ inches (46.7 × 36.2 cm.). Signed at left center on column: *Dom° / Tiepolo / f.*

The biblical text illustrated here appears to be Acts IV:5–13. See also No. 100.

PROVENANCE: Luzarche, Tours; Roger Cormier, Tours (sale, Paris, Galerie Georges Petit, April 30, 1921, number not determined); Duc de Trévise; Tomas Harris, London.

EXHIBITIONS: London, Arts Council, Tiepolo Exhibition, 1955, no. 40.

108 *St. Philip and the Ethiopian Eunuch*

Pen and brown ink, brown wash, over black chalk. Sight measurements: 18⅜×14⅜ inches (46.7×36.5 cm.). Signed at lower left: *Dom.° Tiepolo f.*

In this scene based on Acts VIII:27–35, Domenico delights in the rendering of a rich Venetian brocade and such motifs as the small Veronese-like page to suggest the immense wealth of the eunuch who represents Queen Candace of Ethiopia. See also No. 100.

PROVENANCE: Luzarche, Tours; Roger Cormier, Tours (sale, Paris, Galerie Georges Petit, April 30, 1921, number not determined); Duc de Trévise; Tomas Harris, London.

EXHIBITIONS: London, Arts Council, Tiepolo Exhibition, 1955, no. 41.

109 *St. Paul at Lystra*

Pen and brown ink, brown wash, over black chalk. 18×14¹⁄₁₆ inches (45.6×35.7 cm.). Signed at lower right: *Domo Tiepolo.*

If the subject is correctly identified, it has reference to Acts XIV:8–11. The cart and crutches of the crippled man whom St. Paul has healed are to be seen at the left. See also No. 100.

PROVENANCE: Luzarche, Tours; Roger Cormier, Tours (sale, Paris, Galerie Georges Petit, April 30, 1921, no. 77); Duc de Trévise (sale, Paris, Hôtel Drouot, December 8, 1947, no. 49, repr.); Tomas Harris, London.

EXHIBITIONS: London, Arts Council, Tiepolo Exhibition, 1955, no. 42.

110 *Death of St. Joseph*

Pen and brown ink, brown wash, over black chalk. Sight measurements: 18¼×14¼ inches (46.4×36.2 cm.). Signed in pen and brown ink at lower left: *Domo / Tiepolo f.*

See No. 100.

PROVENANCE: Luzarche, Tours; Roger Cormier, Tours (sale, Paris, Galerie Georges Petit, April 30, 1921, possibly no. 68).

EXHIBITIONS: New York, Metropolitan Museum, Drawings from New York Collections III, 1971, no. 258.

111 *Christ and the Disciples on the Road to Emmaus*

> Pen and brown ink, brown wash, over black chalk; *pentimenti* in tower and figure of saint at right in black chalk. Sight measurements: 18 1/8 × 14 1/4 inches (46.1 × 36.2 cm.). Signed at lower right: *Dom? Tiepolo f.*

For this subject, see Luke XXIV:13–28; see also No. 100.

PROVENANCE: Luzarche, Tours; Roger Cormier, Tours (sale, Paris, Galerie Georges Petit, April 30, 1921, no. 33).

112 *The Presentation of the Fiancée*

> Pen and brown ink, brown and gray wash, over black chalk. Sight measurements: 11 5/16 × 16 inches (28.7 × 40.6 cm.).

This drawing is again representative of a large category of Domenico's drawings, the Scenes of Contemporary Life, most of which were done for his own amusement in the 1790's. As has been suggested, the present drawing perhaps makes a pair with a drawing now also in New York in the collection of Mr. and Mrs. Eugene V. Thaw (see Drawings from New York Collections III, no. 265, repr.). The subject has also been described as "The Matchmaker."

PROVENANCE: Martin Wilson.

BIBLIOGRAPHY: Terisio Pignatti, *I Disegni veneziani del settecento* [Milan, 1966], p. 213, no. 119, repr.

EXHIBITIONS: New York, Metropolitan Museum, Drawings from New York Collections III, 1971, no. 264.

113 *Punchinello Riding on an Ass in a Procession of His Fellows*

> Pen and brown ink, brown and yellow-brown wash with a brighter brown wash in the faces, over black chalk. Sight measurements: 11 × 15 7/8 inches (27.9 × 40.4 cm.). Signed in pen and brown ink at lower left: *Do Tiepolo f.*

The present drawing is number "28" of one hundred and two drawings comprising Domenico's delightful Punchinello series produced very late in his life as a "Divertimento per li Regazzi." It copies almost exactly one of the frescoes from the Camera dei Pagliacci at Zianigo (now in the Palazzo Rezzonico, Venice) except that some of the figures are reversed.

PROVENANCE: Anonymous collection, London; sale, London, Sotheby's, July 6, 1920, part of lot 41; Richard Owen, Paris; Brinsley Ford, London; sale, London, November 10, 1954, no. 40, repr.

EXHIBITIONS: London, Whitechapel Art Gallery, "Eighteenth Century in Venice," 1951, no. 138e; New York, Metropolitan Museum, Drawings from New York Collections III, 1971, no. 273.

114 *Punchinello Takes Part in a "Triumph of Flora"*

Pen and brown ink, brown wash with touches of brighter brown wash in masks of some of the punchinellos, over black chalk. Sight measurements: 12×16½ inches (30.5× 41.9 cm.). Signed at lower left: *Dom° Tiepolo f.*

It has been observed before that this drawing—number "26" of the Punchinello series—is a light-hearted parody of Giambattista's painting, the *Triumph of Flora* (M. H. de Young Memorial Museum, San Francisco. Morassi, 1962, fig. 354). See also No. 113.

PROVENANCE: Anonymous collection, London; sale, London, Sotheby's, July 6, 1920, part of lot 41; Richard Owen, Paris; Countess Wachtmeister (sale, London, Sotheby's, December 15, 1954, no. 107, repr.); Tomas Harris, London.

BIBLIOGRAPHY: Adriano Mariuz, *Giandomenico Tiepolo*, Venice, 1971, fig. 32.

EXHIBITIONS: London, Arts Council, Tiepolo Exhibition, 1955, no. 67, pl. III; New York, Metropolitan Museum of Art, Drawings from New York Collections III, no. 272.

115 *Monkey Swinging on a Parapet*

Pen and brown ink, gray-brown wash. 10×7⅝ inches (25.4×19.4 cm.). Signed in pen and a different brown ink at lower right: *Dom°. Tiepolo.*

It is well known that the monkey clinging to a parapet made his first appearance in Giambattista's Africa fresco at Würzburg and was later repeated in the ceiling of the Throne Room in the Royal Palace at Madrid (see Drawings from New York Collections III, no. 248). It may be added that Domenico used the pose for a human skeleton in his preparatory drawing for the painting of the Last Judgment now at Intra (Stuttgart, Tiepolo Exhibition, 1971, no. 69, repr.), and repeated the monkey in a similar but reversed pose on a sheet of studies in the Musée des Arts Décoratifs, Lyons (Paris, Orangerie des Tuileries, "Venise au dix-huitième siècle," 1971, no. 307, repr.).

PROVENANCE: F. A. C. Prestel; Prestel sale, Frankfort-on-Main, November 12–13, 1918, no. 227, pl. 38; Tomas Harris, London.

BIBLIOGRAPHY: Byam Shaw, *Domenico Tiepolo*, p. 45, no. 47, repr.; Adriano Mariuz, *Giandomenico Tiepolo*, Venice, 1971, fig. 18.

EXHIBITIONS: London, Arts Council, Tiepolo Exhibition, 1955, no. 64, pl. VIII; New York, Drawings from New York Collections III, 1971, no. 248.

116 *Swans and Cormorants*

Pen and brown ink, brown wash, over black chalk. 4×6¾ inches (10.2×17.2 cm.). Signed at lower right: *Domo Tiepolo f.*

This and the following drawing are undoubtedly connected with Domenico's animal frescoes, many of which are still in place at Zianigo (see Byam Shaw, "The Remaining Frescoes in the Villa Tiepolo at Zianigo," *Burlington Magazine*, CI, 1959, pp. 391ff.). Drawings definitely relating to these frescoes are distinguished by a ruled ledge or rocky hillock on which the animals are posed. A similar drawing of swans appeared at Colnaghi's in 1949.

PROVENANCE: Tomas Harris, London.

BIBLIOGRAPHY: London, P. & D. Colnaghi, "Exhibition of Old Master Drawings," 1949, under no. 67.

EXHIBITIONS: London, Arts Council, Tiepolo Exhibition, 1955, no. 66.

117 *Dogs Playing*

Pen and black ink, gray wash, over black chalk. 4 1/2 × 7 7/8 inches (11.4 × 20 cm.). Signed at lower right: *Dom? Tiepolo f.*

See No. 116.

PROVENANCE: Tomas Harris, London.

EXHIBITIONS: London, Arts Council, Tiepolo Exhibition, 1955, no. 65.

118 *Three Ibex*

Pen and brown ink, brown wash, over black chalk. Sight measurements: 7 1/8 × 10 inches (18.2 × 25.4 cm.). Signed at left: *Domo / Tiepolo f.*

Byam Shaw has already observed that the ibex or mountain goat standing on the hillock at the left of this drawing is copied from no. 39 of the etched series *Betrachtung der wilden Thiere* by the eighteenth-century German artist Johann Elias Ridinger. All three goats appear in another of Domenico's drawings, *A Goatherd Lying Asleep Against a Bank*, recently sold at auction (London, Sotheby's, November 11, 1965, no. 27, repr.).

PROVENANCE: Henry S. Reitlinger (sale, London, Sotheby's, December 9, 1953, no. 101).

BIBLIOGRAPHY: Byam Shaw, *Domenico Tiepolo*, no. 53, repr.

119 *Two Dogs with Curling Tails*

Pen and brown ink, brown wash, over black chalk; extraneous spots of blue-green watercolor. Sight measurements: 11 × 6 7/8 inches (28 × 17.5 cm.). Signed at lower right: *Dom Tiepolo f.*

The dog at the right appears time and again in Domenico's drawings; for instance, on folio 106 of the Recueil Fayet, the volume of Large Biblical Scenes in the Cabinet des Dessins at the Louvre, and in the drawing of a farmyard that passed through Colnaghi's hands in 1969.

PROVENANCE: Henry S. Reitlinger (sale, London, Sotheby's, December 9, 1953, no. 102).

BIBLIOGRAPHY: London, P. & D. Colnaghi, "Exhibition of Old Master and English Drawings," 1969, under no. 25.

120 *Caparisoned Camel*

Pen and brown ink, brown wash, over black chalk. Sight measurements: $7\frac{5}{8} \times 10\frac{1}{4}$ inches (19.4 × 26.1 cm.). Signed at lower left: *Dom? Tiepolo f.*

Camels were apparently among Domenico's favorite animals and he often represented them in elaborate trappings. Like No. 87, this particularly good example was once in the collection of Eduard Sack, the early Tiepolo scholar.

PROVENANCE: Eduard Sack, Hamburg (stamp in blue ink at the lower right is not listed under Lugt S. 903a).

PLATES

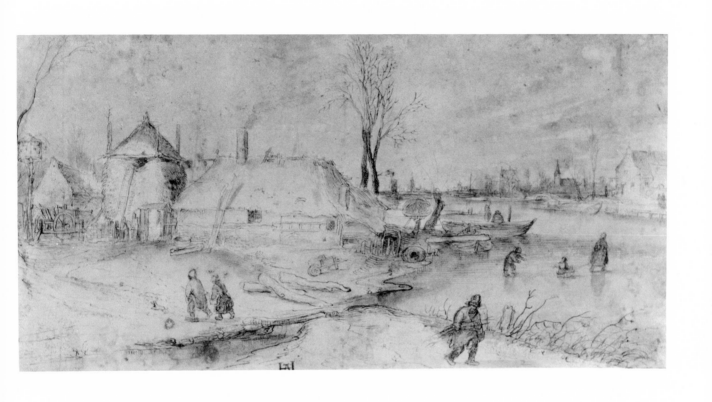

1 Hendrick Avercamp *Winter Landscape*

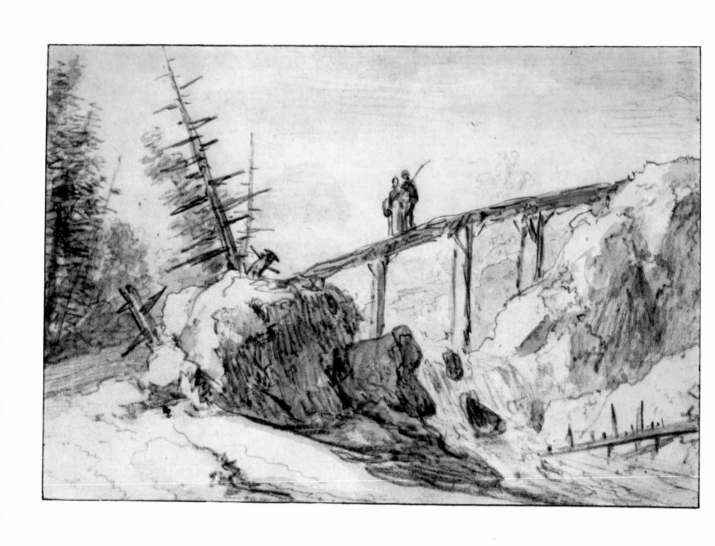

2 Dutch School *Couple Crossing a High Trestle Bridge*

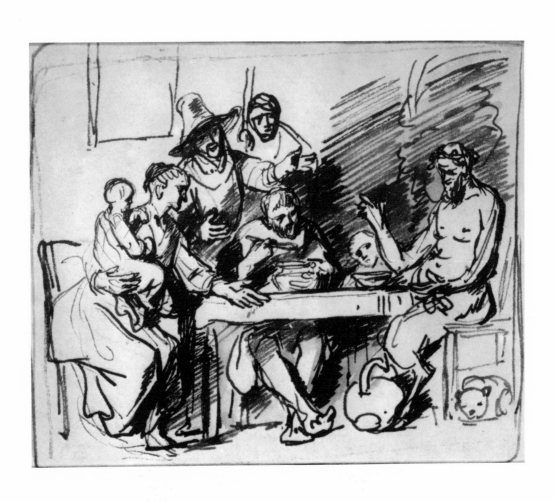

3 Gerbrand van den Eeckhout *The Satyr and the Peasant*

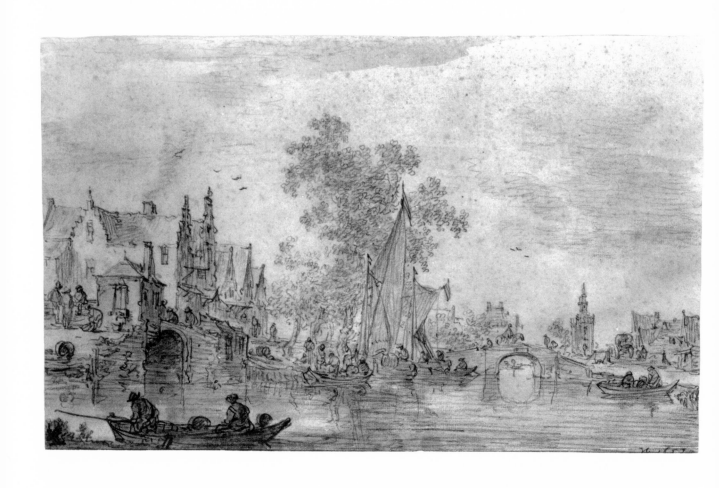

4 Jan van Goyen *Houses along a Canal*

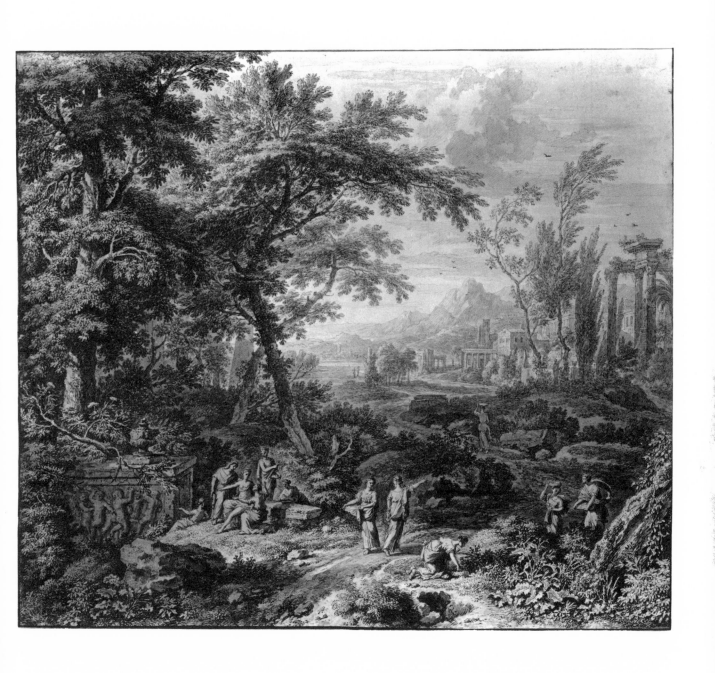

5 Jan van Huysum *Classical Landscape*

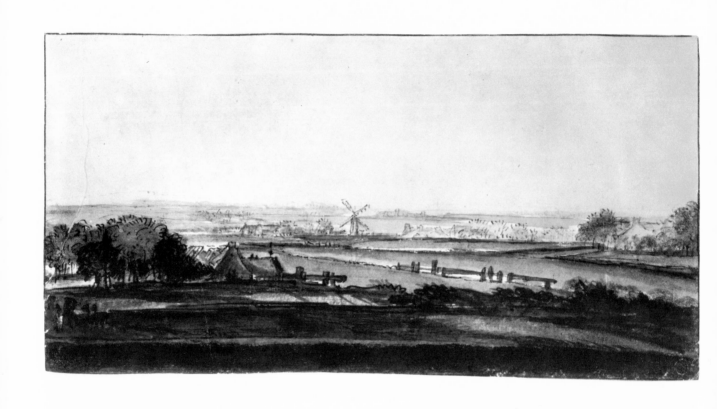

6 Philips Koninck *Flat Landscape with Scattered Houses and a Windmill*

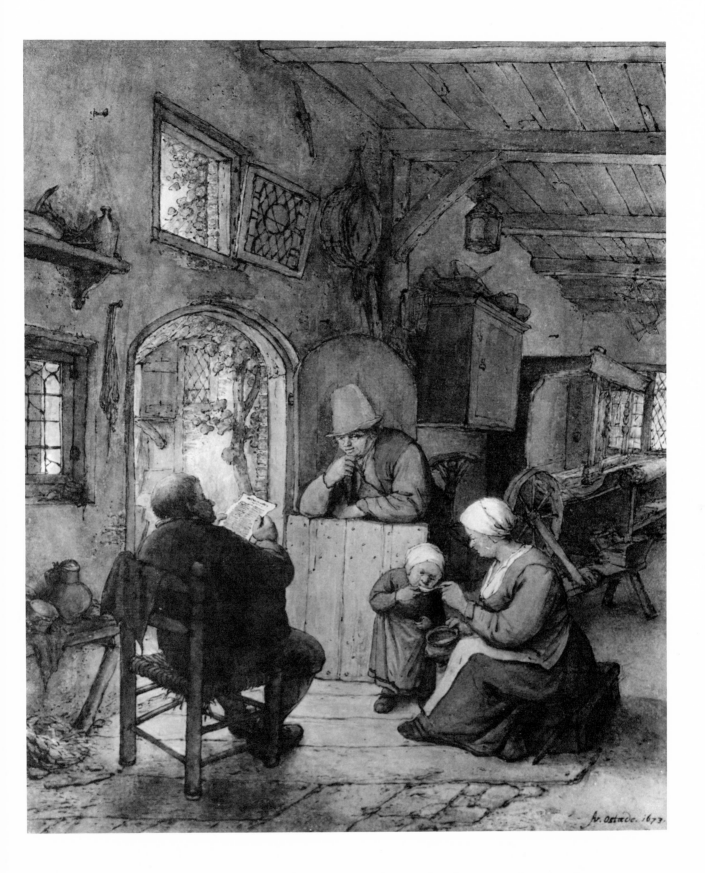

7 Adriaen van Ostade *Reading the News at the Weaver's Cottage*

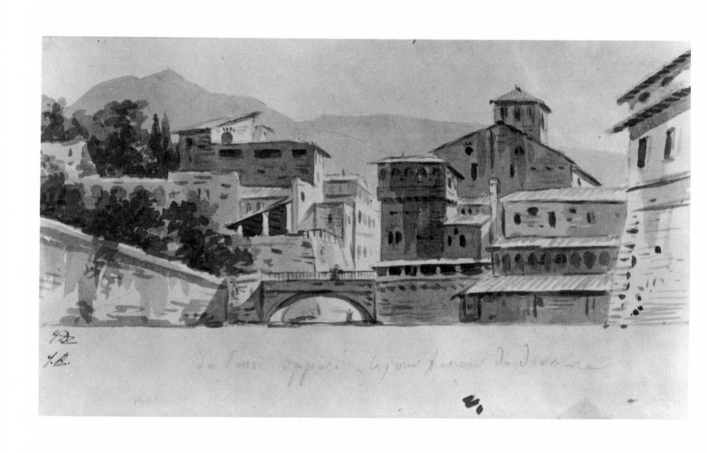

8　Jacques-Louis David　*View of a Town in the Roman Campagna*

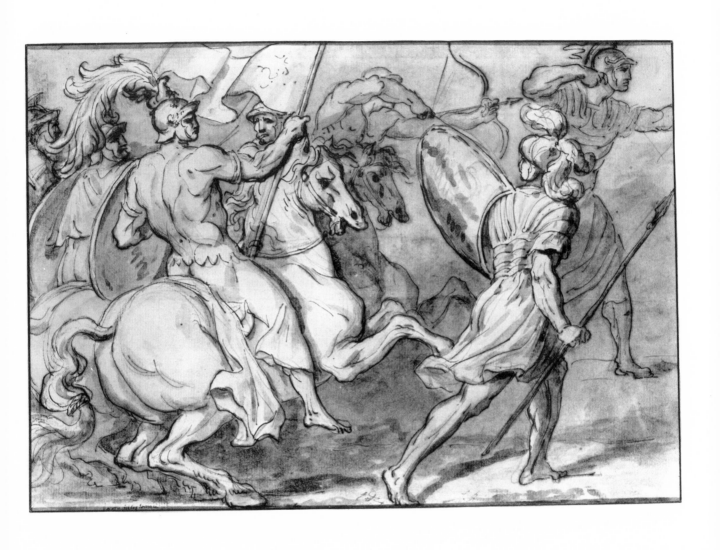

9 Jacques-Louis David *Preparations for the Battle of the Milvian Bridge*

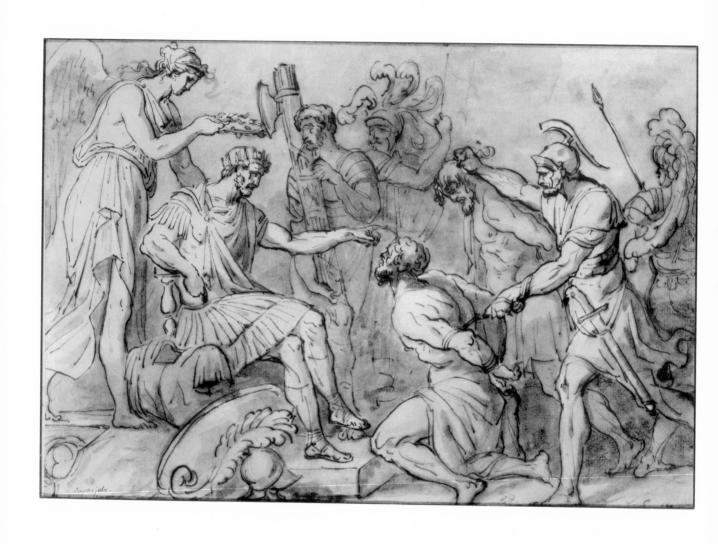

10 Jacques-Louis David *Bound Captives Brought before Constantine*

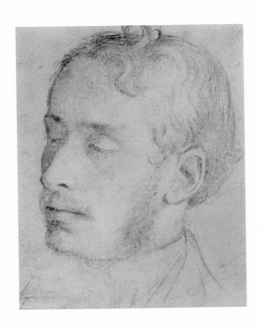

11 Hilaire-Germain-Edgar Degas *Portrait of Adelchi Morbilli*

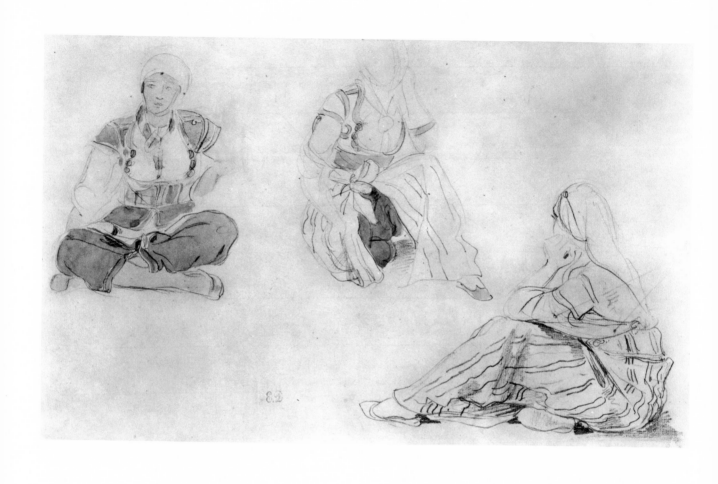

12 Eugène Delacroix *Three Studies of a Young Arab Woman*

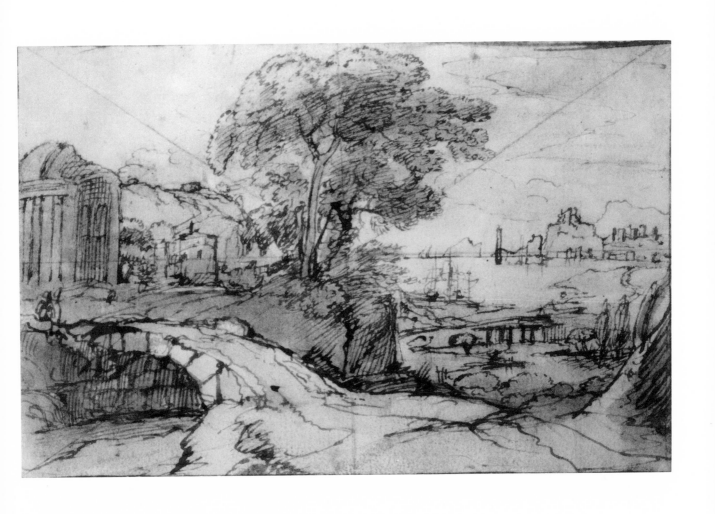

13 Claude Gellée, called Claude Lorrain *Pastoral Landscape*

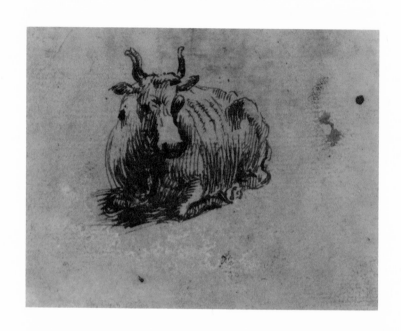

14 Claude Gellée, called Claude Lorrain *Ox*

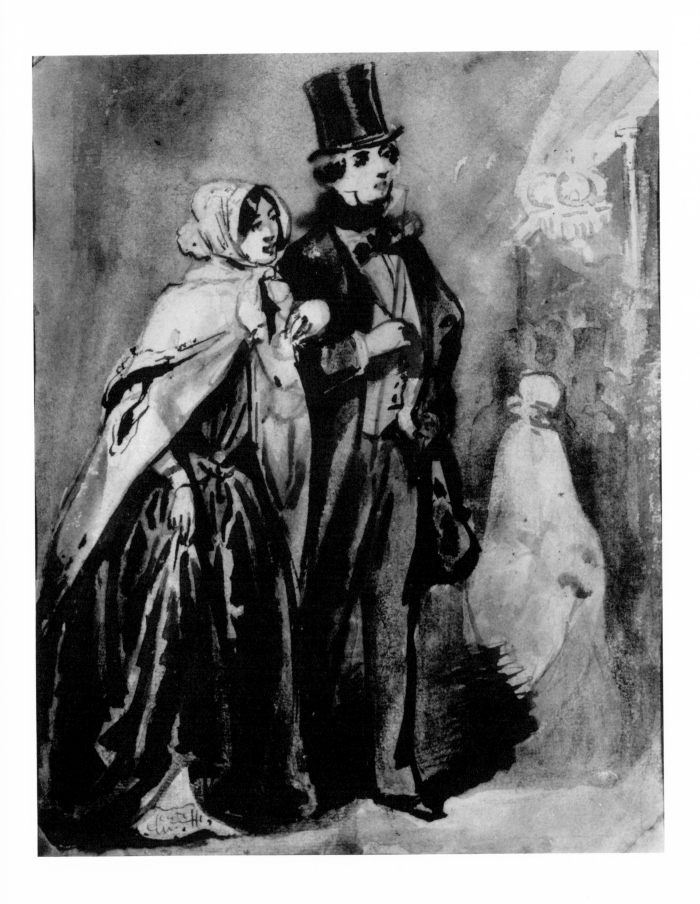

15 Constantin Guys *Couple Promenading*

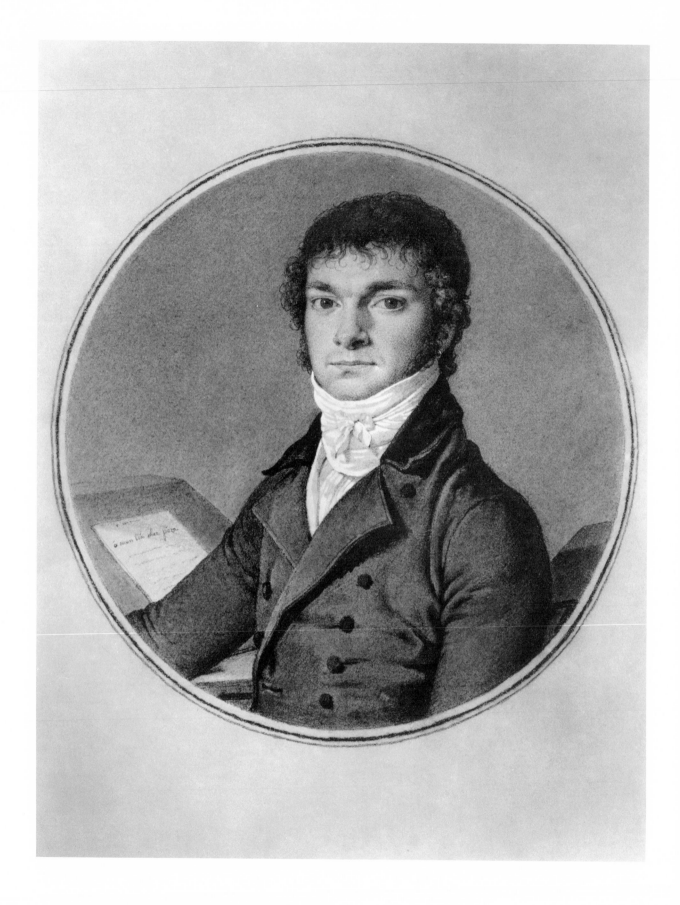

16 Jean-Auguste-Dominique Ingres *Portrait of Pierre-Guillaume Cazeaux*

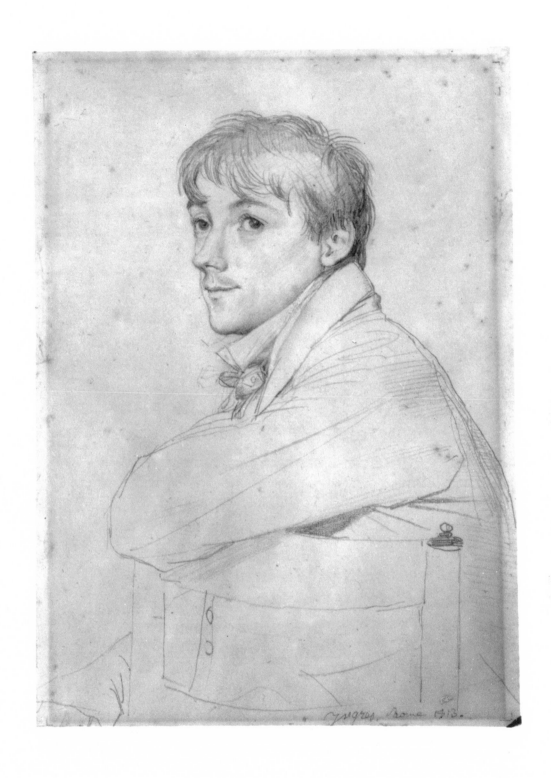

17 Jean-Auguste-Dominique Ingres *Portrait of the Architect Jean-Louis Provost*

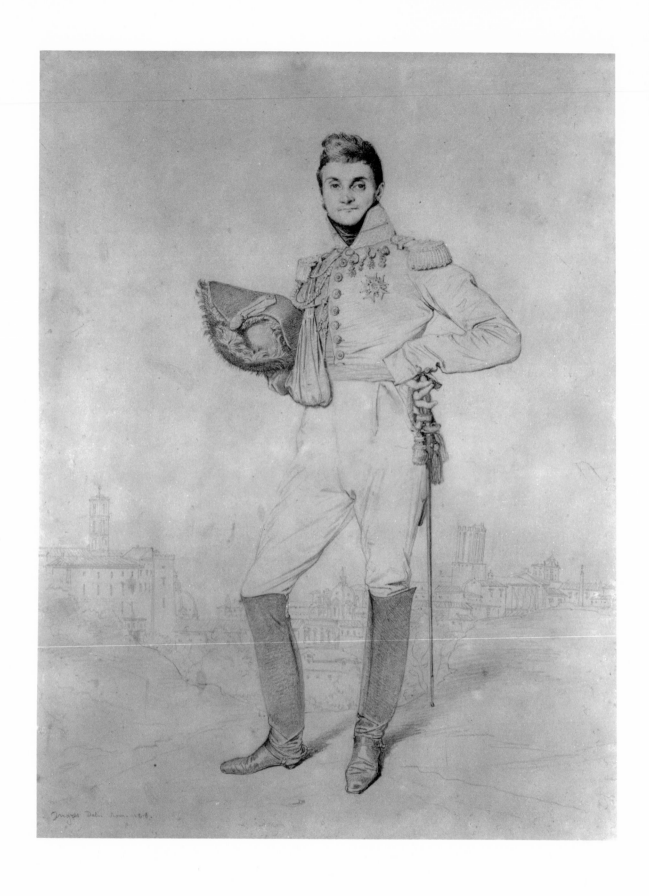

18 Jean–Auguste–Dominique Ingres *Portrait of General Louis–Étienne Dulong de Rosnay*

19 Jean-Auguste-Dominique Ingres *Seated Female Nude Holding a Flower*

20 Jean-Auguste-Dominique Ingres *Study for "The Turkish Bath"*

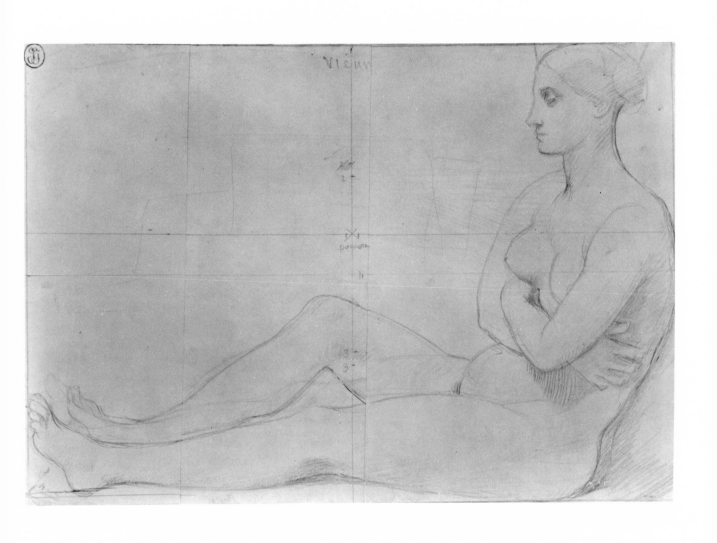

21 Jean-Auguste-Dominique Ingres *Seated Female Nude*

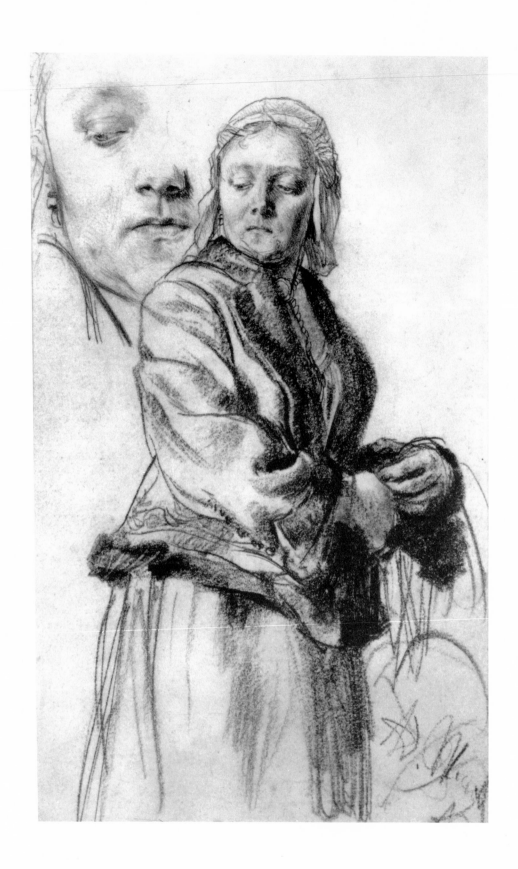

22 Adolph von Menzel *Woman in a Cap and Fur-Edged Jacket*

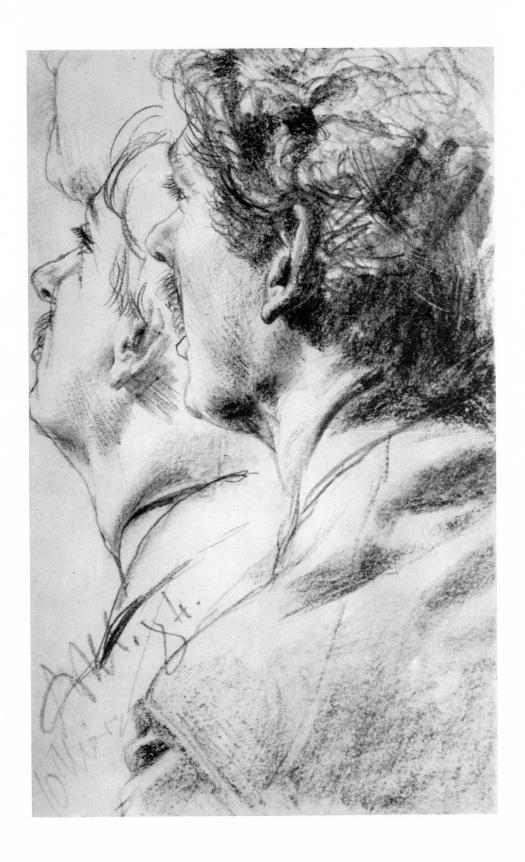

23 Adolph von Menzel *Two Profile Studies of the Head of a Young Man*

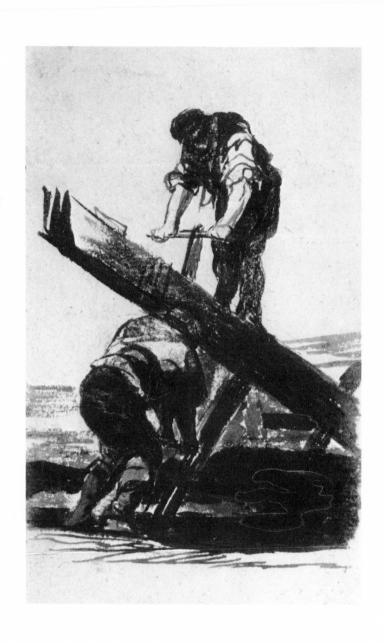

24 Francisco Goya y Lucientes *The Sawyers*

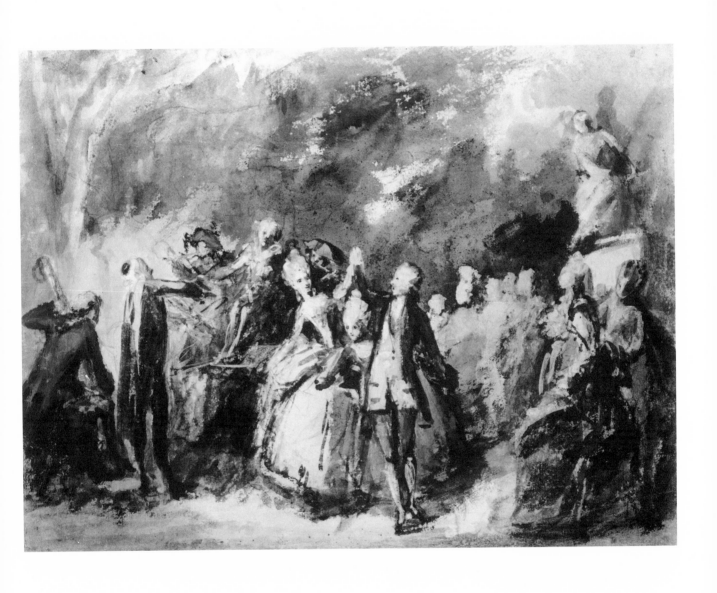

25 Luis Paret y Alcázar *Fête in a Park*

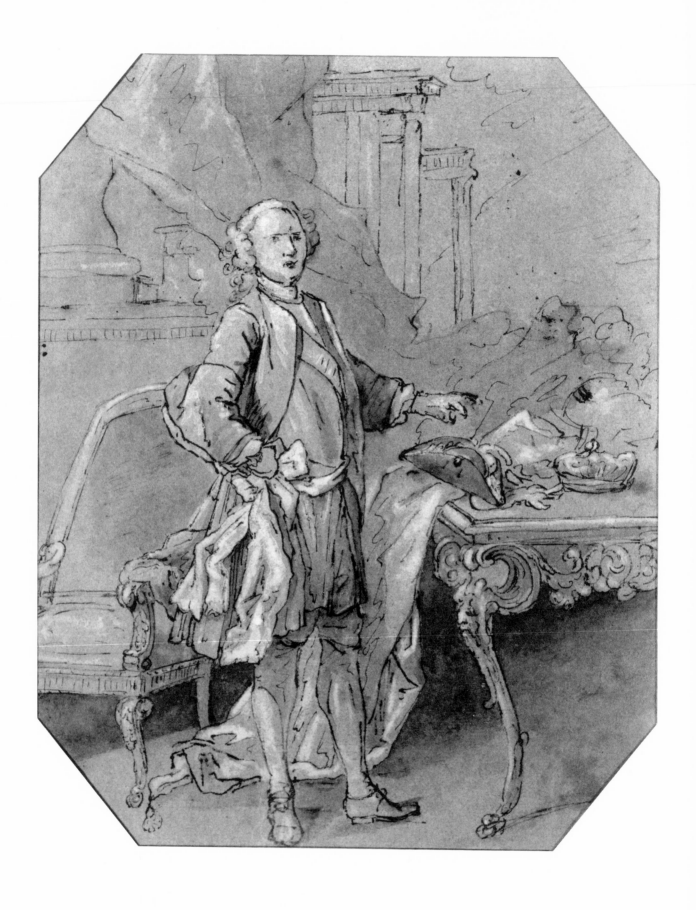

26　Jacopo Amigoni　*Composition Study for a Portrait*

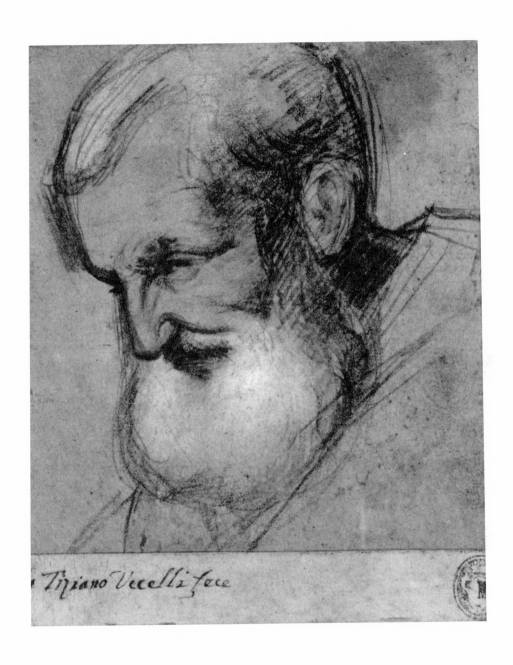

Tiziano Vecelli fece

27 Attributed to Jacopo Bassano *Head of an Old Man*

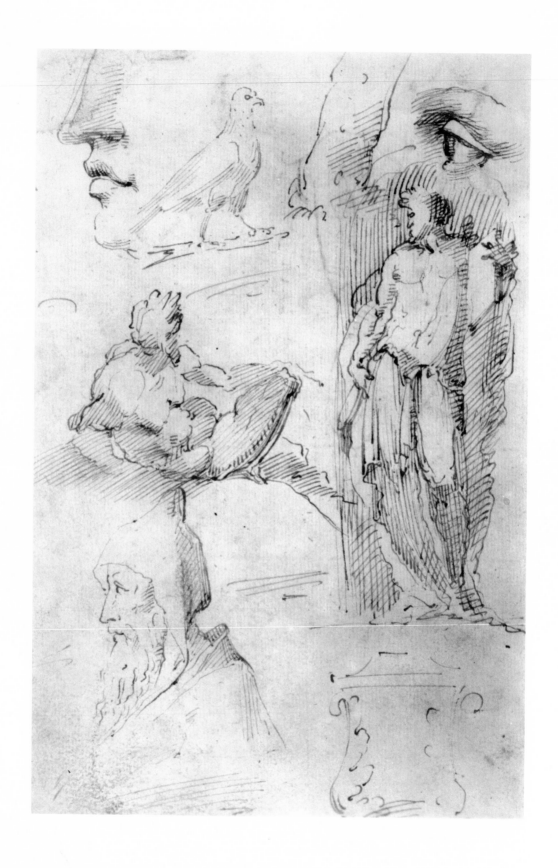

28 Domenico Beccafumi *River God, Standing Apostle, Bird, and Other Sketches*

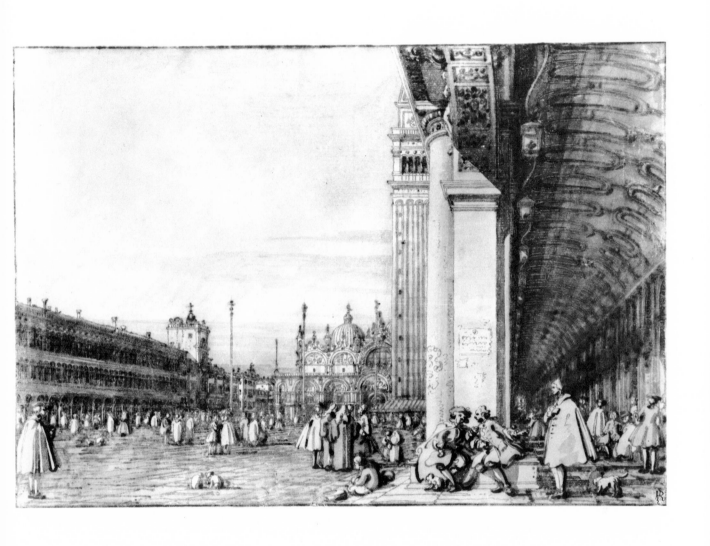

29 Antonio Canal, called Canaletto *St. Mark's Square*

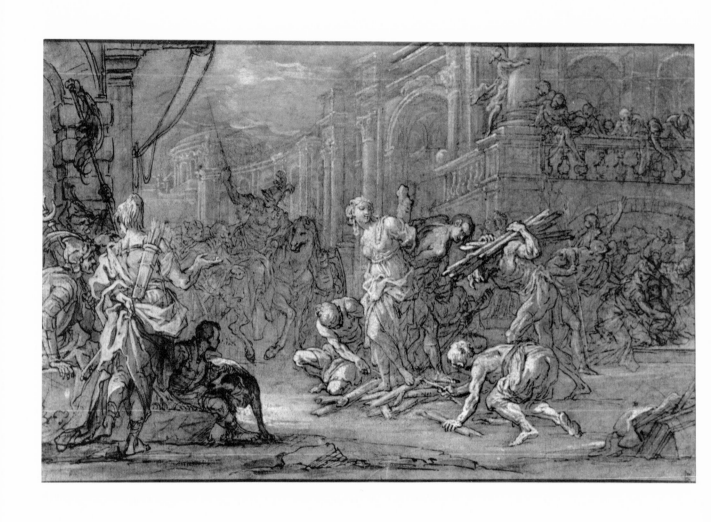

30 Sebastiano Conca *Clorinda Rescuing Sofronia and Olindo*

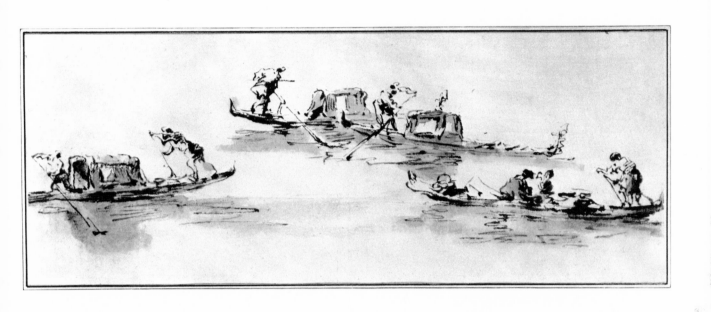

31 Francesco Guardi *Four Gondolas*

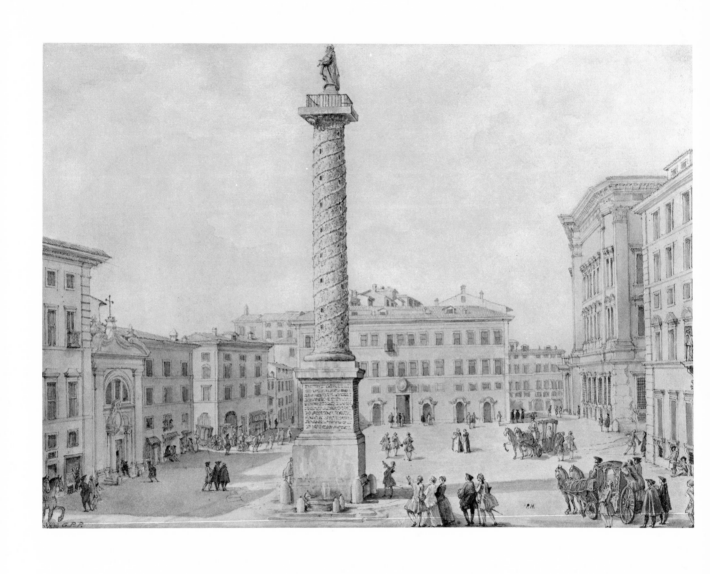

32 Giovanni Paolo Pannini *The Piazza Colonna*

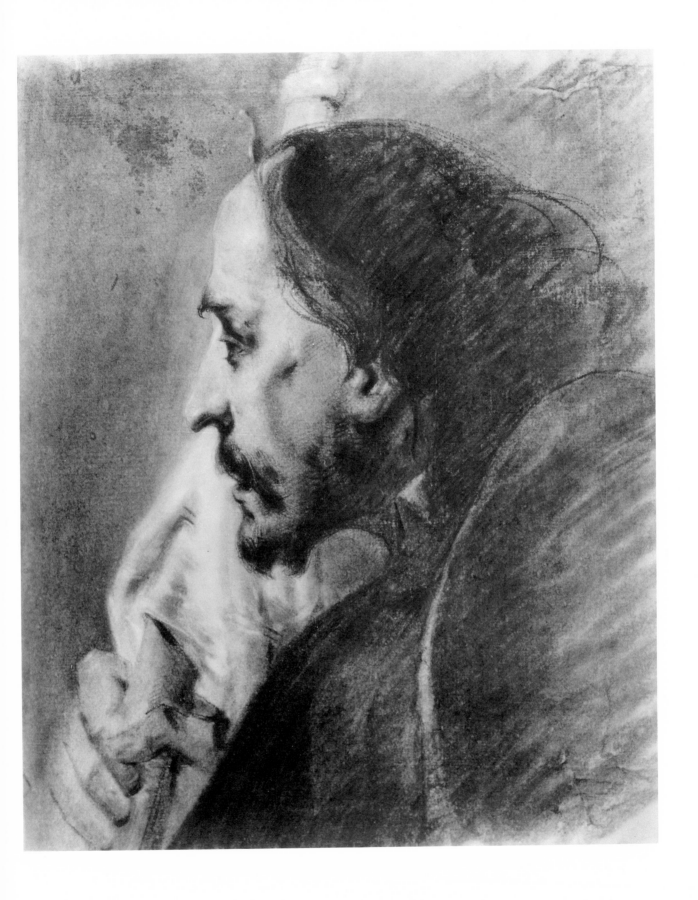

33 Giovanni Battista Piazzetta *St. James Major*

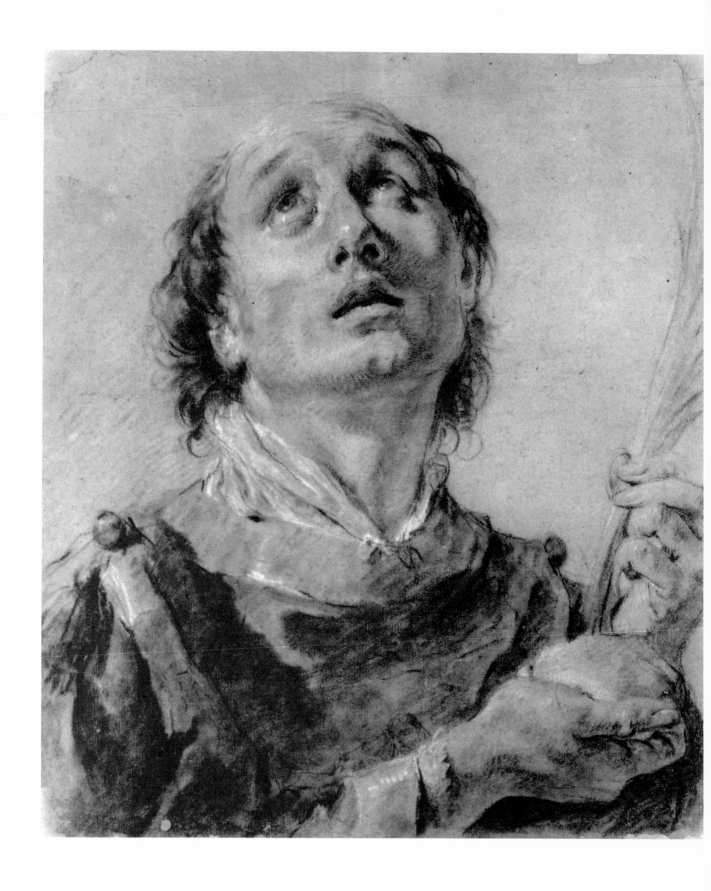

34 Giovanni Battista Piazzetta *St. Stephen*

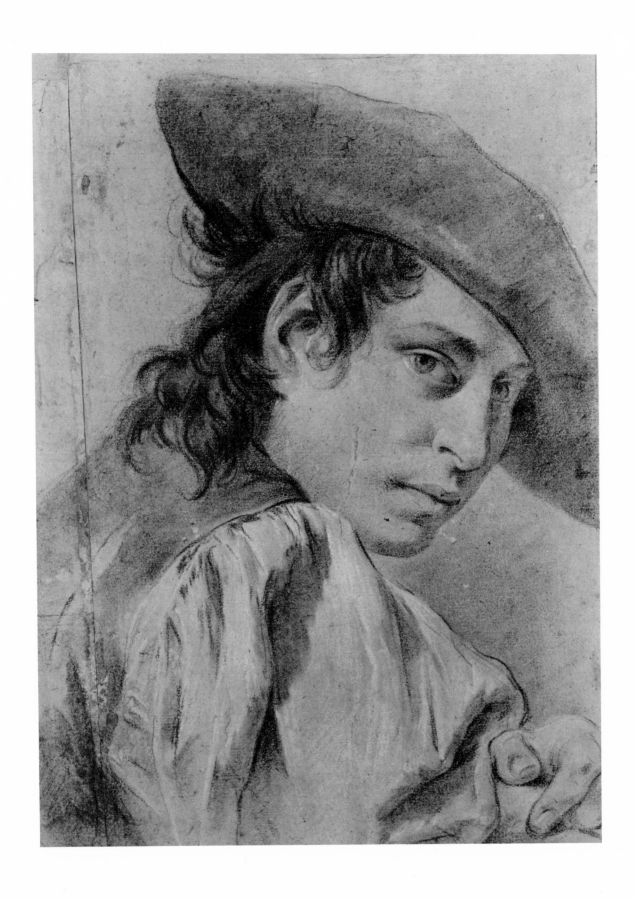

35 Giovanni Battista Piazzetta *Young Man in a Large Hat*

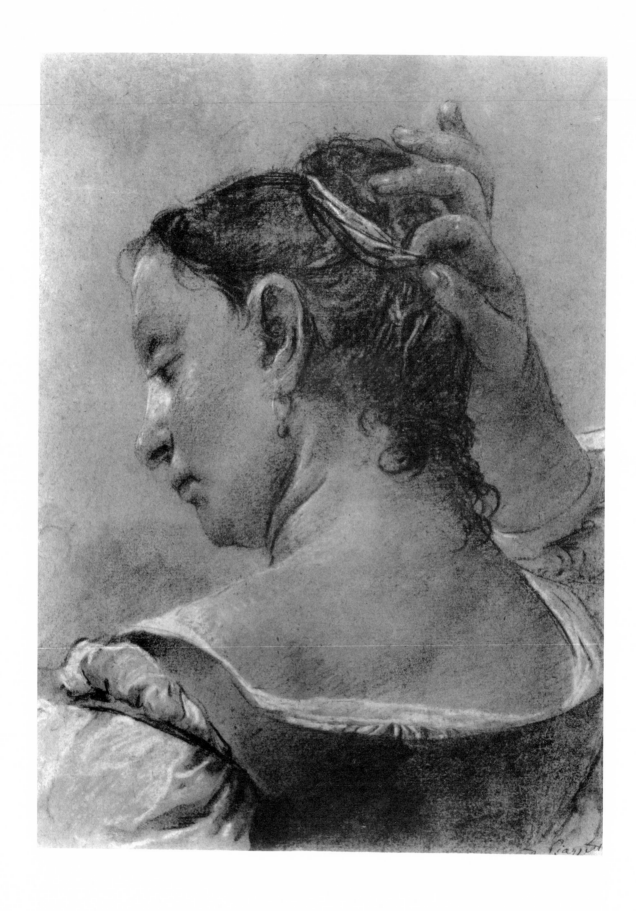

36 Giovanni Battista Piazzetta *Head of a Girl*

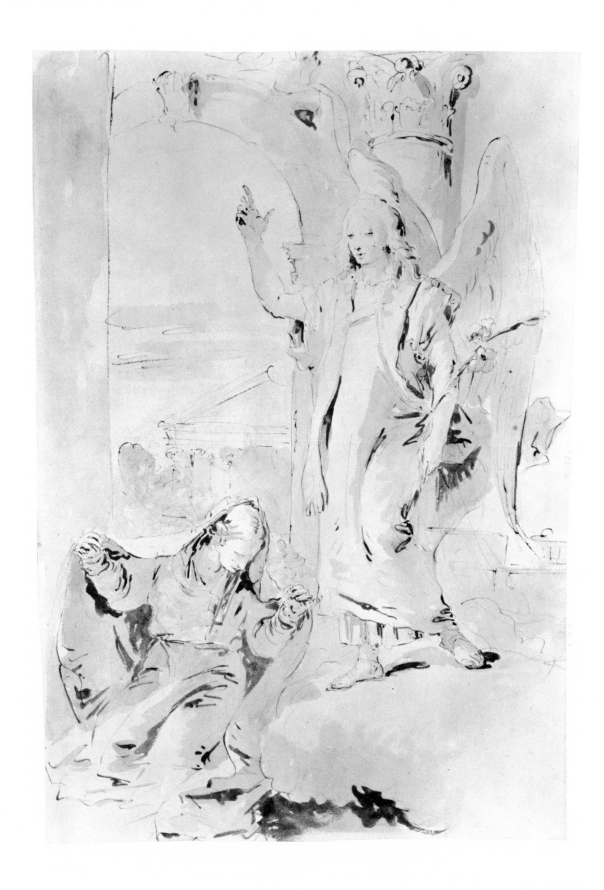

37 Giovanni Battista Tiepolo *The Annunciation*

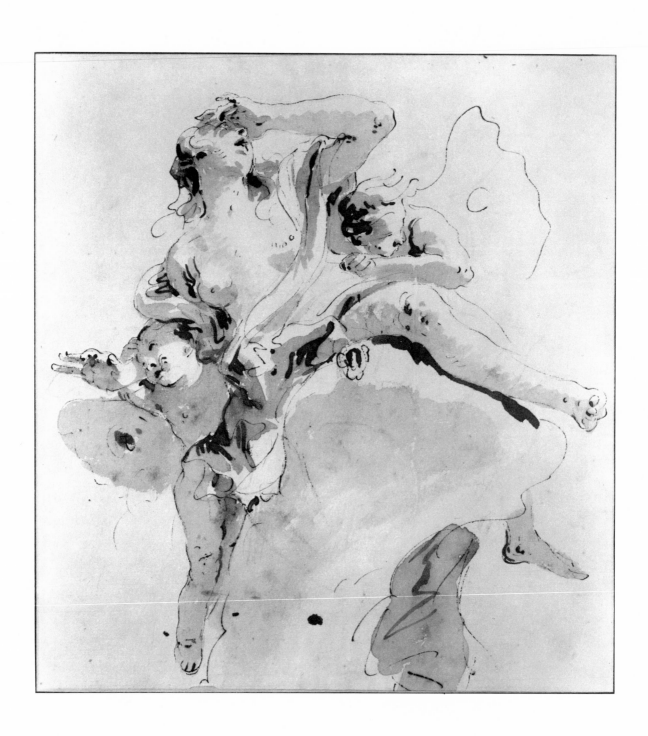

38 Giovanni Battista Tiepolo *Psyche Transported to Olympus*

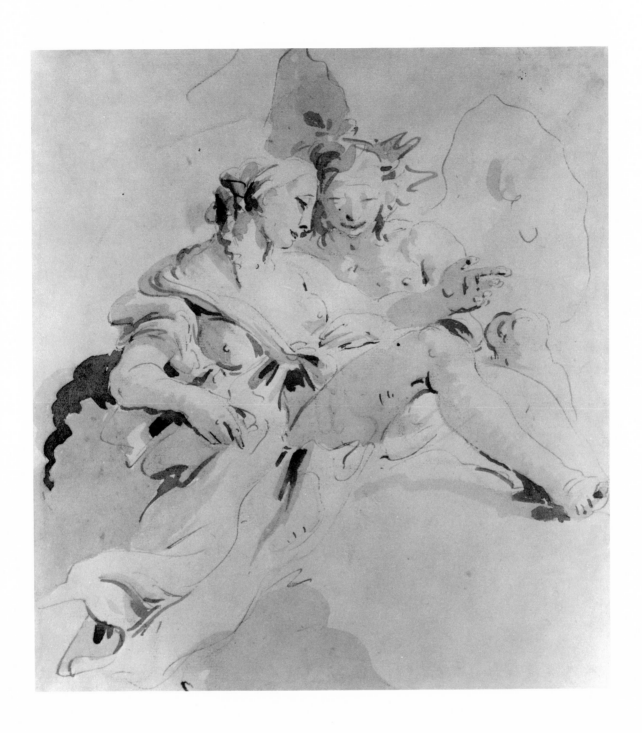

39 Giovanni Battista Tiepolo *Zephyr and Flora*

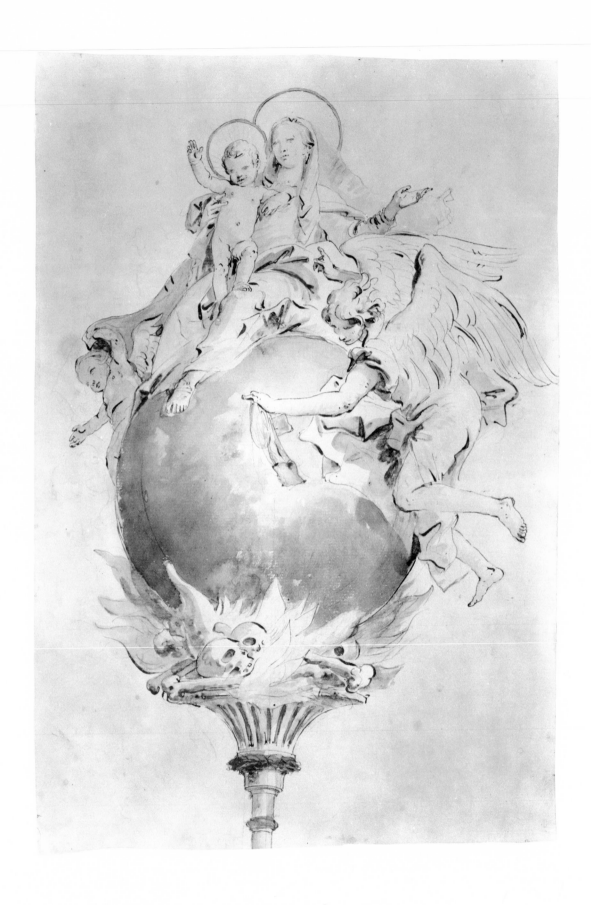

40 Giovanni Battista Tiepolo *Virgin and Child Seated on a Globe*

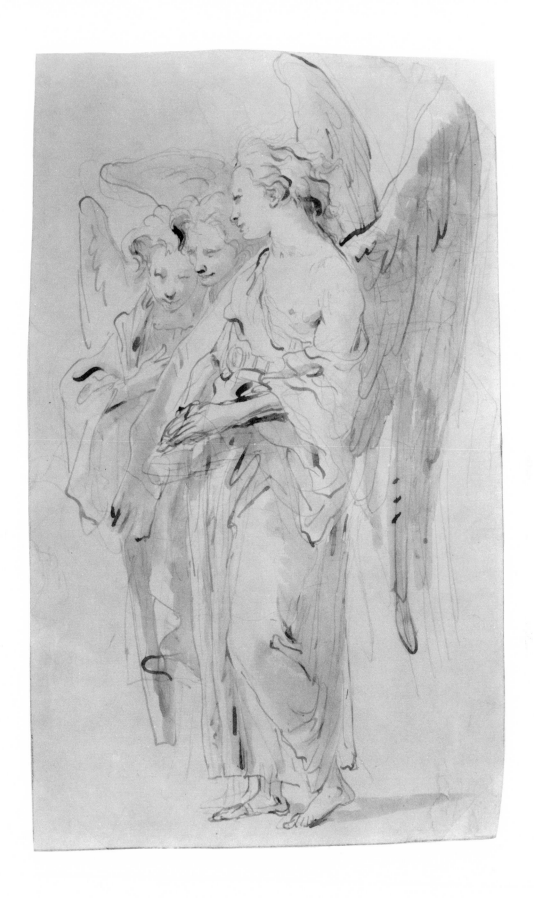

41 Giovanni Battista Tiepolo *Three Angels*

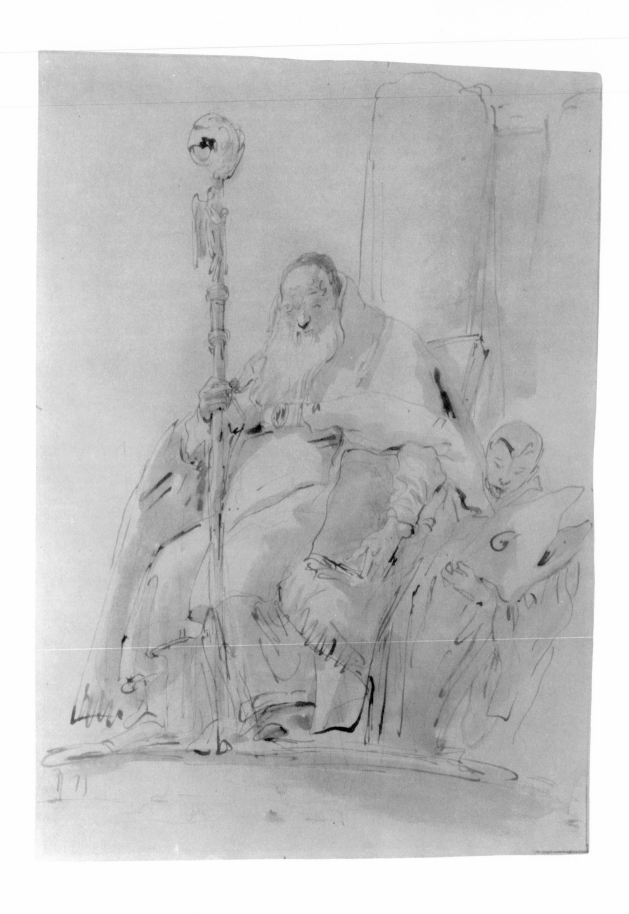

42 Giovanni Battista Tiepolo *Seated Bishop Holding a Crozier and a Book*

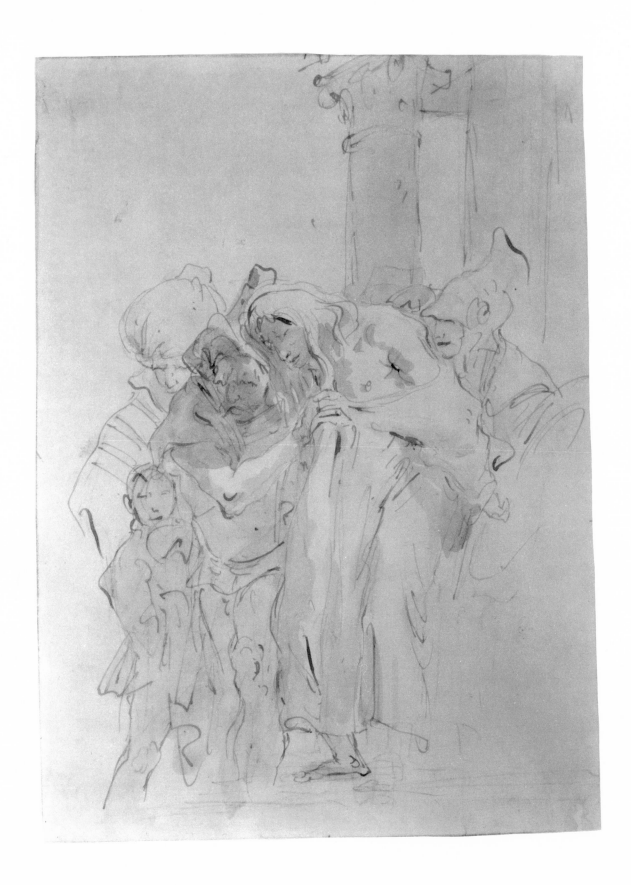

43 Giovanni Battista Tiepolo *Christ Shown to the People*

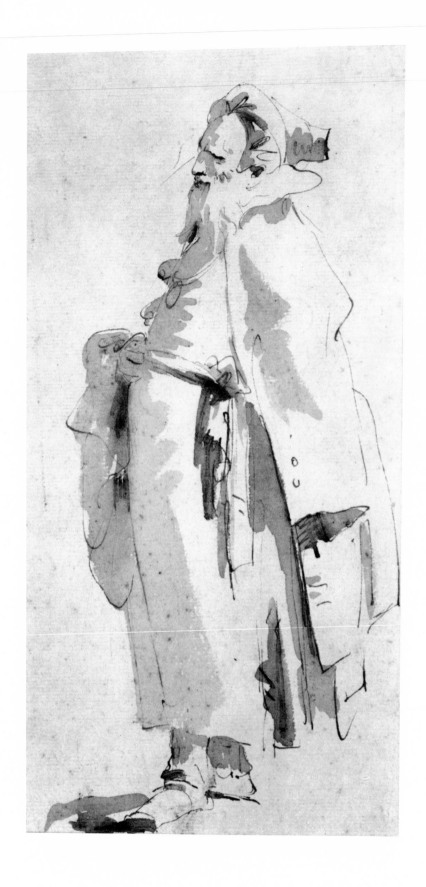

44 Giovanni Battista Tiepolo *Bearded Oriental Wearing a Chain and Seal, and a Broad Sash*

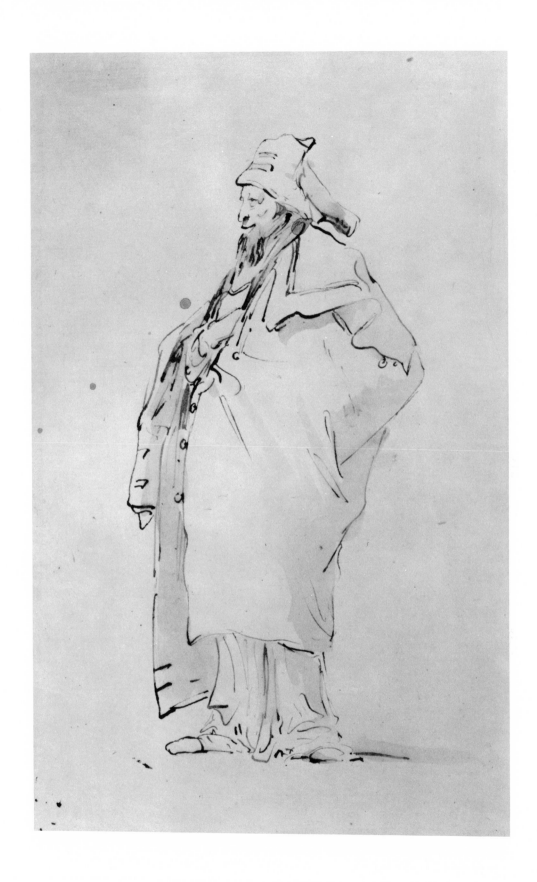

45 Giovanni Battista Tiepolo *Bearded Oriental, His Right Hand across His Chest*

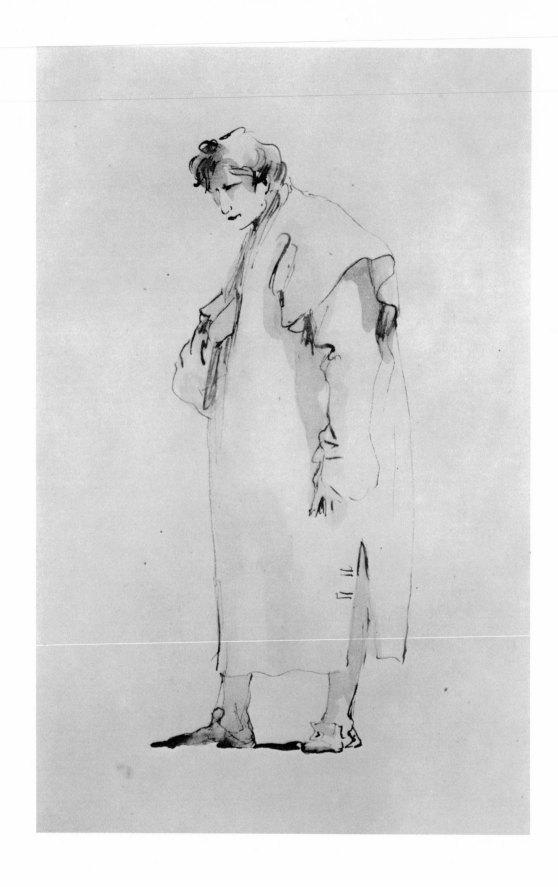

46 Giovanni Battista Tiepolo *Young Man Holding a Book*

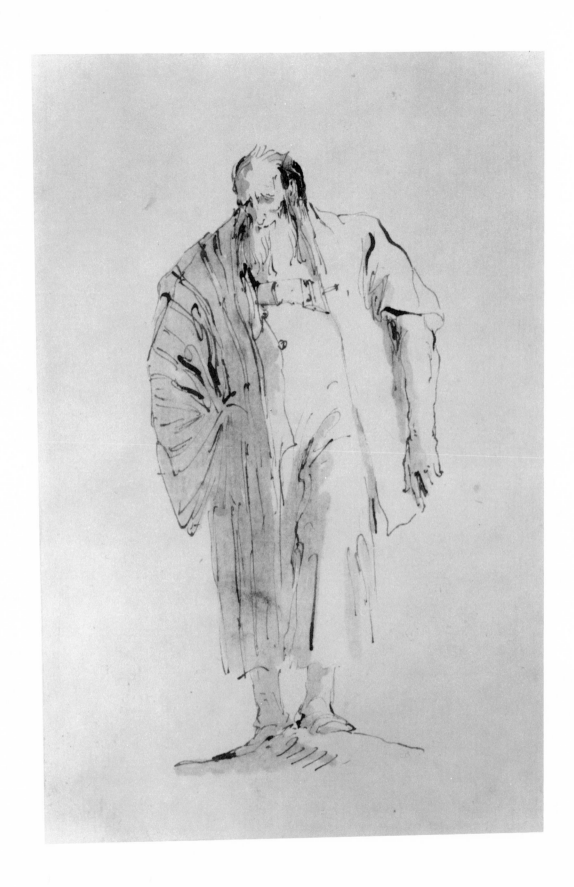

47 Giovanni Battista Tiepolo *Bearded Man Wearing a Striped Mantle*

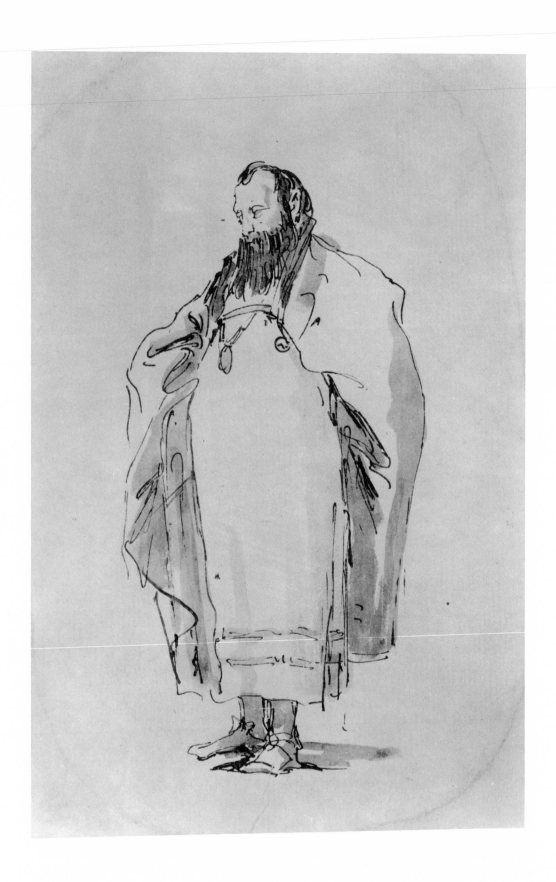

48 Giovanni Battista Tiepolo *Man with a Dark Beard, Wearing a Chain and Seal*

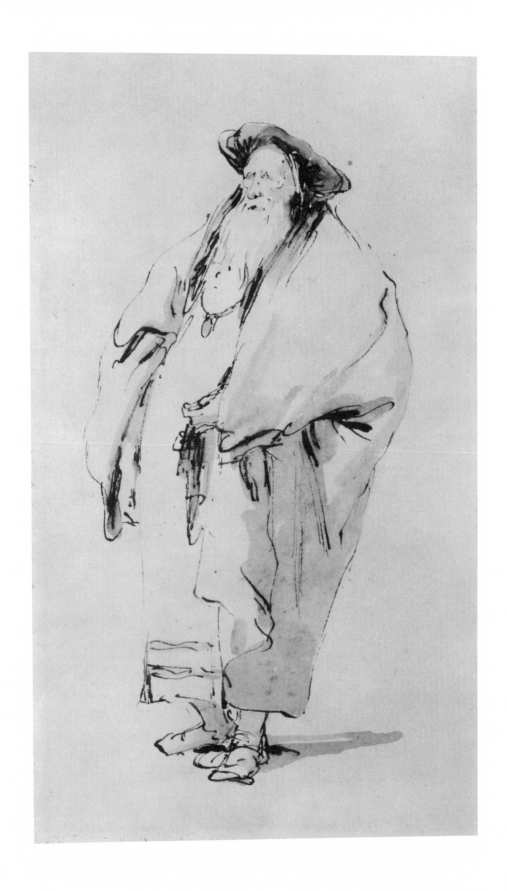

49 Giovanni Battista Tiepolo *Bearded Oriental Wearing a Flat Cap and Cloak*

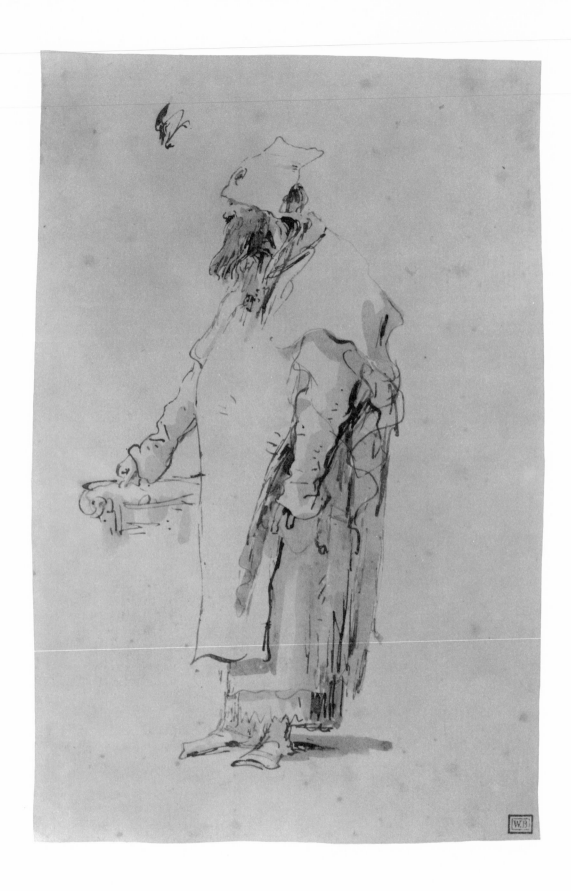

50 Giovanni Battista Tiepolo *Bearded Oriental Resting His Right Hand on a Capital*

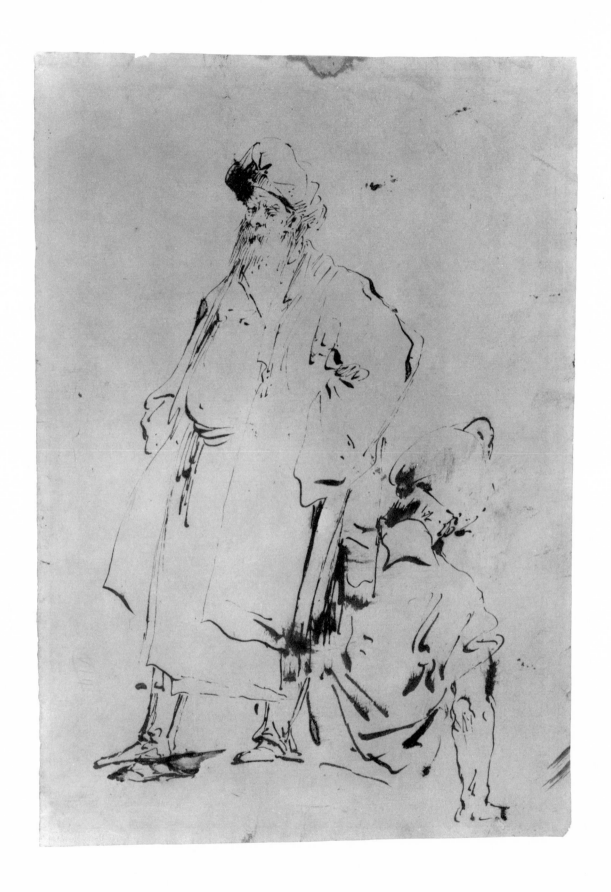

51 Giovanni Battista Tiepolo *Two Orientals, One Standing, One Seated*

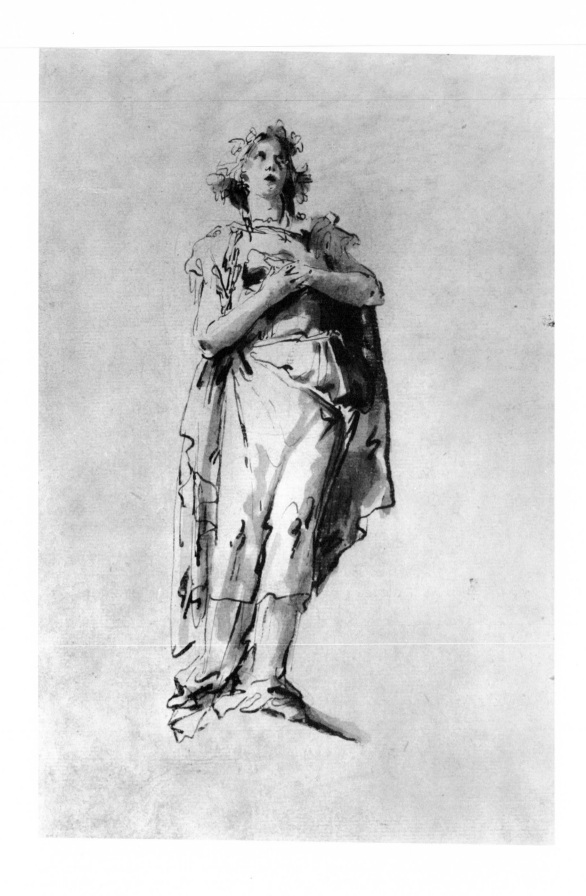

52 Giovanni Battista Tiepolo *Young Woman in Classical Drapery and Wreath*

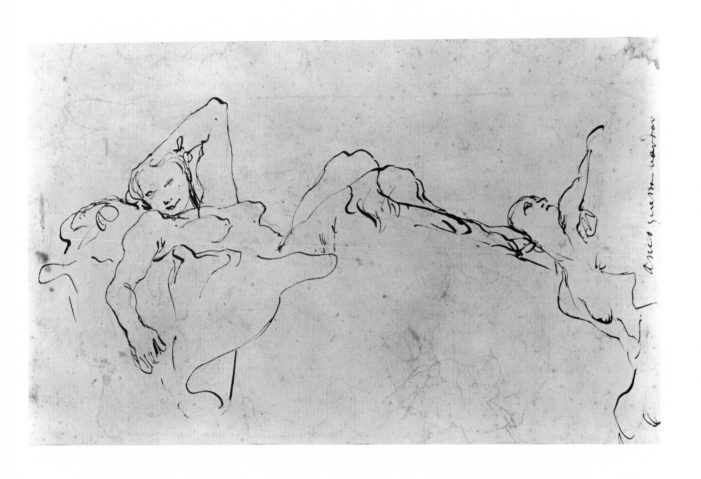

53 Giovanni Battista Tiepolo *Reclining Female Faun*

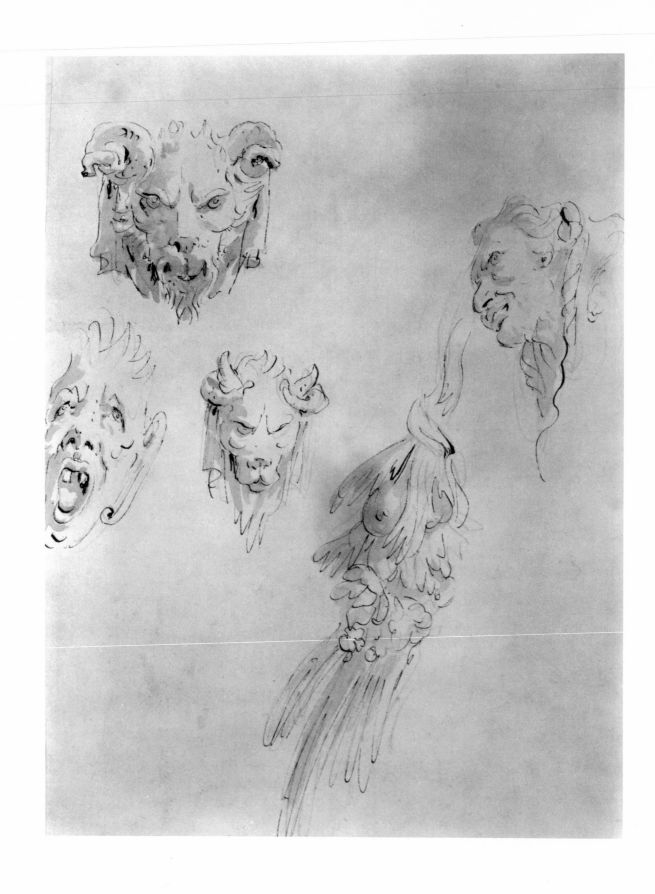

54 Giovanni Battista Tiepolo *Four Masks and a Swag of Fruit*

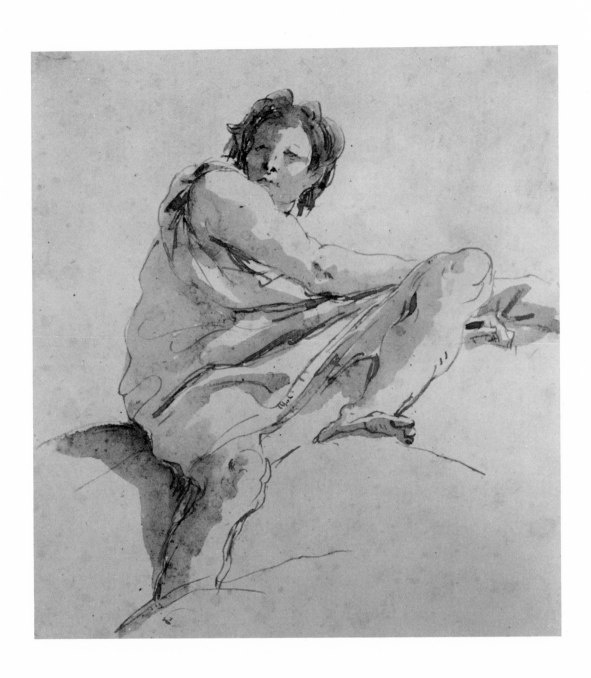

55 Giovanni Battista Tiepolo *Young Man Seated on a Cloud*

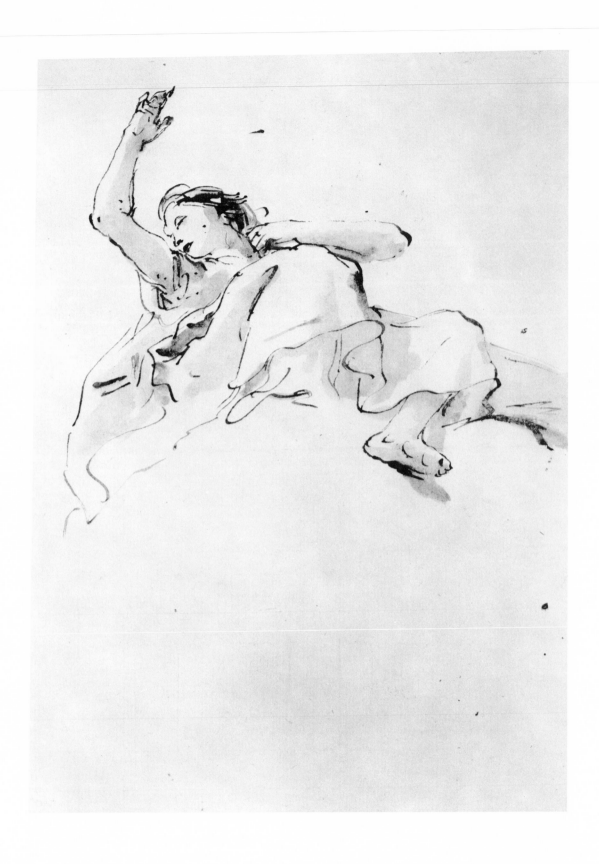

56 Giovanni Battista Tiepolo *Young Woman Seated on a Cloud*

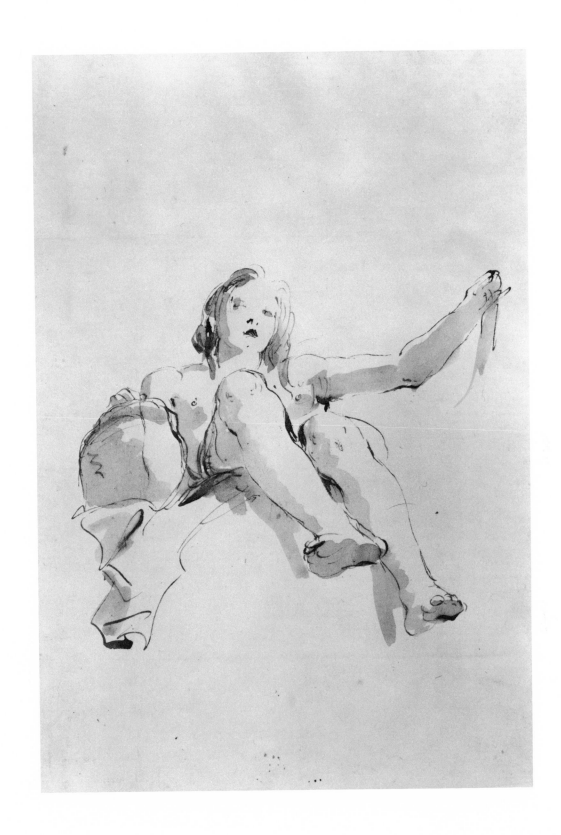

57 Giovanni Battista Tiepolo *Young Girl with a Vase*

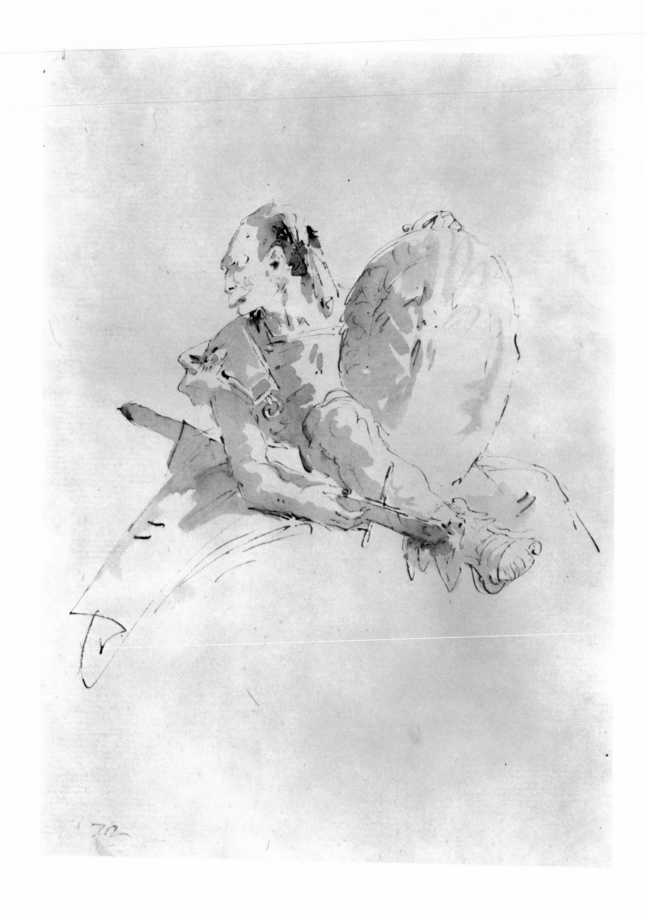

58 Giovanni Battista Tiepolo *Seated Warrior Holding Shield and Sword*

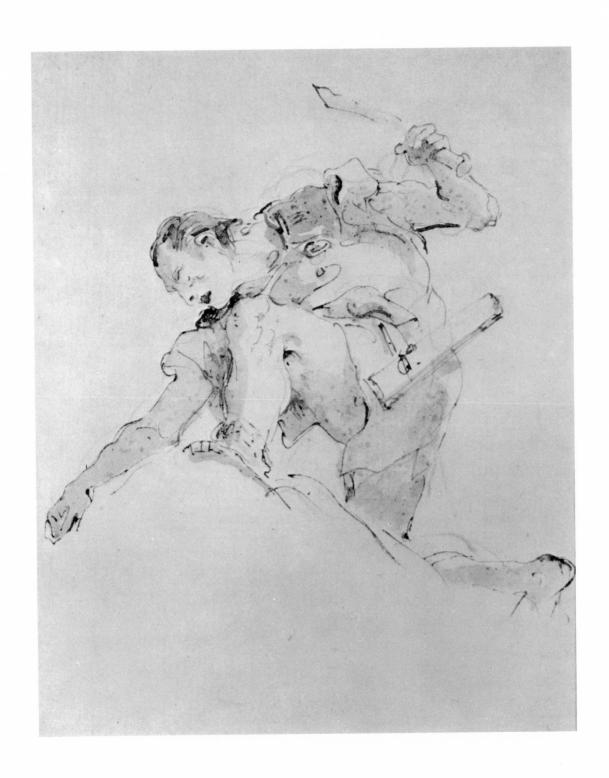

59 Giovanni Battista Tiepolo *Warrior Brandishing a Short Sword*

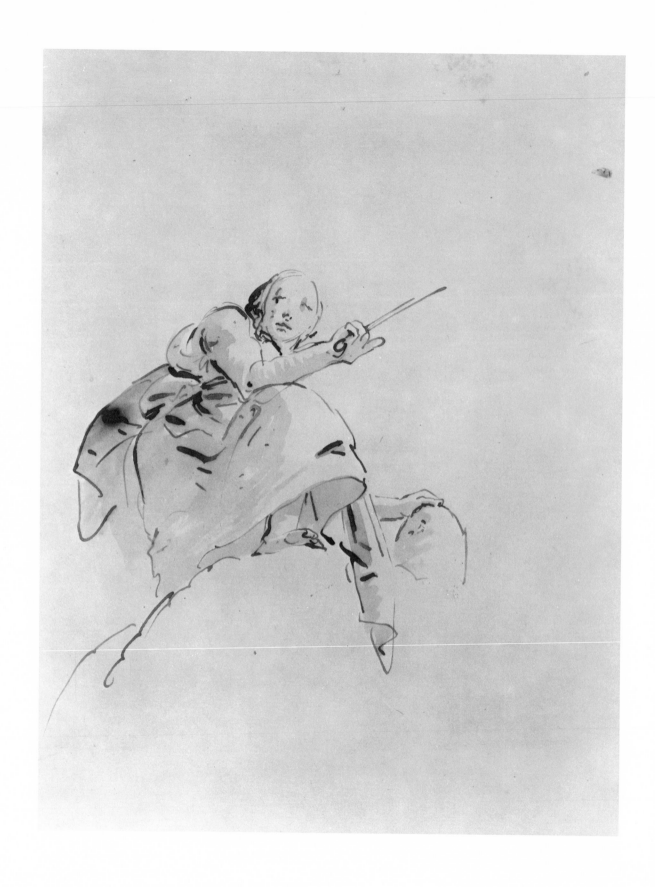

60 Giovanni Battista Tiepolo *Young Woman Standing on a Cloud, Holding a Short Wand*

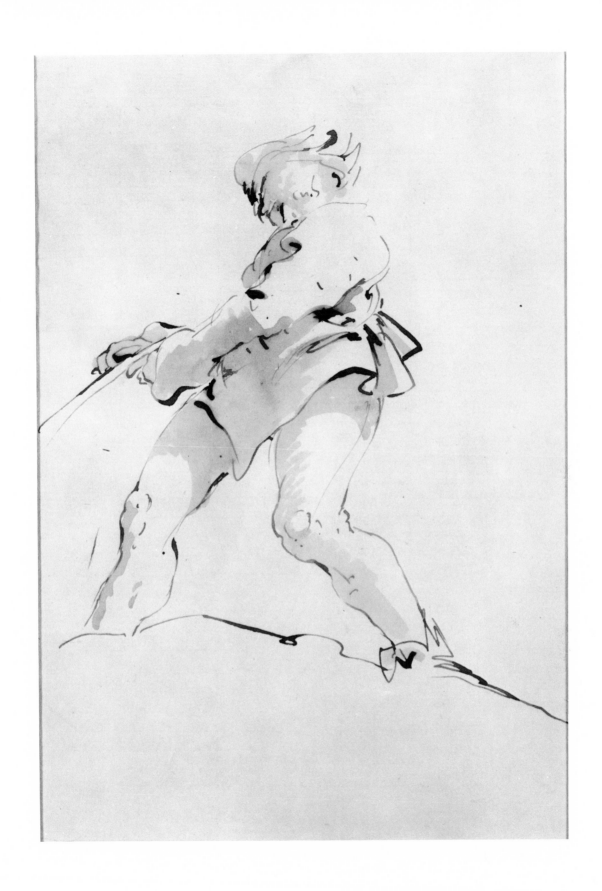

61 Giovanni Battista Tiepolo *Man Pulling on a Rope*

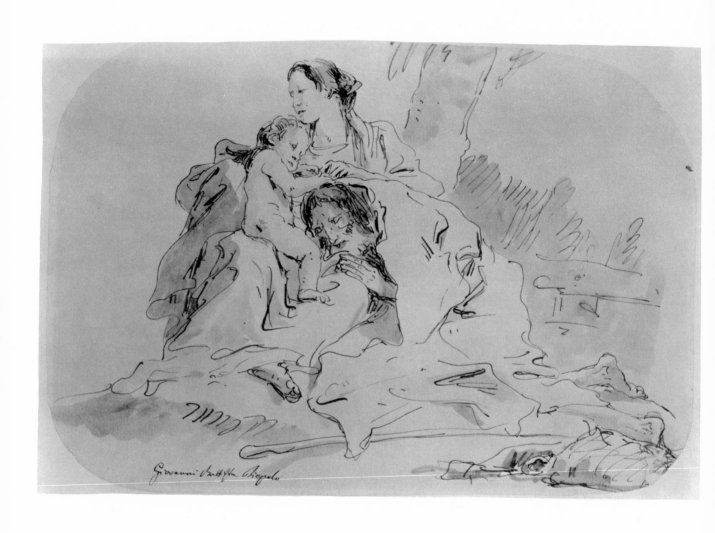

62 Giovanni Battista Tiepolo *Holy Family with St. Joseph Kneeling*

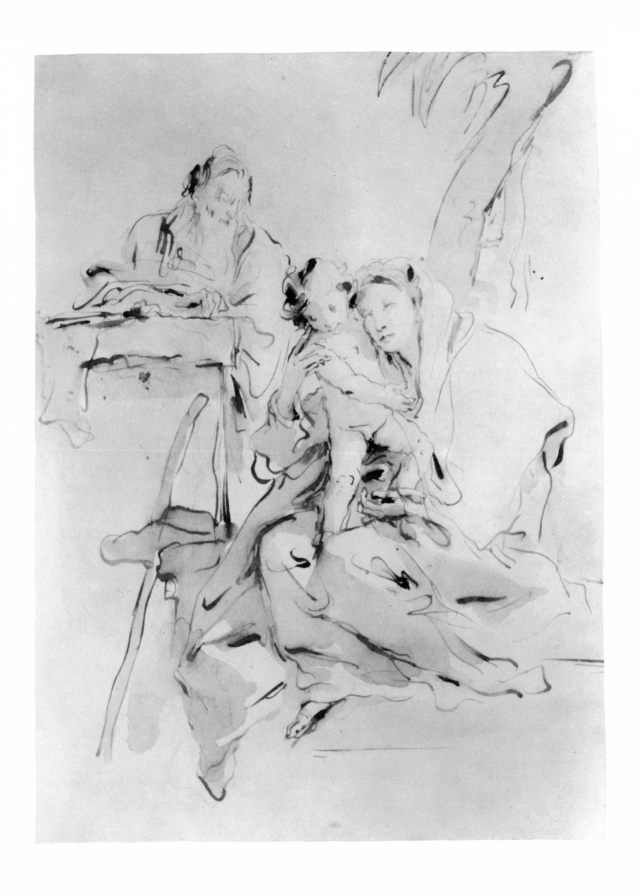

63 Giovanni Battista Tiepolo *Holy Family under a Tree with St. Joseph Standing at a Pedestal*

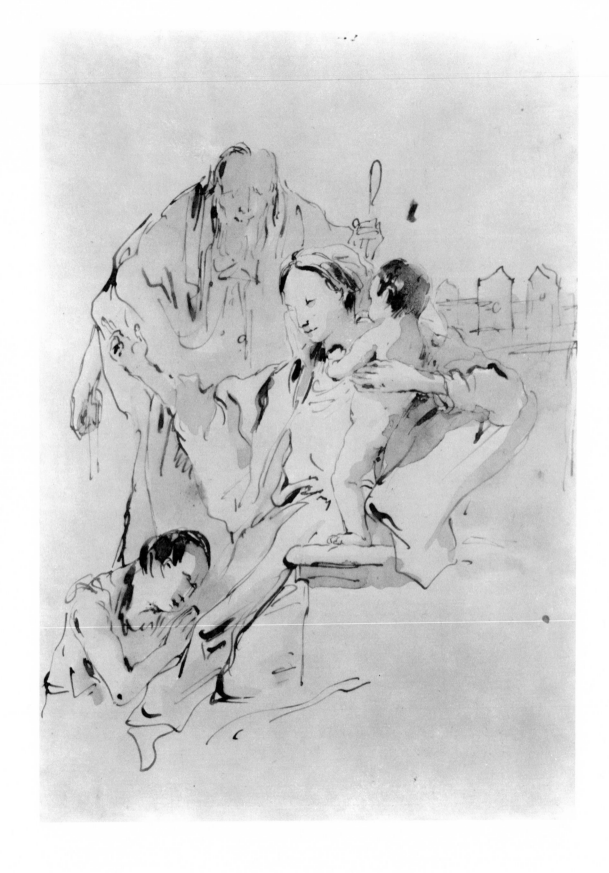

64 Giovanni Battista Tiepolo *Holy Family with the Young St. John*

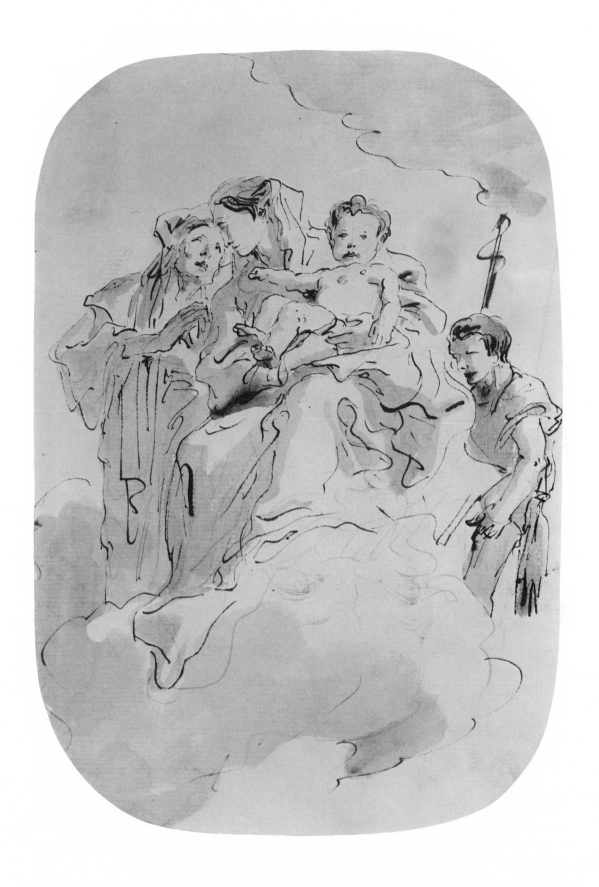

65　Giovanni Battista Tiepolo　*Virgin and Child with St. Anne and St. John*

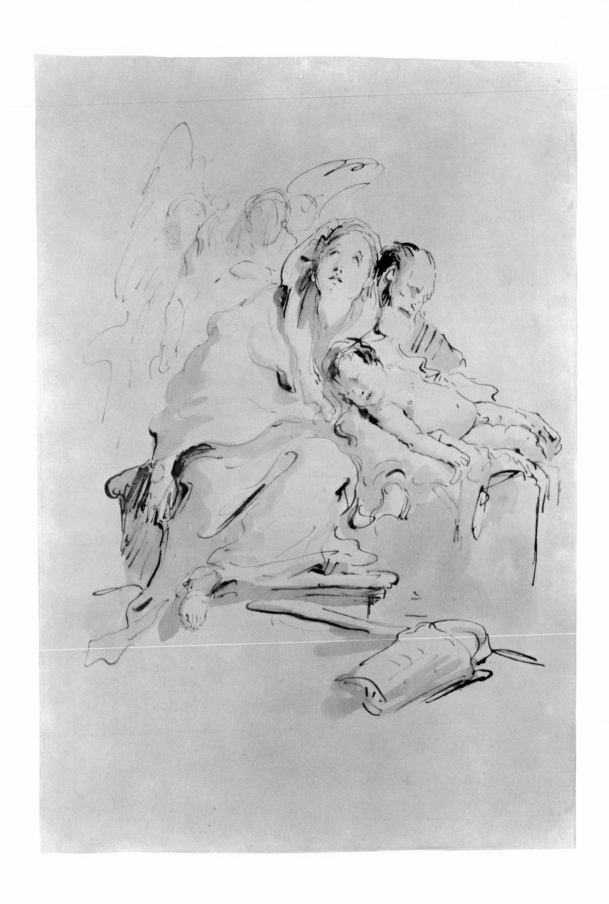

66 Giovanni Battista Tiepolo *Holy Family with the Child Asleep*

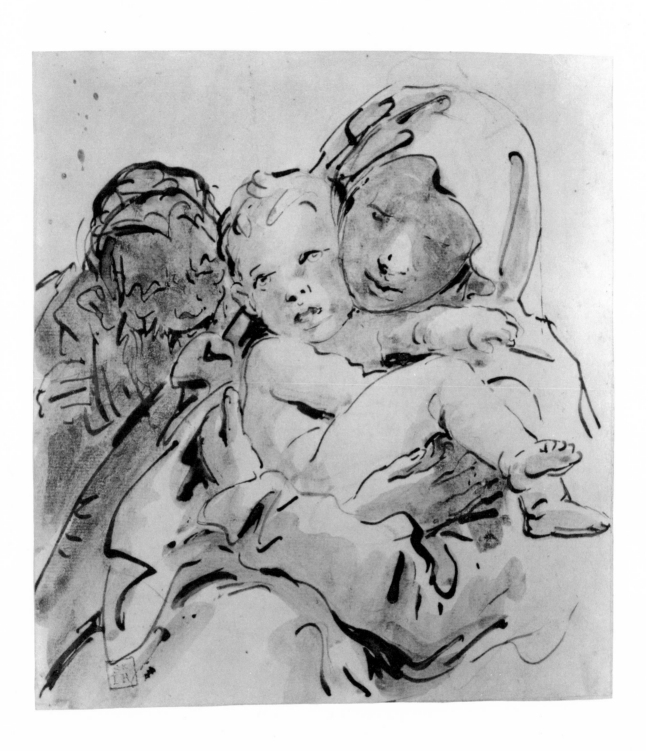

67 Giovanni Battista Tiepolo *Holy Family, Half Length*

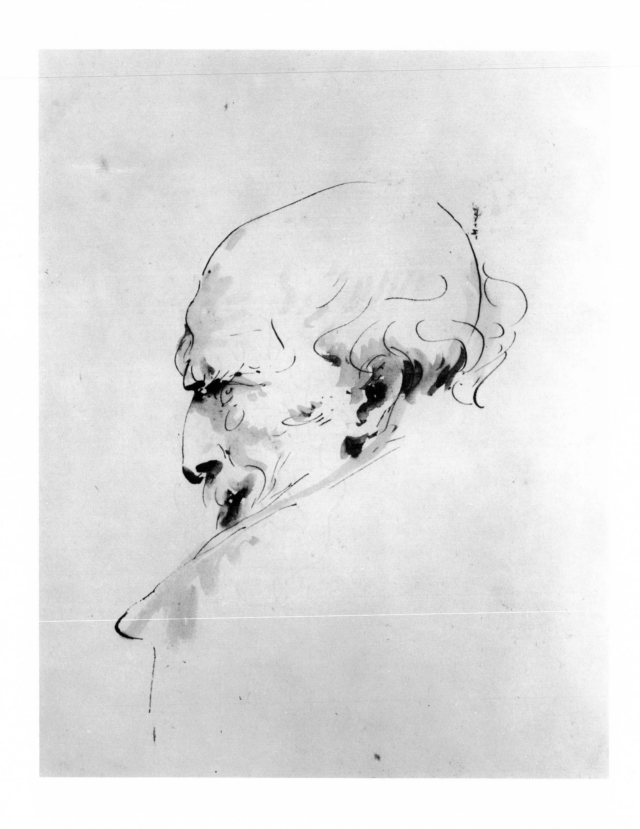

68 Giovanni Battista Tiepolo *Head of an Old Man in Profile*

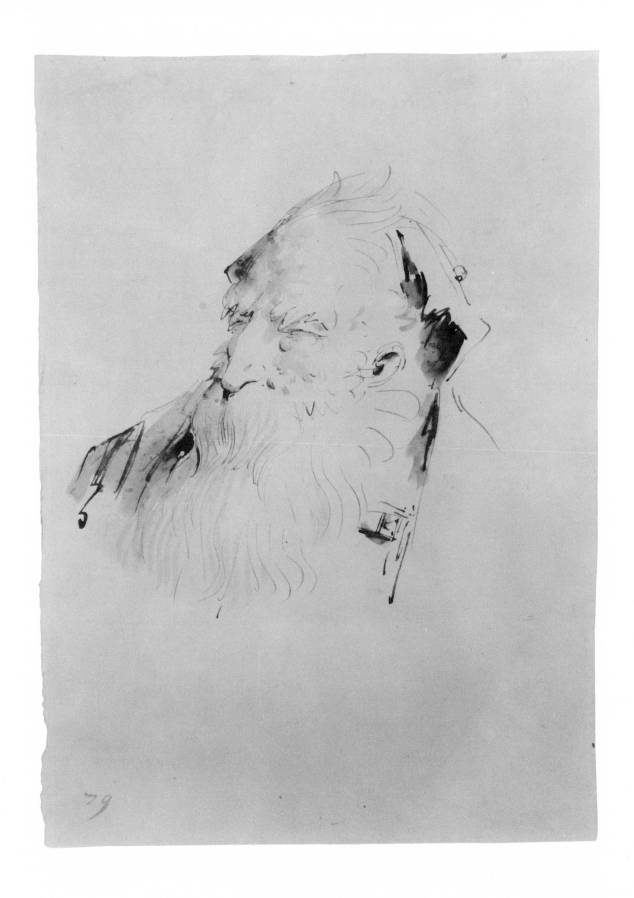

69 Giovanni Battista Tiepolo *Head of an Old Bearded Man*

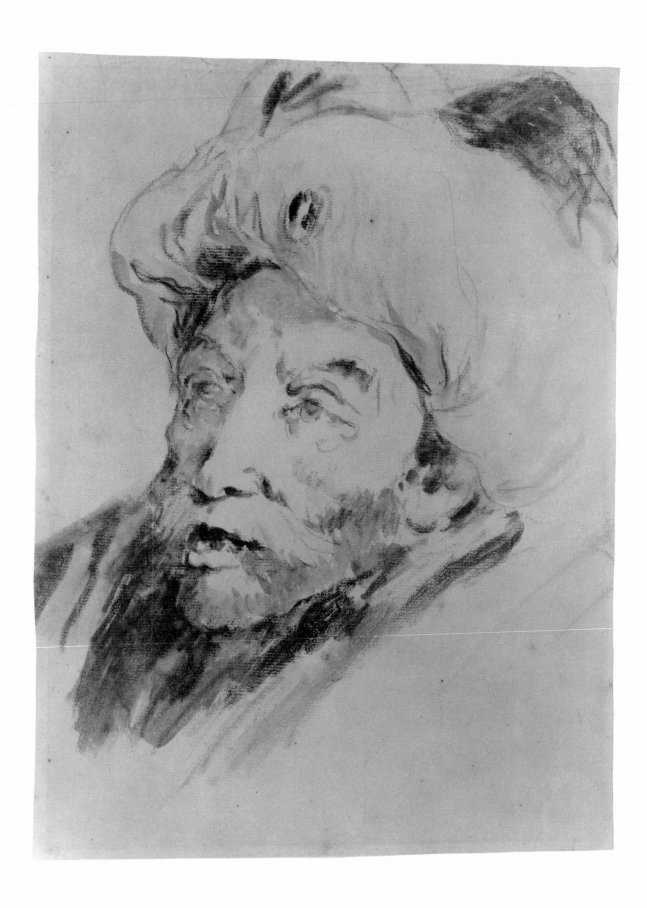

70 Giovanni Battista Tiepolo *Head of an Oriental*

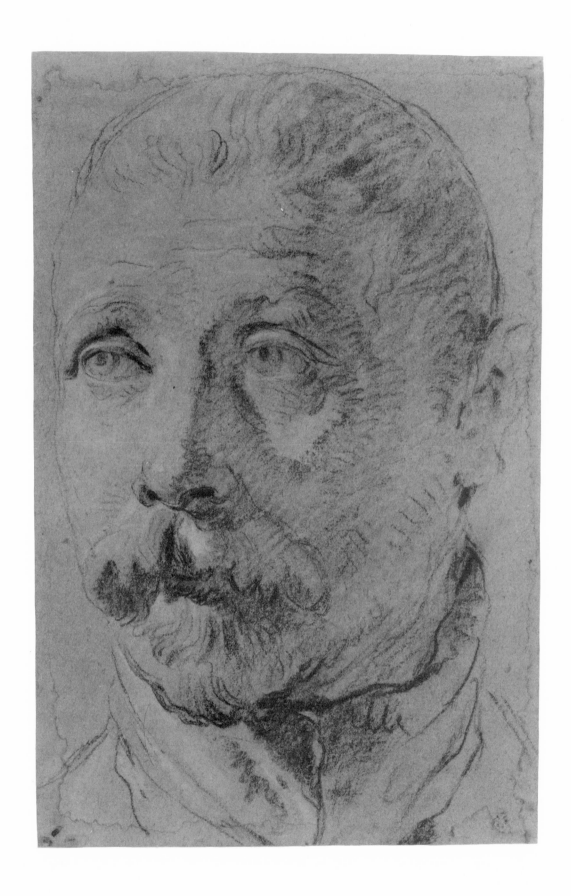

71 Giovanni Battista Tiepolo *Portrait of Palma Giovane*

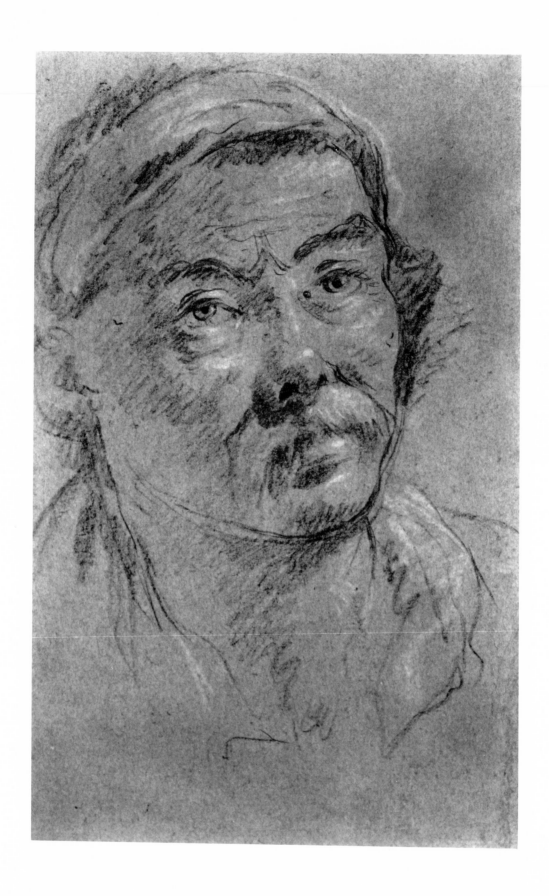

72 Giovanni Battista Tiepolo *Head of an Executioner*

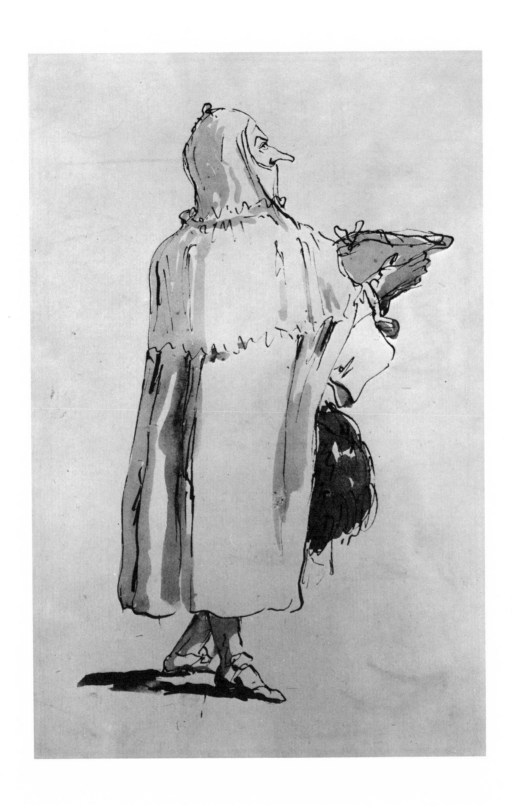

73 Giovanni Battista Tiepolo *Man in a Domino Holding a Tricorne and a Muff*

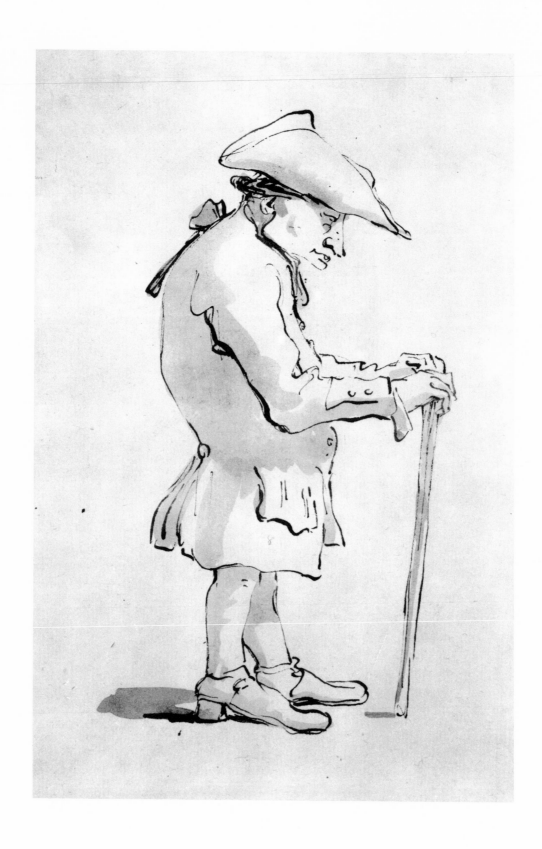

74 Giovanni Battista Tiepolo *Short Man in a Tricorne Resting Both Hands on His Stick*

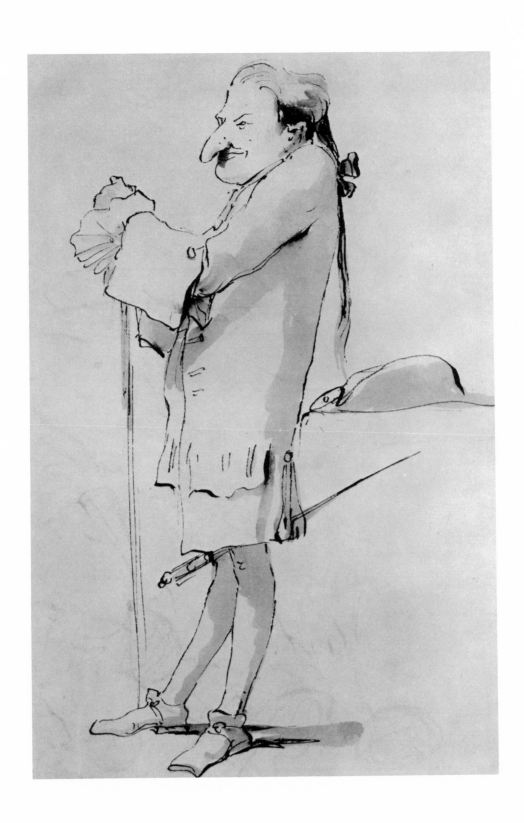

75 Giovanni Battista Tiepolo *Tall Man with a Long Walking Stick, His Sword at His Side*

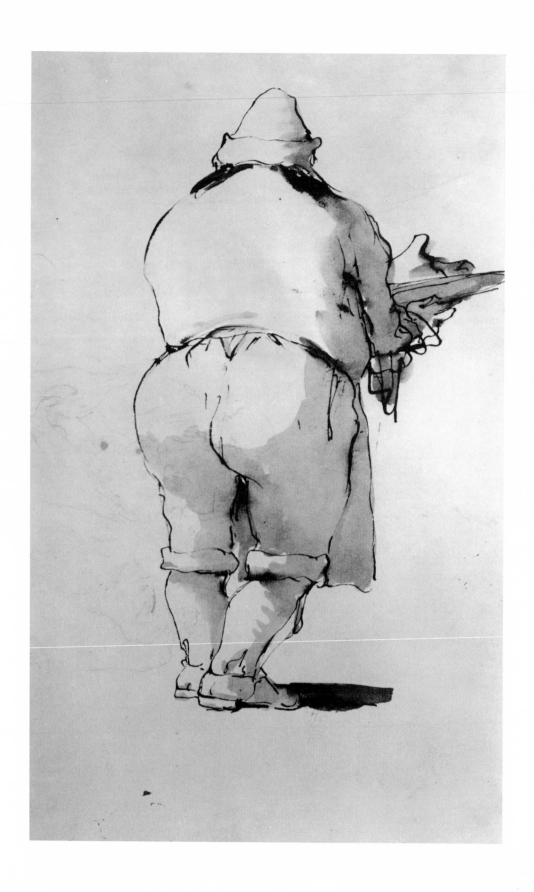

76 Giovanni Battista Tiepolo *The Cook*

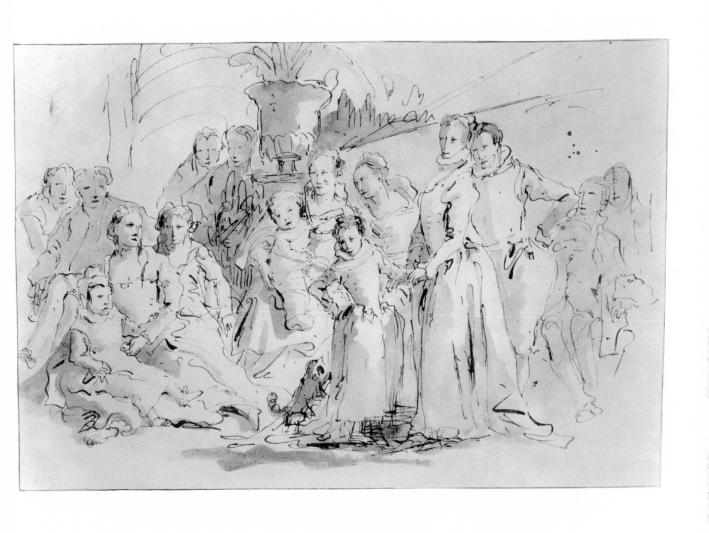

77 Giovanni Battista Tiepolo *Study for a Family Group*

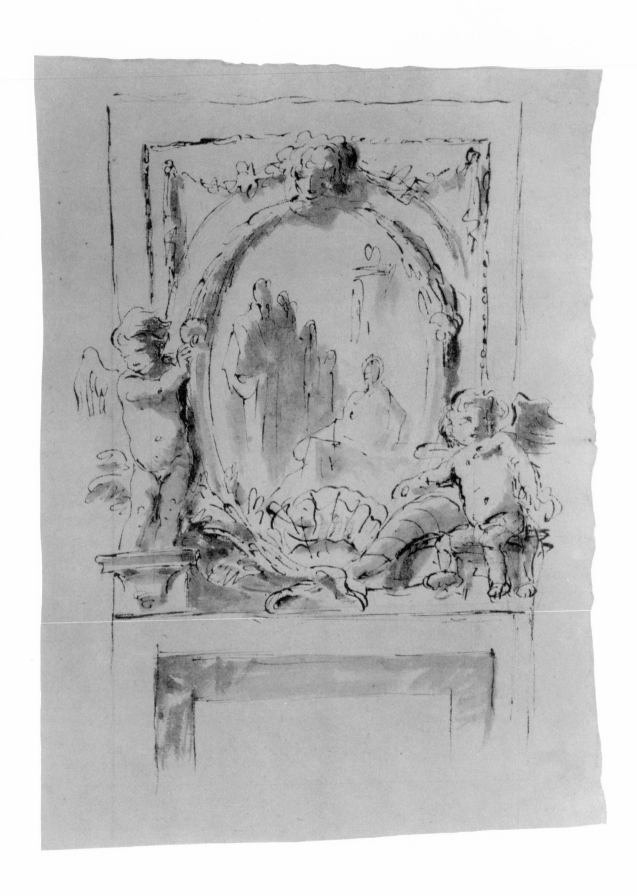

78 Giovanni Battista Tiepolo *Design for an Overdoor with Cherubs*

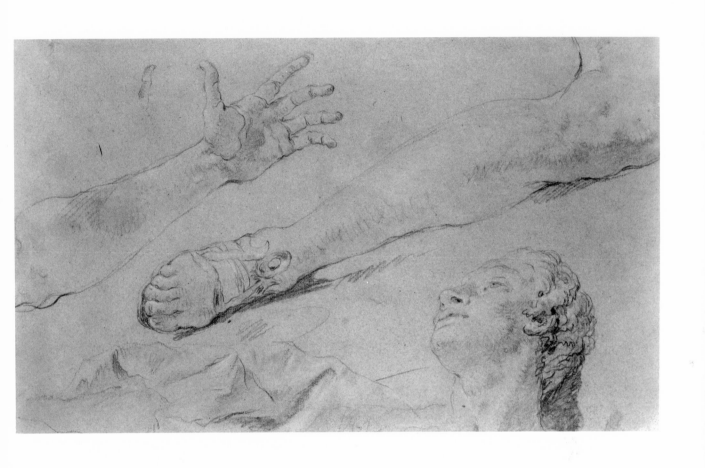

79 Giovanni Domenico Tiepolo *Details of "The Death of Hyacinth"*

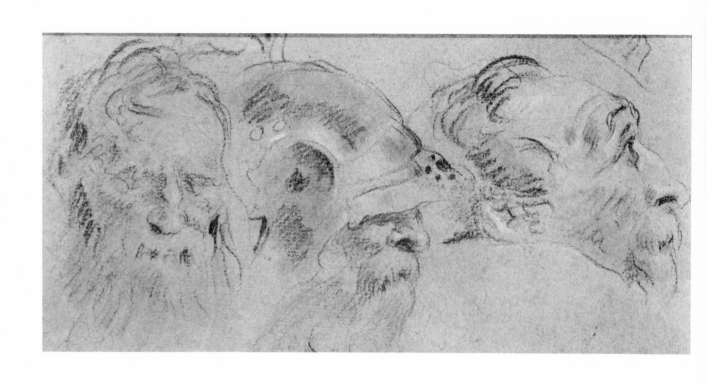

80　Giovanni Domenico Tiepolo　*Three Heads*

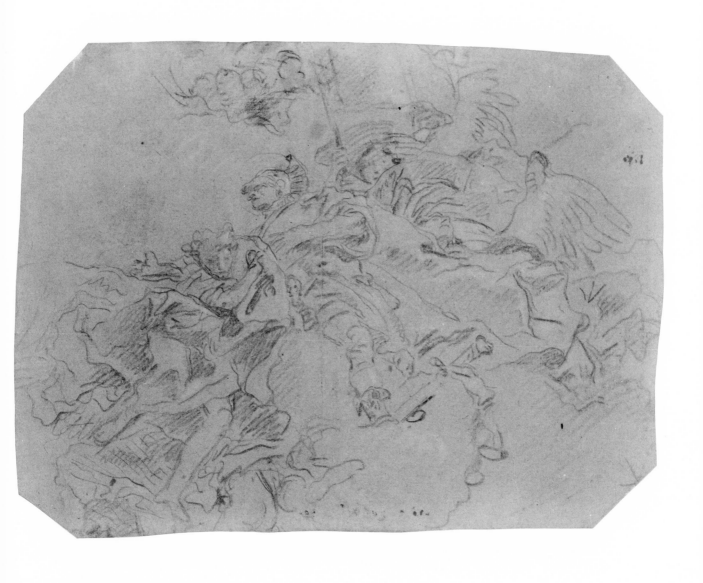

81 Giovanni Domenico Tiepolo *S. Faustino Carried to Heaven*

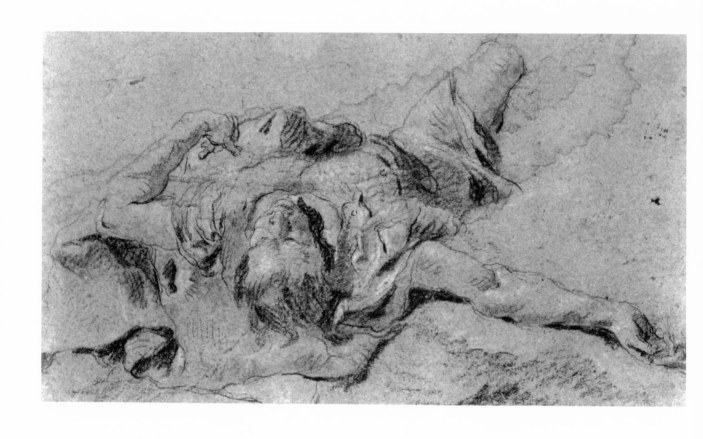

82 Giovanni Domenico Tiepolo *Fallen Warrior*

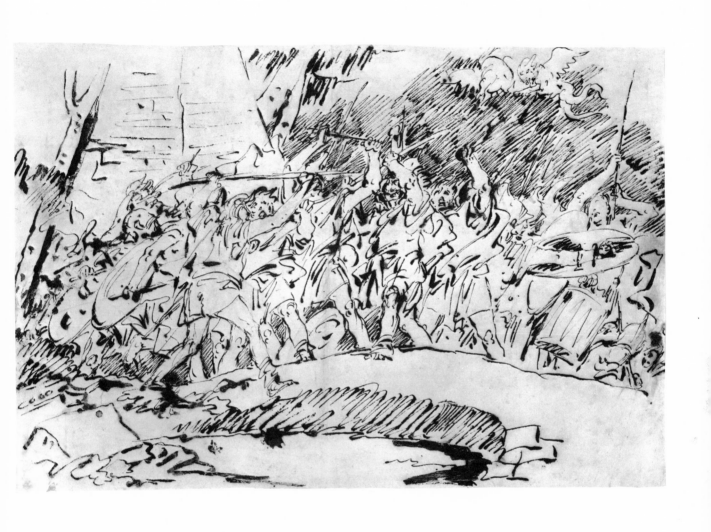

83 Giovanni Domenico Tiepolo *Horatius Holding the Bridge*

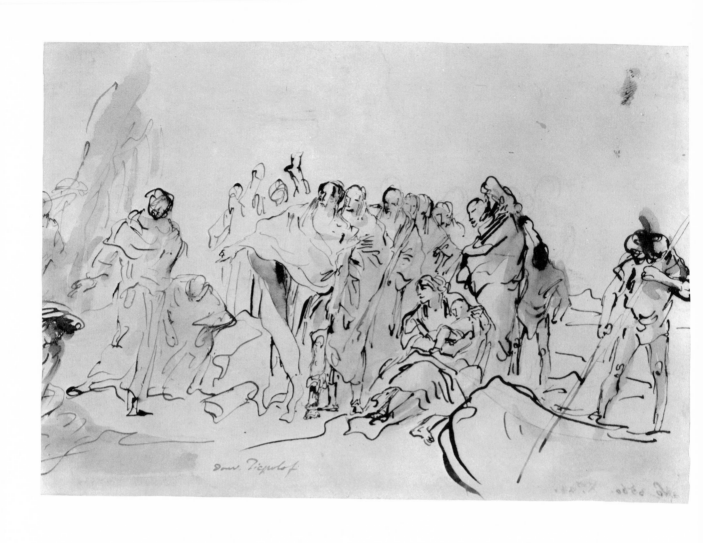

84 Giovanni Domenico Tiepolo *Boatman and Crowd at the Shores of a Lake*

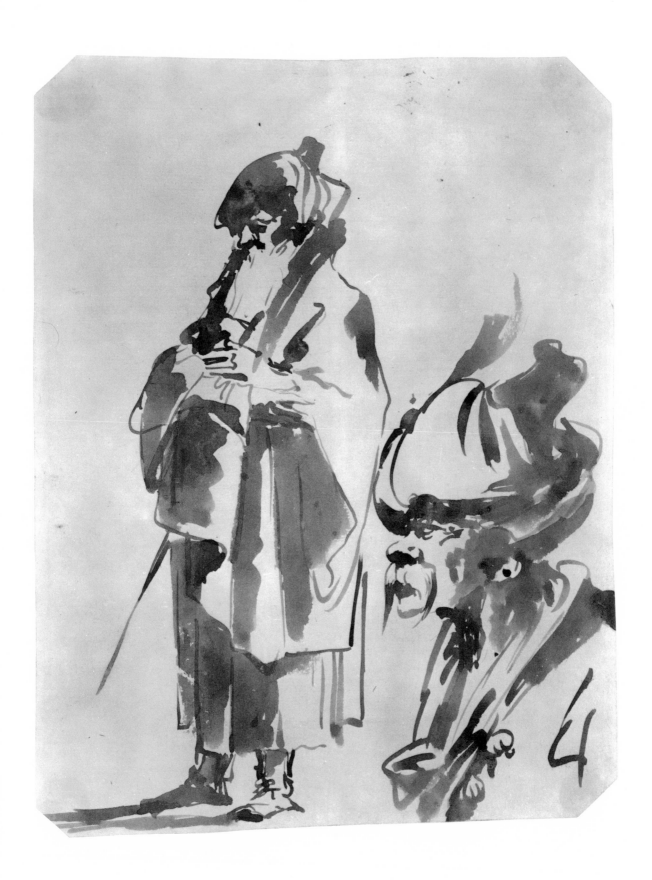

85 Giovanni Domenico Tiepolo *Two Orientals*

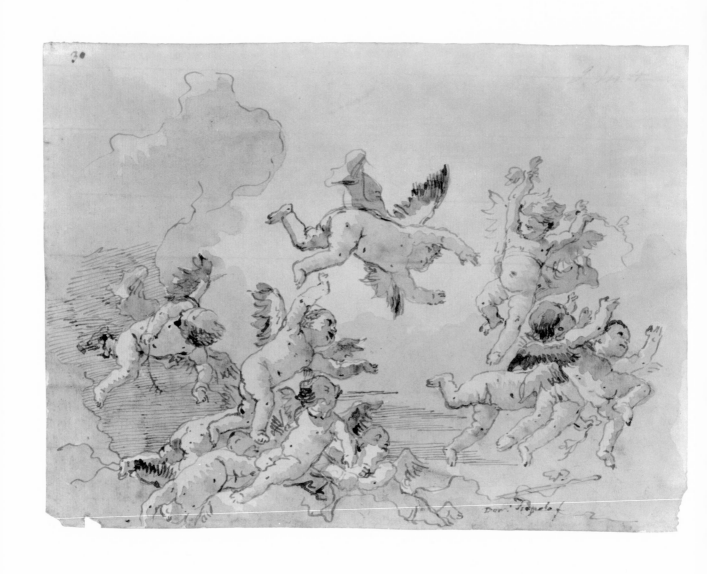

86 Giovanni Domenico Tiepolo *Cherubs Playing in the Clouds*

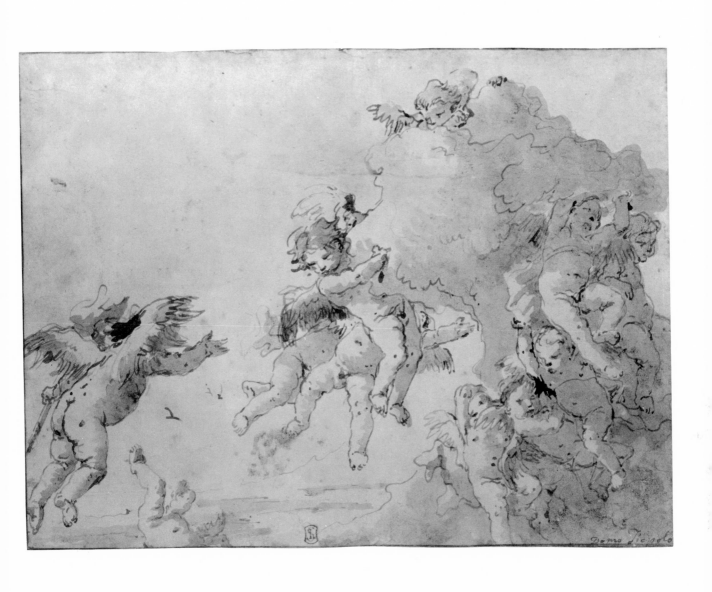

87 Giovanni Domenico Tiepolo *Cherubs Playing in the Clouds*

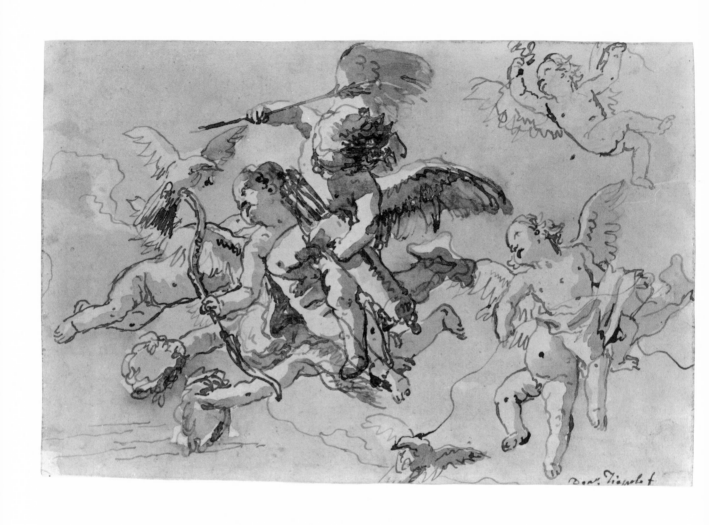

88 Giovanni Domenico Tiepolo *Cupid and Cherubs in the Clouds*

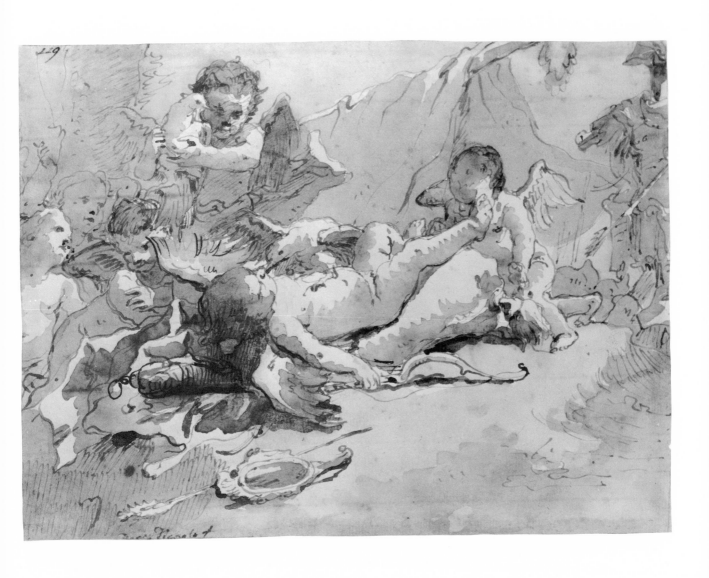

89 Giovanni Domenico Tiepolo *Cupid and Cherubs Playing with Doves*

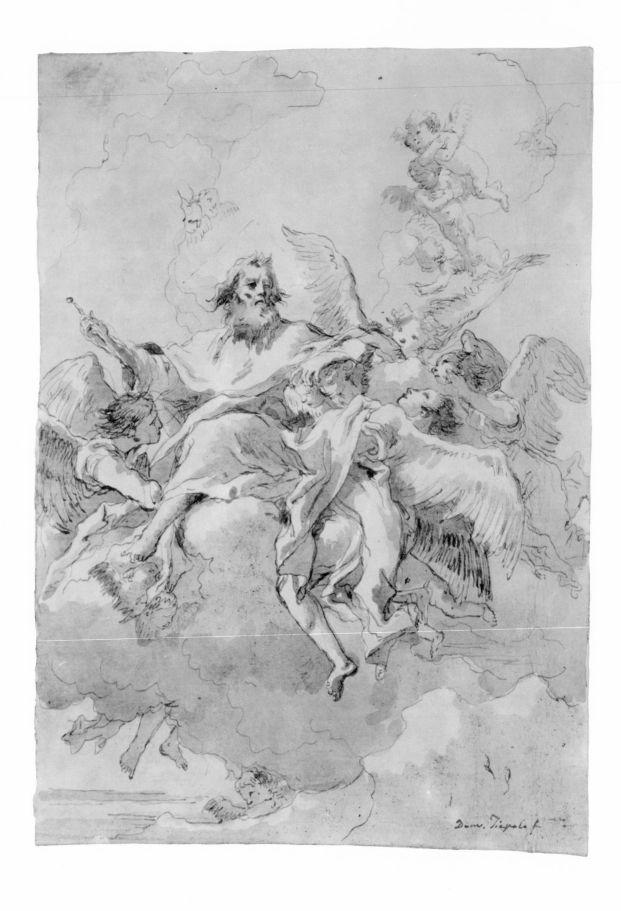

90　Giovanni Domenico Tiepolo　*God the Father Supported by Angels and Cherubs*

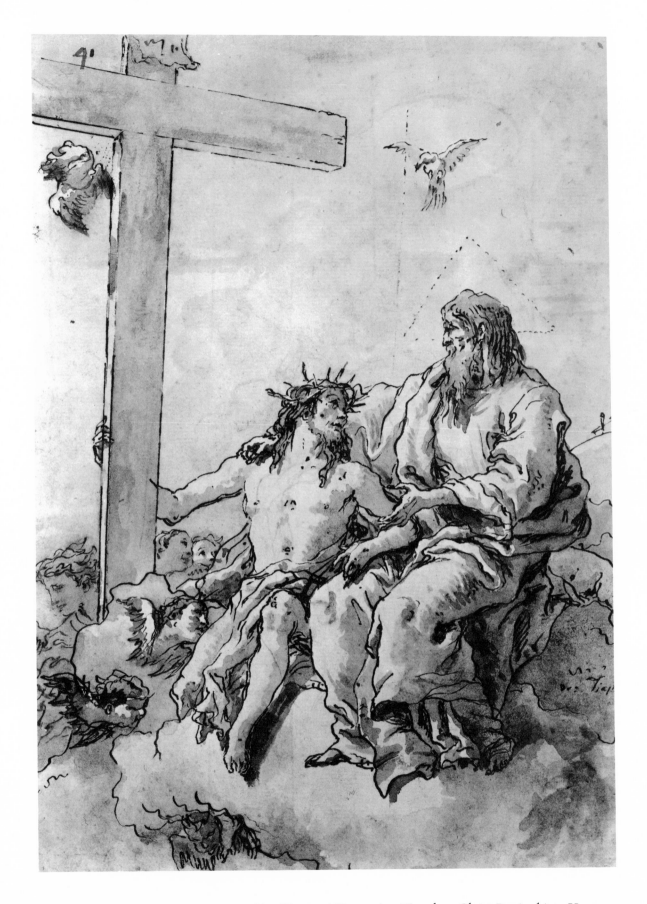

91 Giovanni Domenico Tiepolo *Christ Received into Heaven*

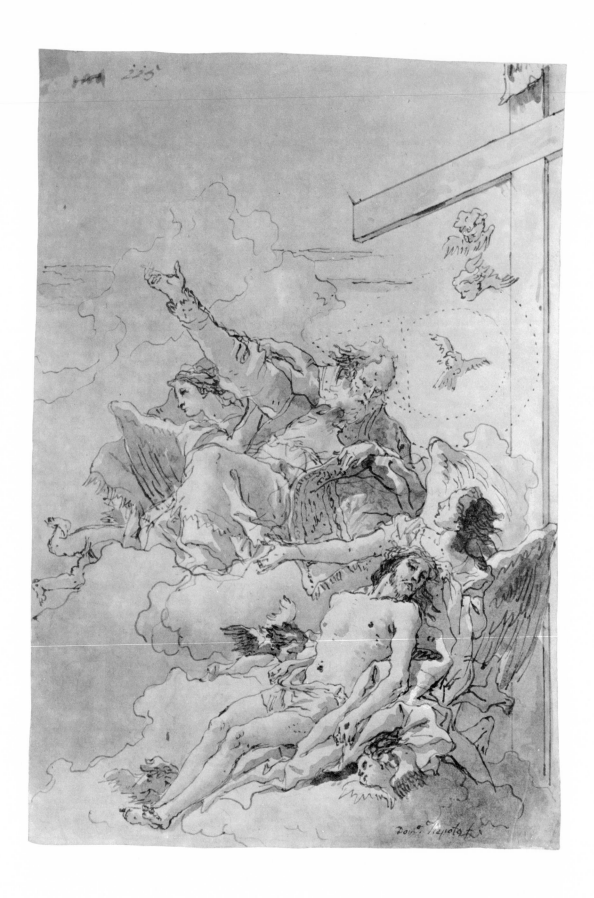

92 Giovanni Domenico Tiepolo *Christ Received into Heaven*

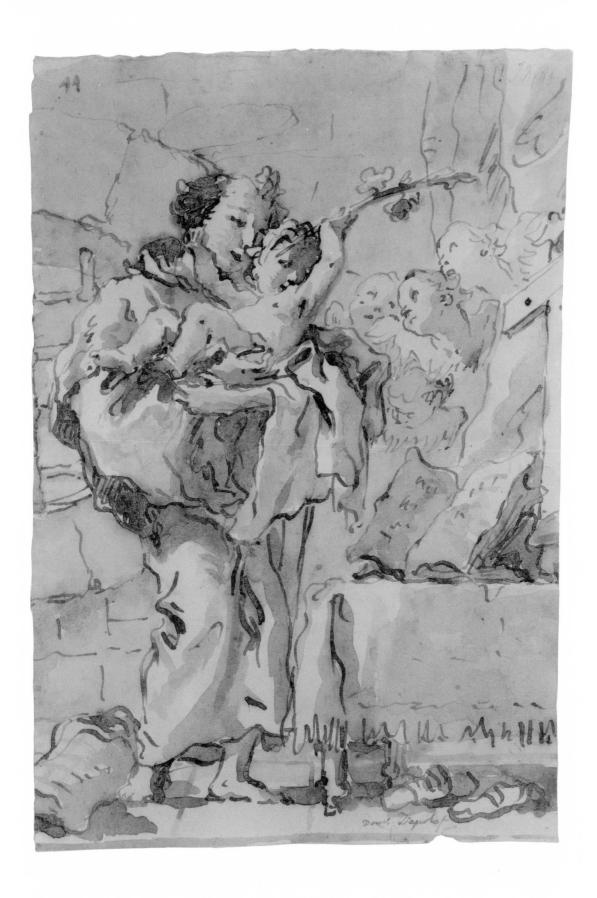

93 Giovanni Domenico Tiepolo *St. Anthony Holding the Christ Child before an Altar*

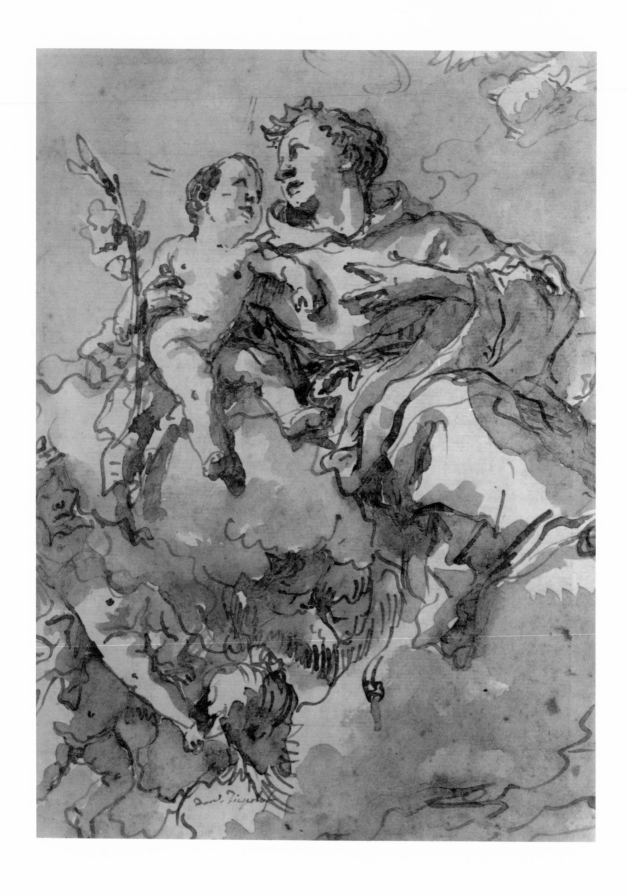

94 Giovanni Domenico Tiepolo *St. Anthony and the Christ Child in the Clouds*

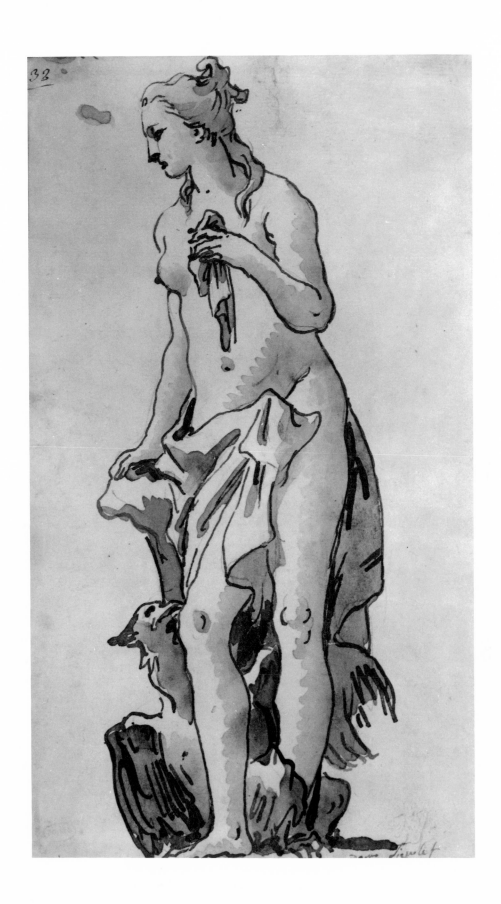

95 Giovanni Domenico Tiepolo *Juno with Jupiter's Eagle*

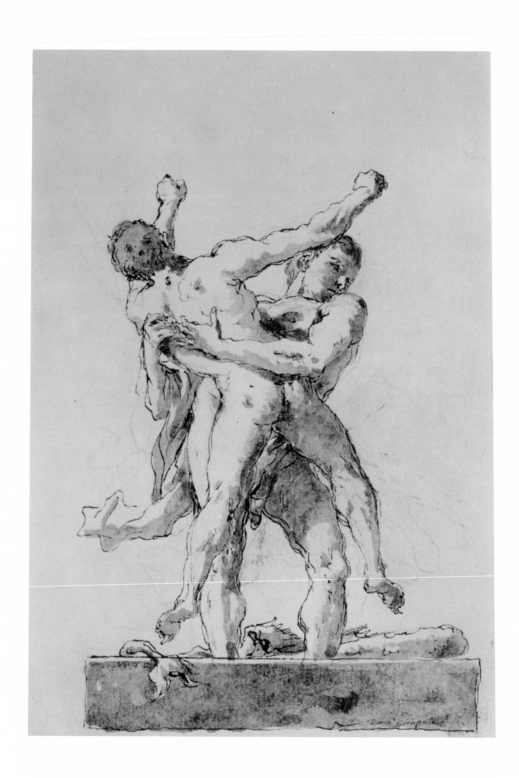

96 Giovanni Domenico Tiepolo *Hercules and Antaeus*

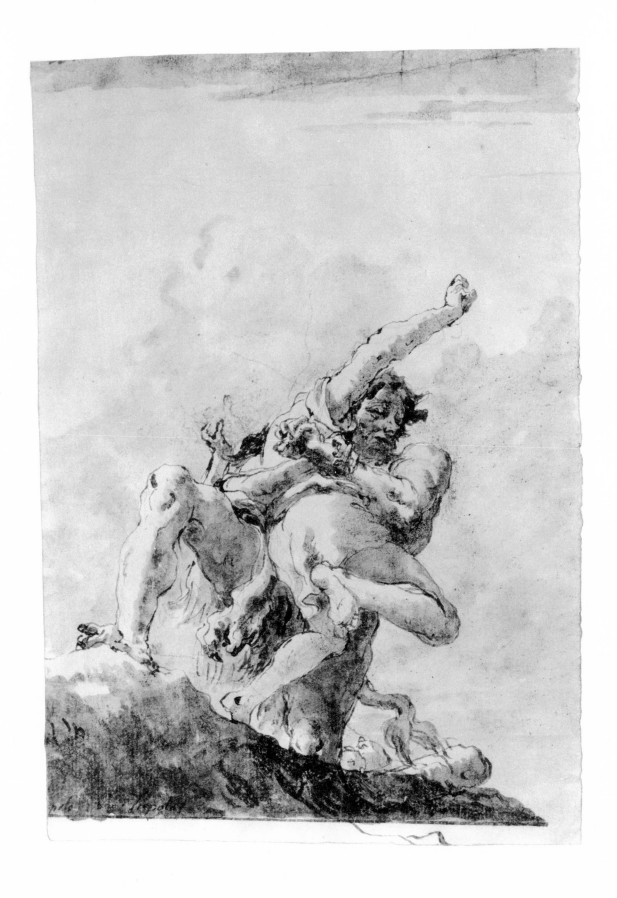

97 Giovanni Domenico Tiepolo *Hercules and Antaeus*

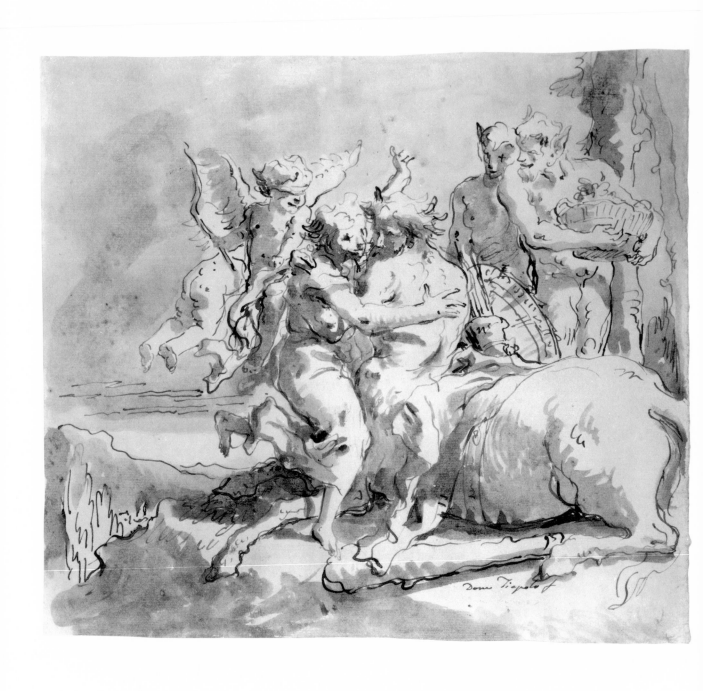

98 Giovanni Domenico Tiepolo *Centaurs Abducting a Woman, with Cupid and Satyrs*

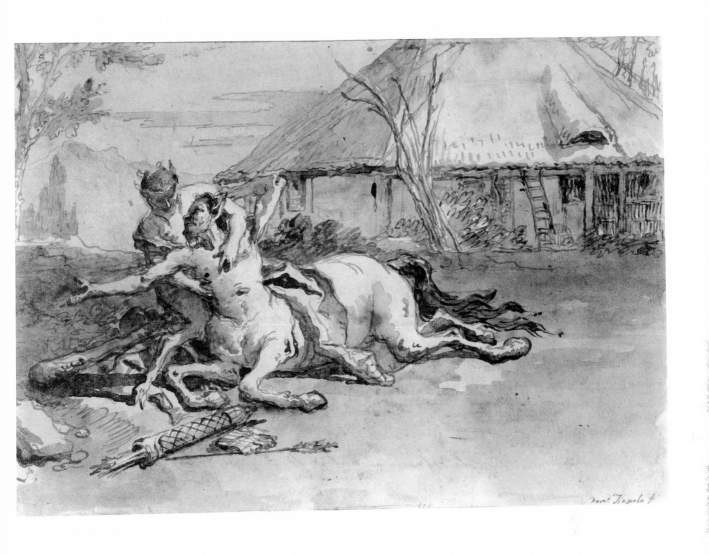

99 Giovanni Domenico Tiepolo *Centaur and Faun in a Landscape*

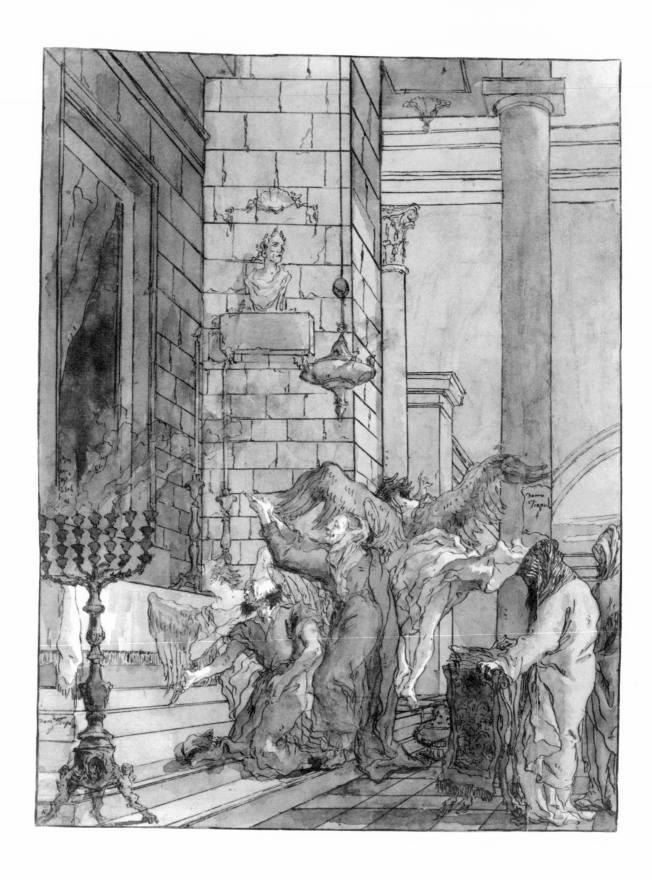

100 Giovanni Domenico Tiepolo *Joachim and Anna in the Temple*

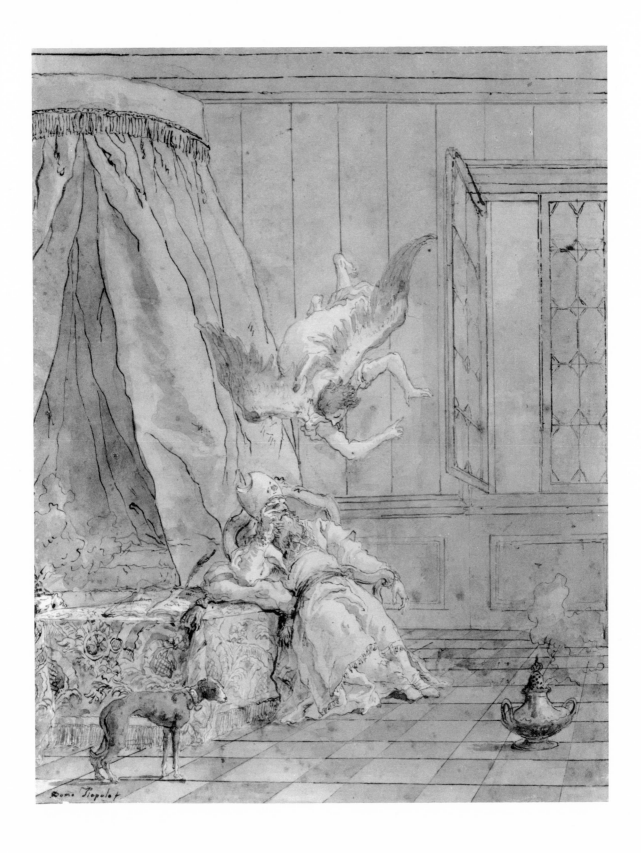

101 Giovanni Domenico Tiepolo *Announcement of the Birth of St. John to Zacharias*

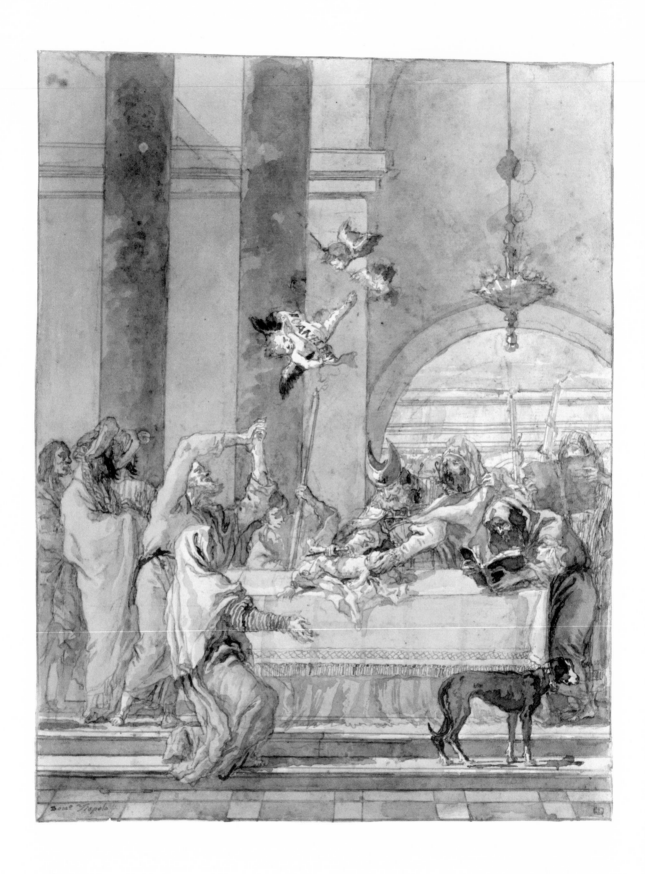

102 Giovanni Domenico Tiepolo *Circumcision of St. John the Baptist*

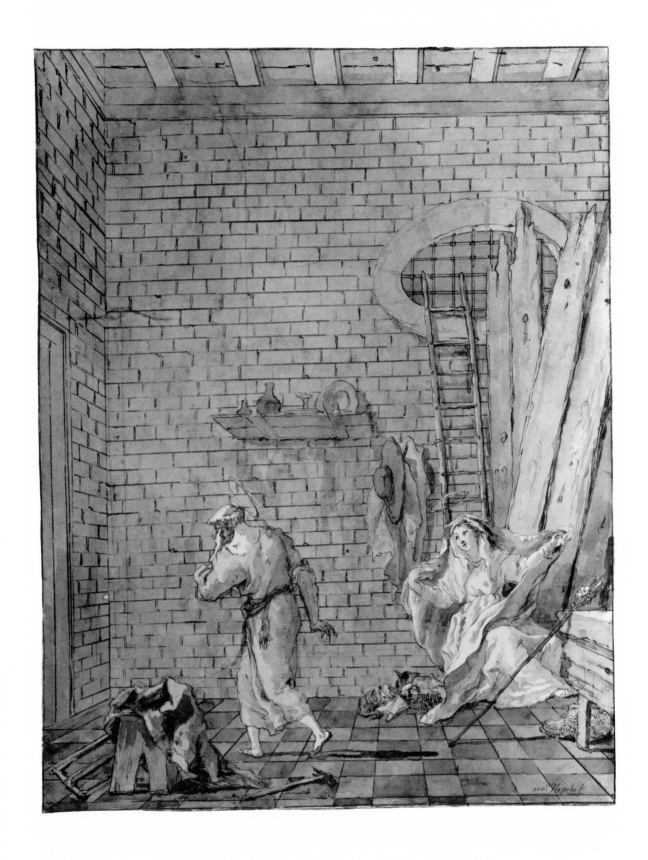

103 Giovanni Domenico Tiepolo *Mary Disclosing the Angel Gabriel's Message to Joseph*

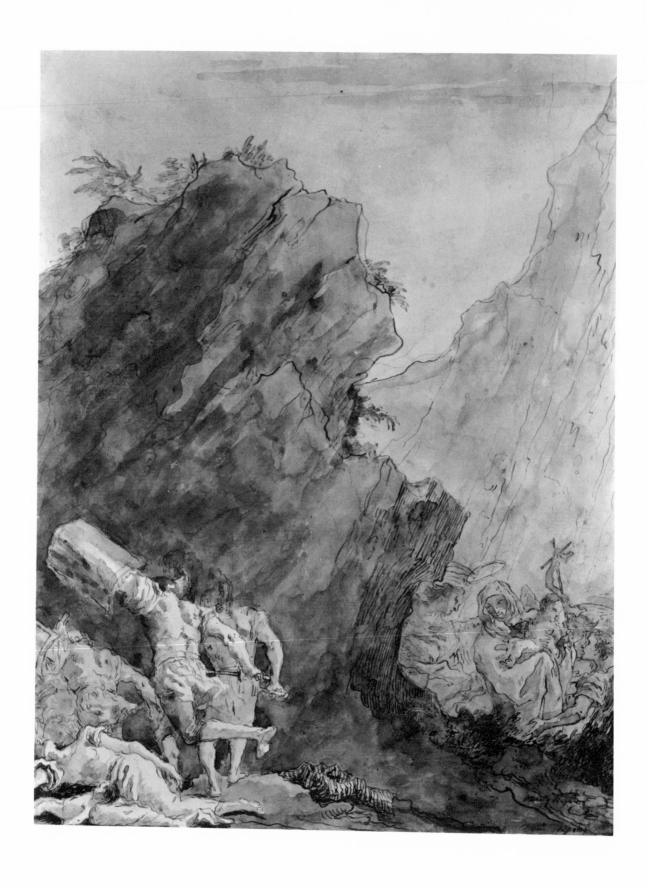

104 Giovanni Domenico Tiepolo *Flight into Egypt and the Massacre of the Innocents*

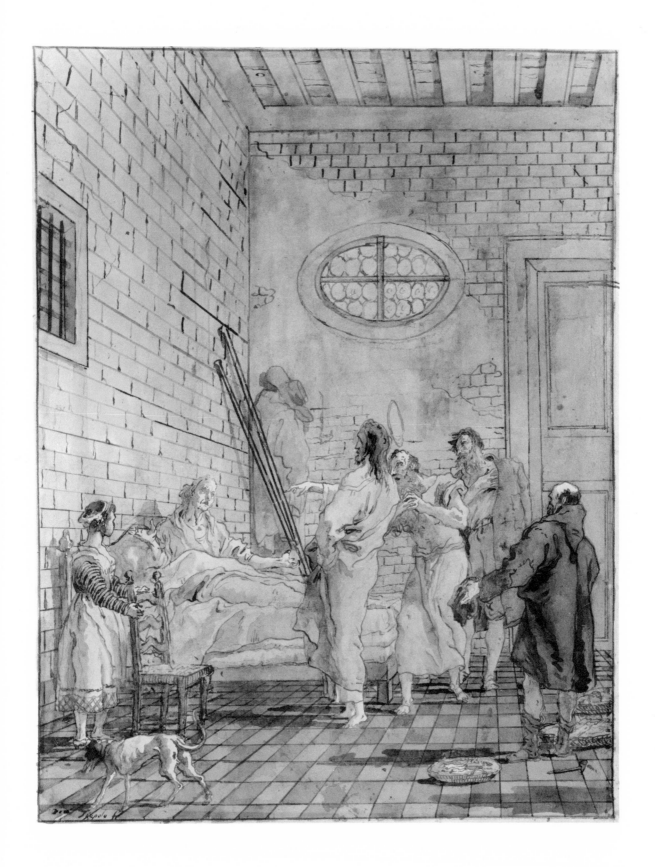

105 Giovanni Domenico Tiepolo *Christ Curing St. Peter's Mother-in-Law of a Fever*

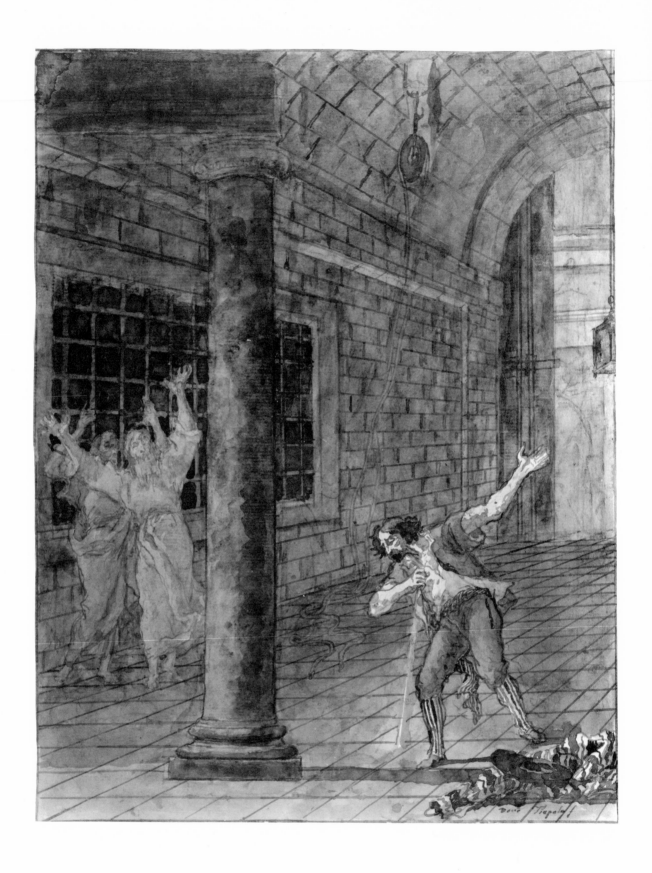

106 Giovanni Domenico Tiepolo *Death of Judas*

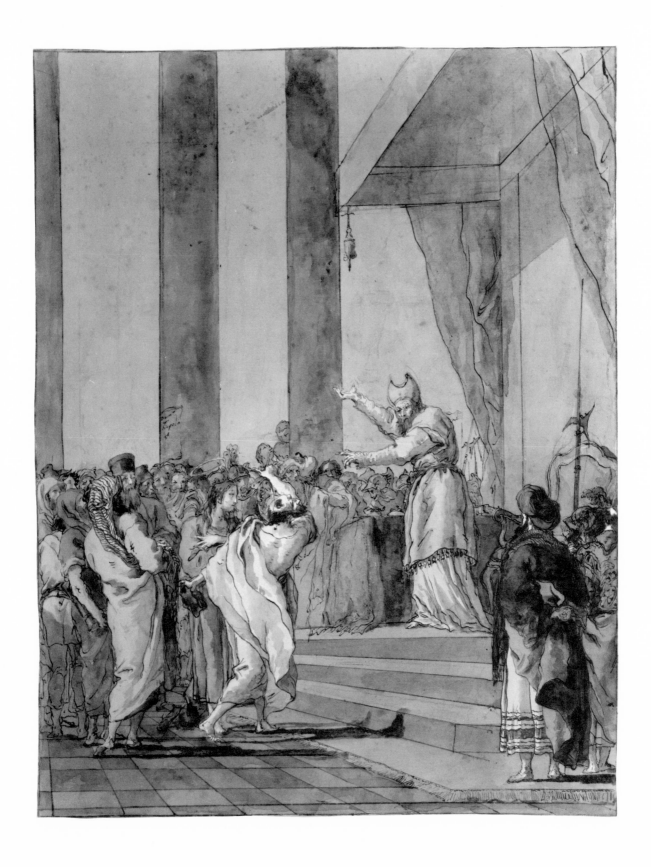

107 Giovanni Domenico Tiepolo *St. Peter and St. John before Annas*

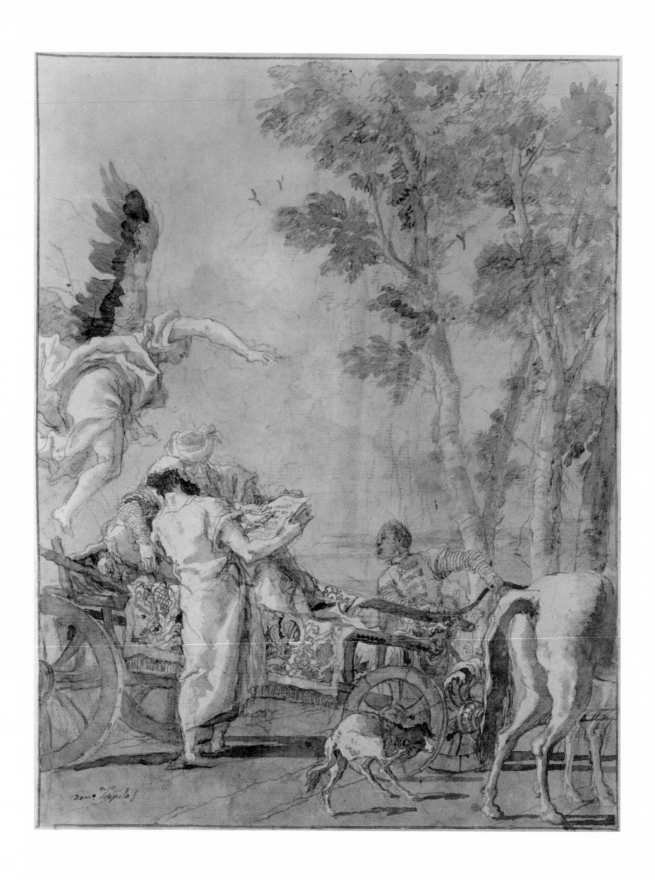

108 Giovanni Domenico Tiepolo *St. Philip and the Ethiopian Eunuch*

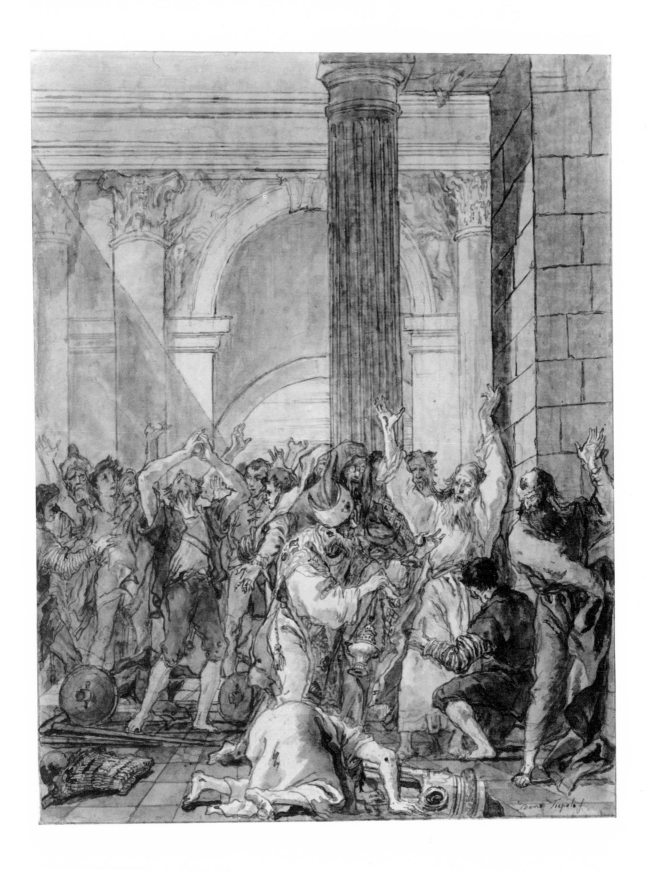

109 Giovanni Domenico Tiepolo *St. Paul at Lystra*

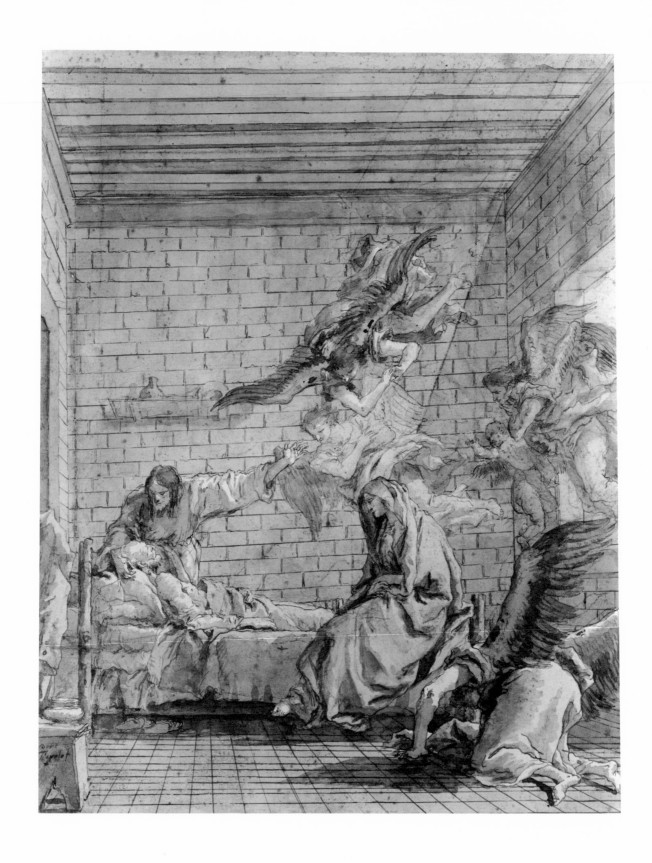

110 Giovanni Domenico Tiepolo *Death of St. Joseph*

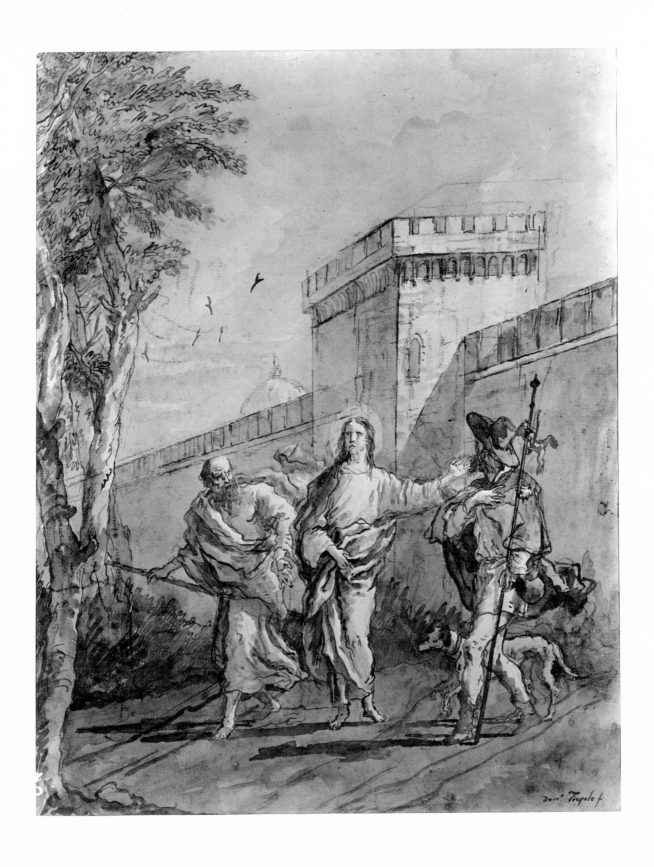

111 Giovanni Domenico Tiepolo *Christ and the Disciples on the Road to Emmaus*

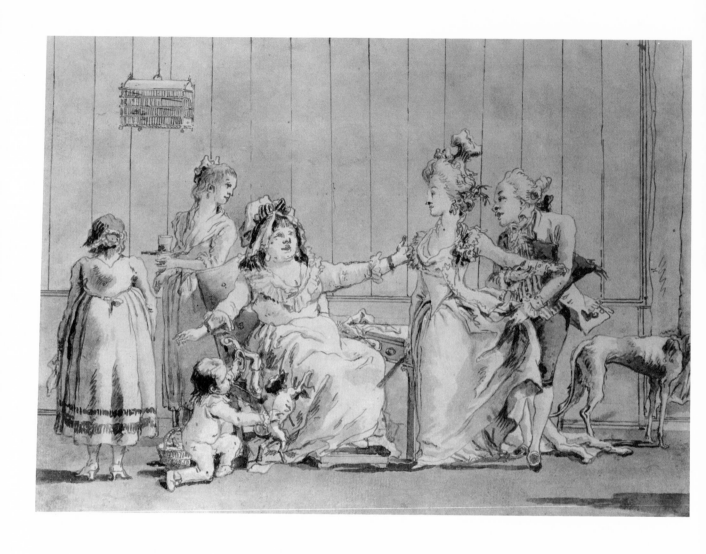

112 Giovanni Domenico Tiepolo *The Presentation of the Fiancée*

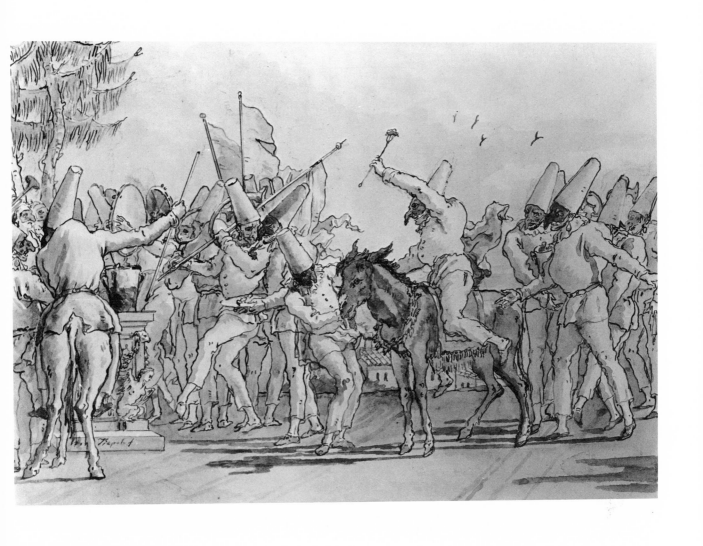

113 Giovanni Domenico Tiepolo *Punchinello Riding on an Ass in a Procession of His Fellows*

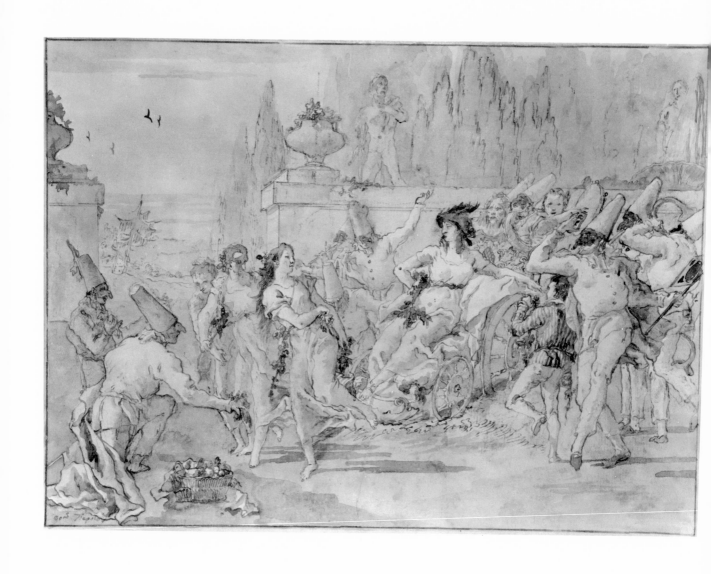

114 Giovanni Domenico Tiepolo *Punchinello Takes Part in a "Triumph of Flora"*

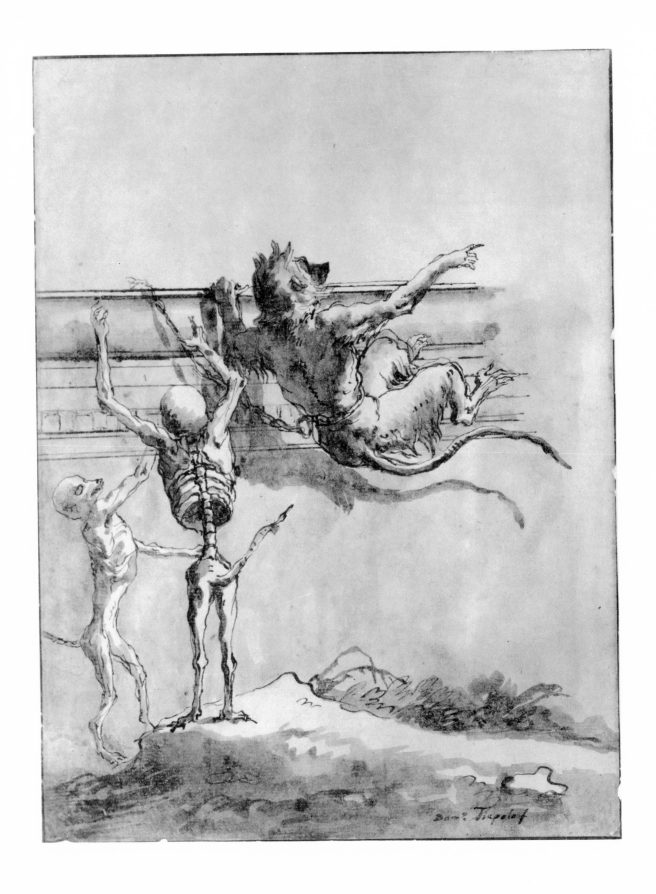

115 Giovanni Domenico Tiepolo *Monkey Swinging on a Parapet*

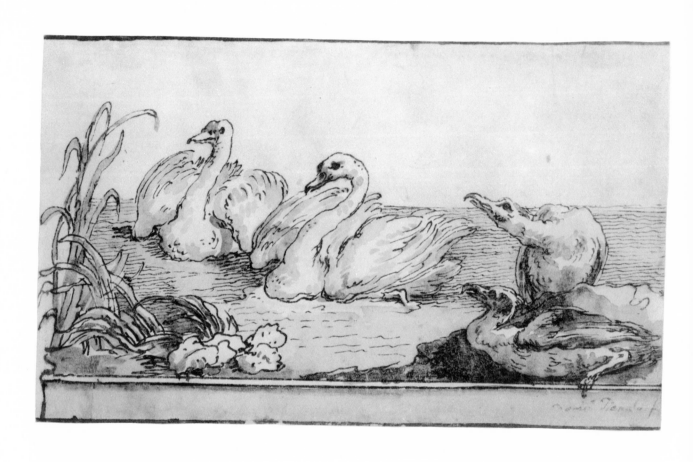

116 Giovanni Domenico Tiepolo *Swans and Cormorants*

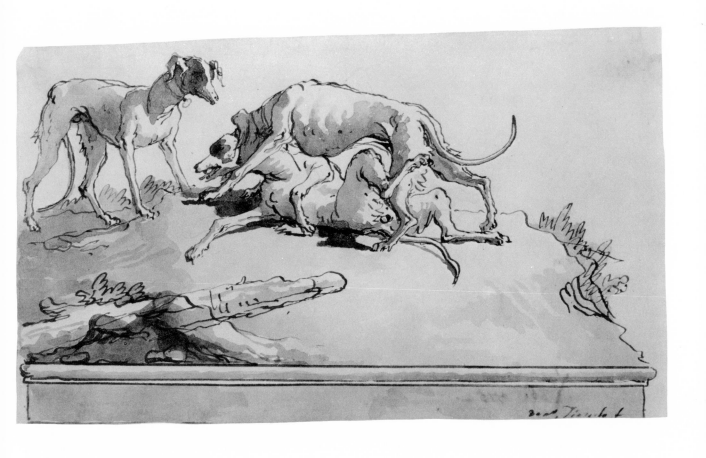

117　Giovanni Domenico Tiepolo　*Dogs Playing*

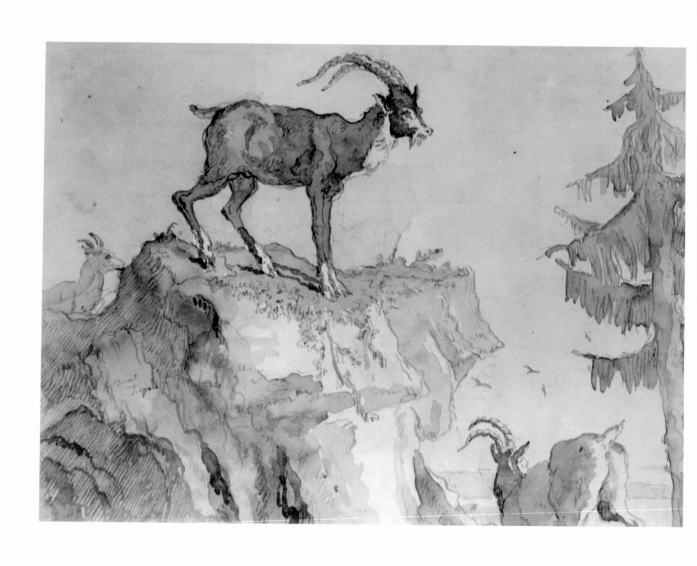

118 Giovanni Domenico Tiepolo *Three Ibex*

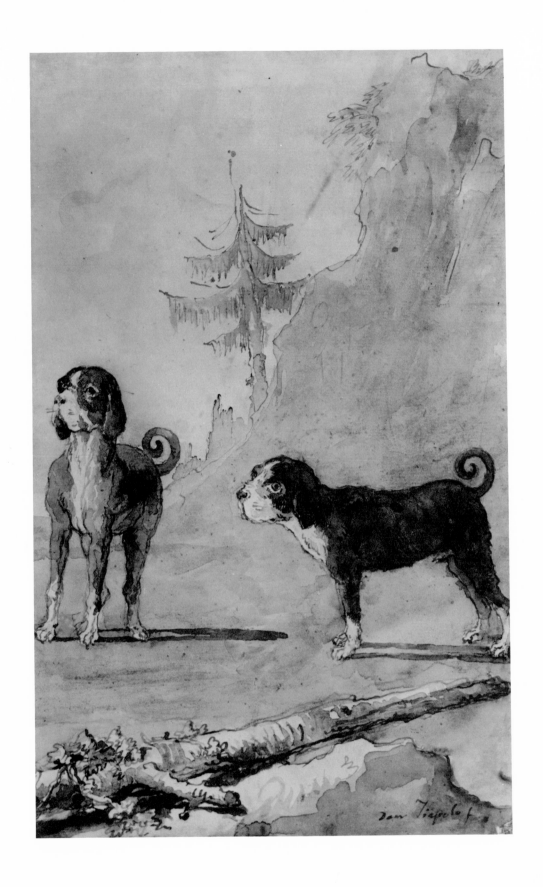

119 Giovanni Domenico Tiepolo *Two Dogs with Curling Tails*